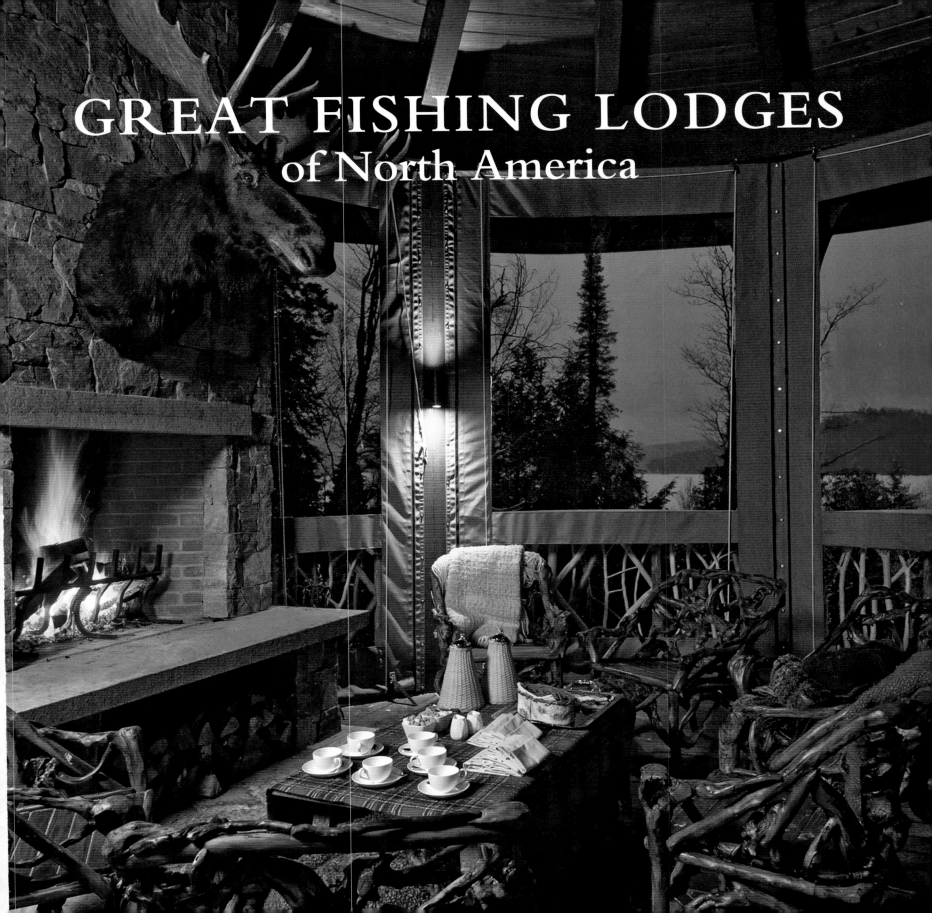

GREAT FISHING LODGES
of North America

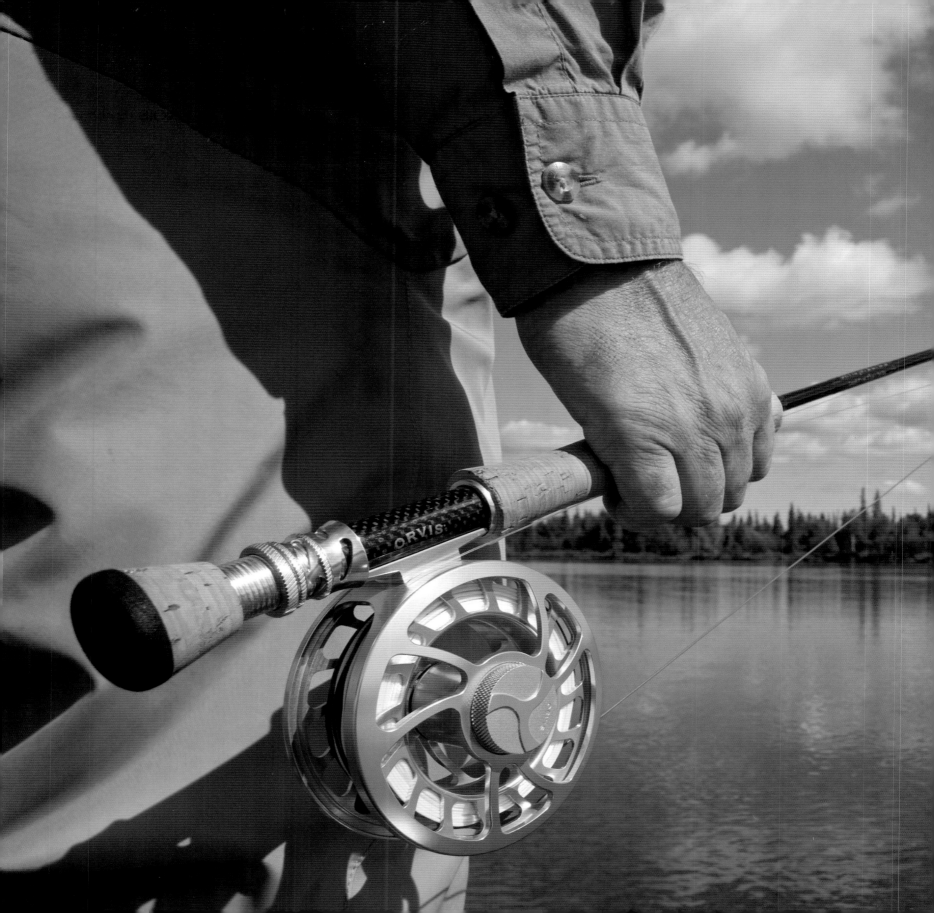

GREAT FISHING LODGES
of North America

FLY FISHING'S FINEST DESTINATIONS

ORVIS

RIZZOLI
NEW YORK

New York · Paris · London · Milan

First published in the United States of America in 2010
by Rizzoli International Publications, Inc.
300 Park Avenue South
New York, NY 10010
www.rizzoliusa.com

Project Editor: Candice Fehrman
Band-f Ltd. President: f-stop Fitzgerald
Book Design and Production: Maria Fernandez
Copyeditor: Leigh Grossman

2010 2011 2012 2013 / 10 9 8 7 6 5 4 3 2 1

Printed in China

ISBN-13: 978-0-8478-3424-2

Library of Congress Catalog Control Number: 2009933840

HALF TITLE PAGE: *Lake Placid Lodge.*
TITLE PAGE: *Lake Nerka in Dillingham, Alaska.*

CONTENTS

FOREWORD

BY TOM ROSENBAUER

Thirty years ago, Orvis owner Leigh Perkins met a cowboy/rancher/fish biologist named Vern Bressler who was managing a lodge called the Crescent H Ranch in Wilson, Wyoming, outside of Jackson. Leigh fell in love with the spring creeks Vern had rehabilitated on the ranch property, spending hours casting tiny mayfly imitations to the large and very selective cutthroat trout that rose all day long in the clear, shallow pools. Leigh was impressed with both the fishing and with Vern's talent for running a ranch—motivating the wait staff, cabin cleaners, cooks, wranglers, and fishing guides so that each guest had a world-class experience. Leigh had just instituted the country's first fly-fishing schools and wanted to guide customers into their next experience after learning to cast and tie knots. What better place, he thought, to keep customers interested in fly fishing than a ranch in one of the world's most scenic locations with great fishing and customer service that matched his own high standards.

So Leigh wrote an article for *The Orvis News*, the company's highly regarded newspaper, which was then and is still today the world's largest fly-fishing publication.

The owner/manager of Crescent H Ranch then bought Three Rivers Ranch in Idaho and Firehole Ranch in Montana, both still fishing lodges endorsed by Orvis today. Vern found himself running three fishing lodges, which gave him an idea for an entire network of fishing operations throughout North America. Leigh was enthusiastic about the idea, and the Orvis-Endorsed program was born. The program later added hunting lodges and dog breeding operations, and today there are more than 250 endorsed sporting operations, including more than 50 fishing lodges. Only the very best sporting operations are included. They are inspected yearly by Orvis staff members, and if standards at any lodge slip below what Leigh would be proud to recommend to friends or customers, the lodge's contract is not renewed.

Customers can take their pick of a wide variety of experiences in the Orvis program, from elegant dude ranches to wilderness Alaskan lodges to down-home fishing camps. And although the amenities vary widely in style, they are always best-in-class. It's the people, though, who make the real difference at lodges endorsed by Orvis. Vern Bressler always said he could rate an operation in about 15 minutes by watching the staff. If they were happy, he knew the operation would be a success. It might need a little extra cleaning up on the grounds or the fishing guides might need a touch more experience, but if the lodge was staffed by cheerful people, Vern knew he had a winner.

It says a lot for the concept that both Firehole Ranch and Three Rivers Ranch are still in the Orvis program—and it's amazing that Three Rivers still has the same head guide, Doug Gibson, and Firehole still has the same chefs, Bruno and Kris Georgeton. In fact, there has been a lot of continuity in the program. Leigh Perkins's son David, now vice-chairman of Orvis, worked as a fishing guide for Three Rivers during his college years and Vern never let Dave forget that he once beat the strapping 19-year-old in a wood splitting contest. When Vern retired, his son Mark took over management of the Orvis-Endorsed program for many years, and it is now in the able hands of Tom Evenson and Scott McEnaney, both hardcore fly anglers, wingshooters, and Orvis veterans.

It's difficult to describe a typical Orvis lodge because there is no such thing. These places are hardly formulaic, and each lodge has its own ambiance and specialties that make it a distinctive experience. I know Firehole Ranch best, as I helped Vern name it. The first time I visited the ranch it was still under renovation, with trenches across the property and half-finished cabins, but since the early days I have been there many times—I've driven the dusty road along Hebgan Lake; gazed at the spectacular view of mountains and wildflowers; tasted the chef's pan-seared Canadian walleye and local buffalo tenderloins; glimpsed moose, bighorn sheep, and grizzly bears; fished one of the most remote parts of the Madison River for brown and rainbow trout; floated all day on one of North America's most scenic streams; and enjoyed the cool Montana night. Each visit is like returning to a long-treasured summer camp with old friends. For years I visited Firehole Ranch over the Fourth of July week, and invariably the guest list was almost a carbon copy of the previous year, a testimony to the ranch's appeal.

This is just a glimpse into one of our many endorsed lodges—Firehole Ranch, the one I know best—but guests can expect to find a similar experience at any of the other fantastic lodges included in this book. Visiting a lodge endorsed by Orvis means visiting one of the best fishing facilities in the best fishing areas of North America. While each lodge has its own character and unique aspects, all lodges share the same high standards: great service, great fishing, and an experienced, professional staff. Vern Bressler died of cancer way too young and the sparkle in his eyes that was as bright as Venus on a clear Wyoming morning no longer shines on the world, but he would be proud of what Leigh Perkins, his sons—Perk and David—and his grandchildren have built with the endorsed lodge program.

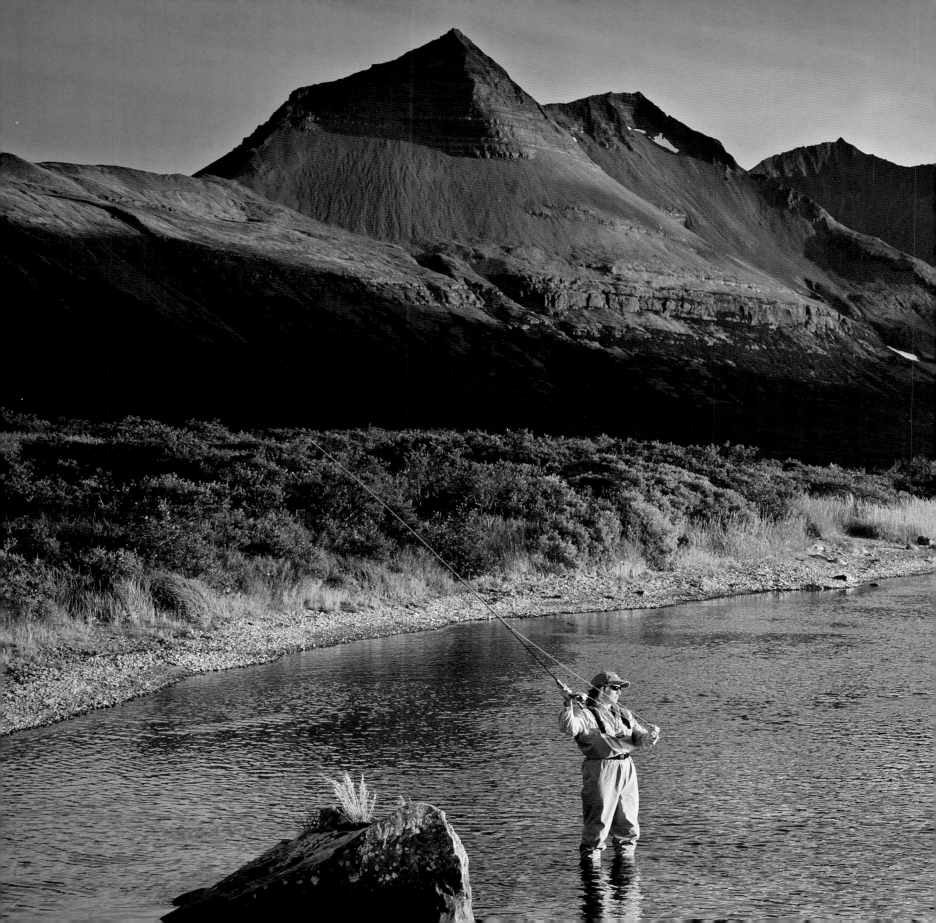

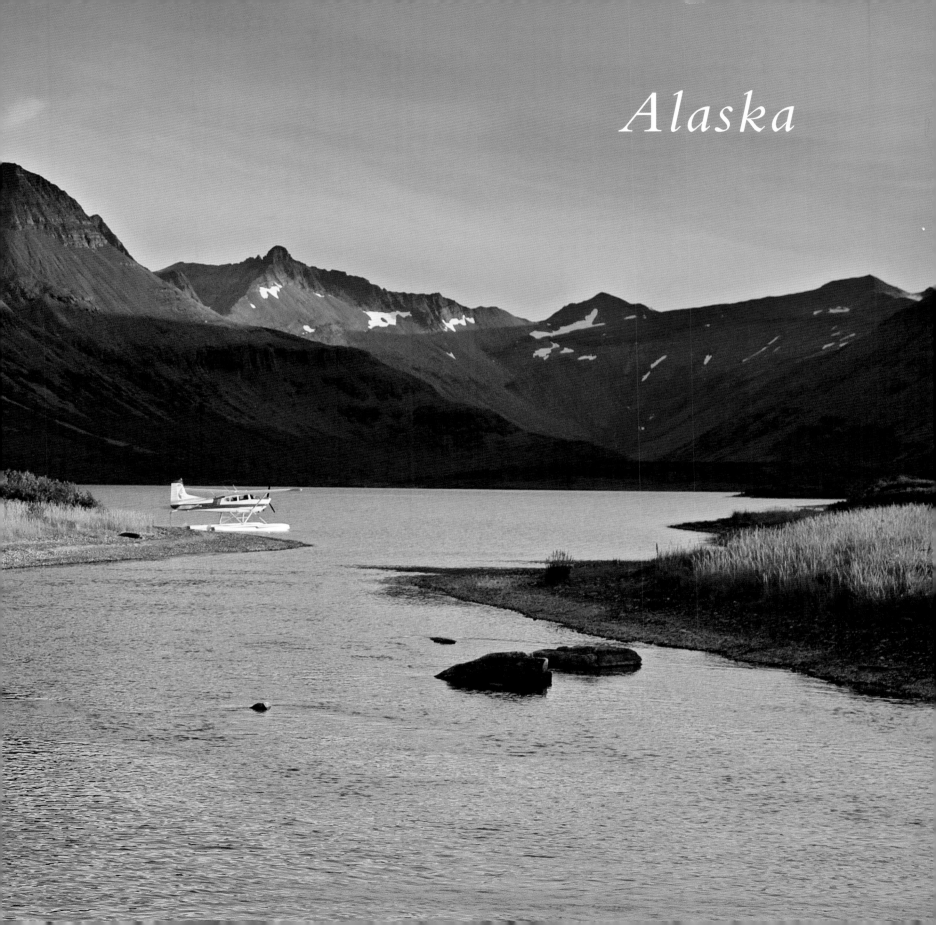

Alaska

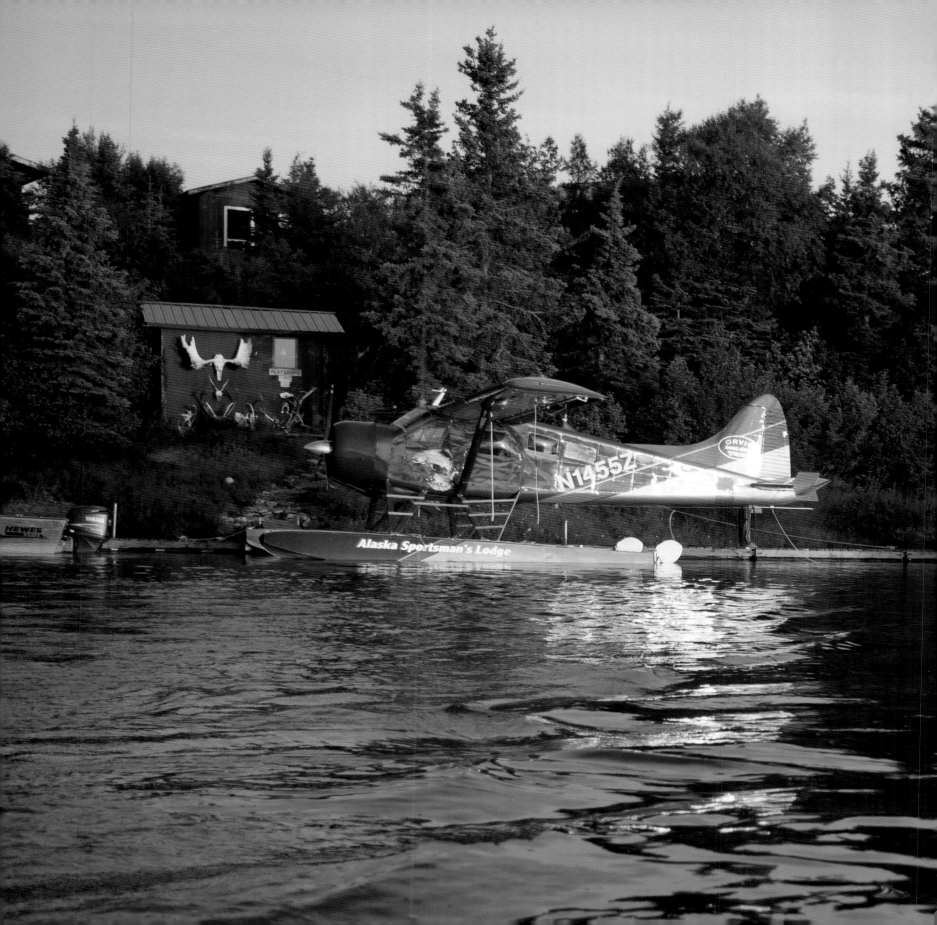

Alaska Sportsman's Lodge

LAKE ILIAMNA, ALASKA

Located on the largest freshwater lake in Alaska
Founded in 1997

The Kvichak River is a swift-flowing, crystal-clear river located about 250 miles southwest of Anchorage. What makes this river so unique is that it's the only connection between Bristol Bay and Lake Iliamna, the largest freshwater lake in Alaska and the ultimate end of more than 32 rivers that flow into it. This makes the Kvichak (from the native language meaning "up to great water," in reference to its beginnings at Lake Iliamna) the single entry point for millions of salmon that move up into this vast watershed to spawn.

The Bristol Bay watershed is Alaska's only designated "trophy rainbow trout" area. With annual salmon runs in the millions (and rainbow trout feeding on their eggs and flesh and growing in excess of 30 inches), it is no wonder that anglers throughout the world see this pristine wilderness as the pinnacle of sportfishing.

Built entirely by hand in 1997, Alaska Sportsman's Lodge quickly raised the standards of the fishing experience in this remote region. Every piece of the 500,000 pounds of construction material was flown to an airstrip four miles from the lodge and floated down the river by boat. Each piece was then carried by hand up the ridge to where the lodge was built overlooking the river.

Selected as the Orvis-Endorsed Lodge of the Year for 2005, the lodge consists of a 3,500-square-foot solid cedar-style main

PAGES 8–9: *An angler fishes for Arctic char in the shadow of the Alaska Peninsula Mountain Range, Becharof National Wildlife Refuge.* OPPOSITE: *A DeHaviland Beaver docks in front of Alaska Sportsman's Lodge on the Kvichak River.*

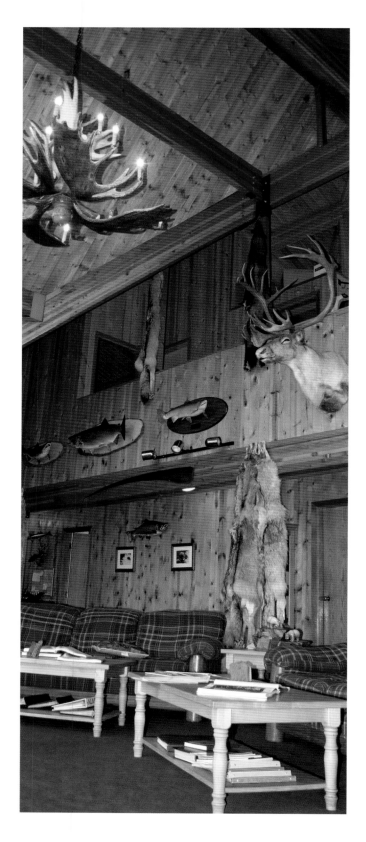

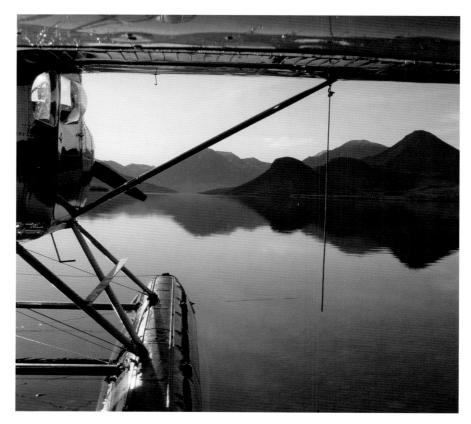

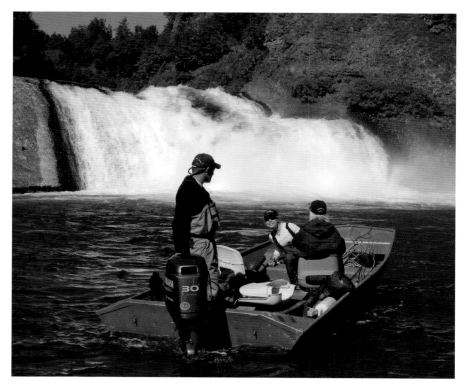

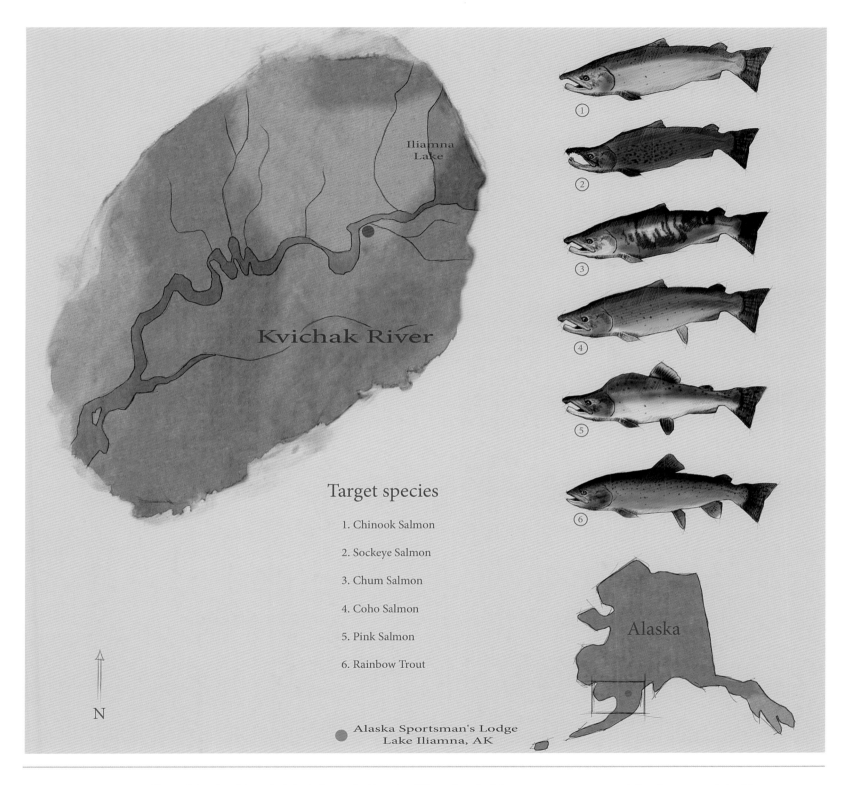

Iliamna Lake

Kvichak River

N

Target species

1. Chinook Salmon

2. Sockeye Salmon

3. Chum Salmon

4. Coho Salmon

5. Pink Salmon

6. Rainbow Trout

Alaska Sportsman's Lodge
Lake Iliamna, AK

Alaska

OPPOSITE, LEFT: *The rustic interior of the main lodge is festooned with antlers, hides, and trophy fish.* OPPOSITE, TOP RIGHT: *A floatplane rests on Lake Illiamna.*
OPPOSITE, BOTTOM RIGHT: *A guide runs his anglers to the falls in a rugged and remote area of southwest Alaska to fish for silver salmon, chum salmon, and Dolly Varden.*

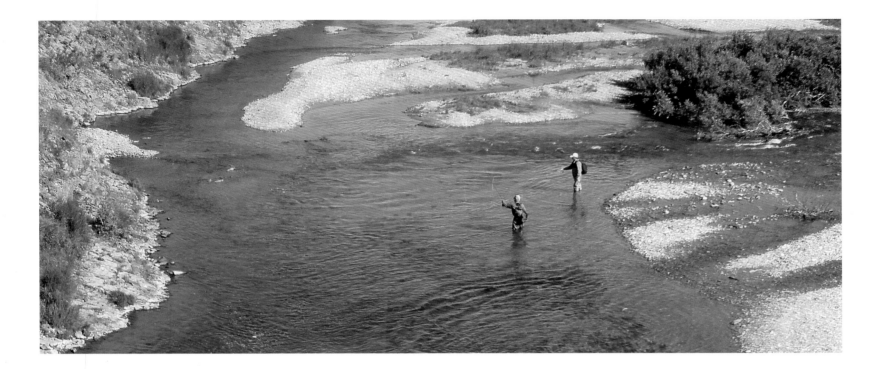

lodge building, three duplex guest cabins, the Iliamna suite, and a sauna. There are numerous decks overlooking the river; the lodge accommodates 16 guests each week during the season, along with the 15 staff members.

During June, shortly after the ice goes out, the sportfishing season in the Bristol Bay area opens. The first part of June is great for exciting rainbow trout, Arctic grayling, and northern pike. This is an excellent time for dry-fly fishing.

The mighty king salmon begin to arrive in their native rivers during mid-June. Anglers visiting at this time of the year will have a combination rainbow trout and king salmon trip. The kings average 25–30 pounds, and it is not uncommon for a guest to land 10 kings in one afternoon. During the end of June and through July, millions of sockeye pass right in front of the lodge. At the peak of the run, there are approximately 30,000 fish passing through every hour.

Next to arrive (around the beginning of August) on the Kvichak are the silver, chum, and pink salmon. Silver salmon fishing is exciting; many anglers prefer silvers to all other salmon because of their hard strikes and many long runs with spectacular tail dances. Beginning in August and going through October, the rainbow trout return to the Kvichak. This is "trophy" time at Alaska Sportsman's Lodge: there are 10 different rivers that offer some of the best fly fishing possible during late July and August.

Combine the abundance of fish and fishing opportunities with an award-winning lodge and this is undoubtedly one of the "must go" destinations for those who love big fish in a setting that is truly the last frontier.

ABOVE: *Anglers stand amid thousands of sockeye in one of the most prolific streams in the Bristol Bay area of Alaska. This stream, accessible only by air, is a short 15-minute flight from Alaska Sportsman's Lodge.* OPPOSITE: *Anglers walk the gravel bars of the Kvichak River.*

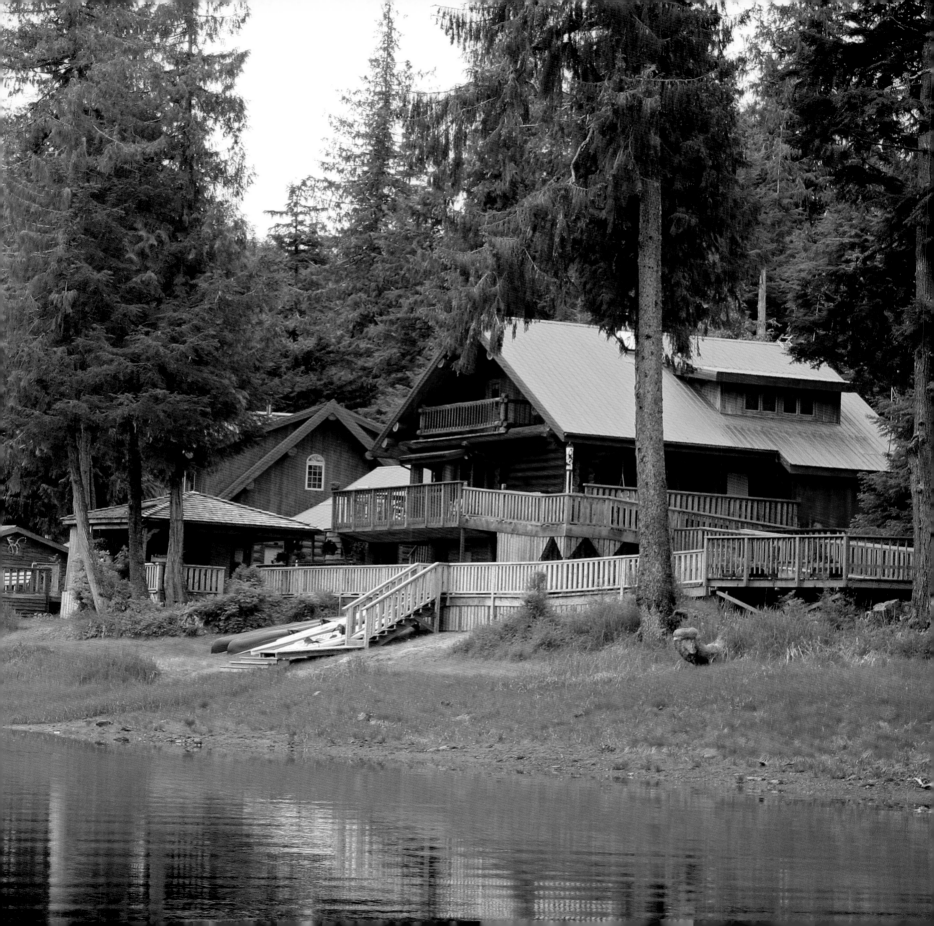

Alaska's Boardwalk Lodge

THORNE BAY, ALASKA

*Located on the serene Prince of Wales Island
Founded in 1990*

The panhandle region of Alaska reaches southeast toward the lower 48 as if trying to connect itself to the rest of the country, although the fiercely independent Alaskan residents would never condone such a thing. The magnificent and unspoiled nature of Alaska is incomparable to anything the lower 48 have to offer; Alaska is a remarkable place, and the sheer size offers such incredible ecological diversity it is hard to imagine so much can be offered in one state.

Alaska's Boardwalk Lodge is an oceanfront resort located on Prince of Wales Island in temperate southeast Alaska. The lodge takes its name from a 300-yard boardwalk that stretches from the boat docks and spans the tidal inlet to the lodge. Alaska's Boardwalk Lodge is accessible via a 35-minute floatplane ride from Ketchikan, but there's no need to fly further out from the lodge to fish. Boardwalk guides escort their anglers by four-wheel drive to some of the finest fishing water in the Northwest, with 23 lakes, rivers, and streams nearby. The Thorne River, one of the island's largest waterways, is minutes down the road.

Construction of the main lodge began in 1990. Each log was felled and towed across Thorne Bay, accompanied by the humpback whales who surfaced around the boats, and then drifted back down after its inspection. In true Alaskan spirit, the raw lumber was milled, peeled, and notched by hand. Eventually the lodge expanded to provide accommodations for up to 19 guests.

Fishing pressure is basically nonexistent in these parts. Many waters on the island are only fished when Boardwalk anglers venture out. The vast majority of these fish have never seen an artificial fly, much less taken one, and wild native steelhead, rainbow, cutthroat, Dolly Varden, and salmon are plentiful.

For those looking for truly huge fish on heavier tackle, saltwater

OPPOSITE: *Alaska's Boardwalk Lodge sits on the shores of Thorne Bay.*

captains lead daily excursions on a fleet of 28-foot cruisers, each fitted with a heated cabin and restroom. Anglers can fish for huge king salmon or experience the thrill of hauling in one of Alaska's monster halibut that range well over 100 pounds. This area is comprised of hundreds of islands, protected passages, bays, and inlets; the waters teem with aquatic life, including whales, orcas, dolphins, and otters, as well as plentiful game fish.

Opportunities for other diversions aside from fishing are also plentiful, from sea kayaking to mountain biking, hiking, and even exploration of the El Capitan Caves, North America's deepest cavern system. Trips to native villages and photography excursions are available as well. One could bring a camera here and do nothing else but shoot beautiful pictures.

There is peace and serenity here. It is an island in a temperate rain forest and the fishing is as untouched as one could ever wish for in this modern world. Given the reputation of the staff and the fishing, this is certainly not a place to be missed if Alaska is on your list of places to fish before you die.

TOP: *Kassan Bay is surrounded by beautiful pine trees, including Sitka spruce, Western hemlock, and red and yellow cedar.* ABOVE: *A fresh steelhead comes to net.*

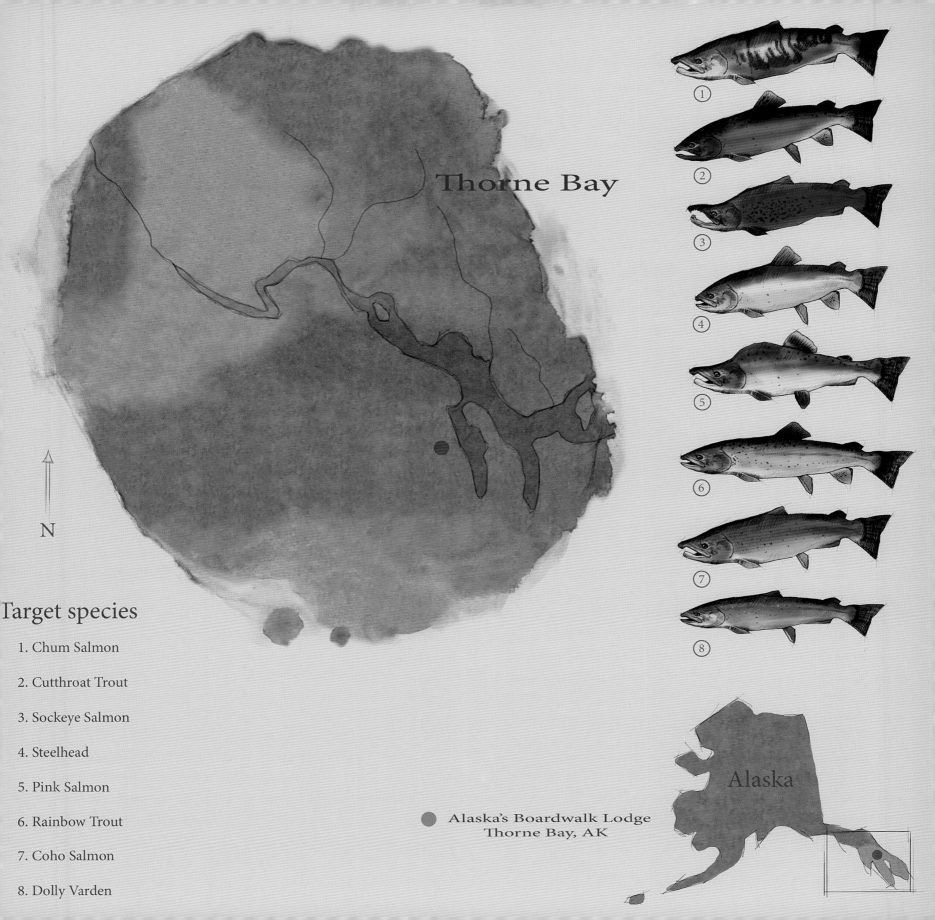

Thorne Bay

N

Target species

1. Chum Salmon

2. Cutthroat Trout

3. Sockeye Salmon

4. Steelhead

5. Pink Salmon

6. Rainbow Trout

7. Coho Salmon

8. Dolly Varden

Alaska's Boardwalk Lodge
Thorne Bay, AK

Alaska

Crystal Creek Lodge

KING SALMON, ALASKA

*Located in the heart of the Alaskan Peninsula
Founded in 1987*

Southwest Alaska is home to one of the most spectacular ecological events on earth each year, as the five species of Pacific salmon return to spawn in the northwestern rivers and lakes of the North American continent. Crystal Creek Lodge, located on the Alaskan Peninsula, lies in the heart of it, along the Naknek River just three miles from the 4.1-million-acre Katmai National Park and Preserve.

Each year, millions of salmon return to their home waters to spawn, eventually die, and provide the huge biomass that feeds this entire ecological system. Virtually every living thing in this system is directly or indirectly dependent on the salmon, from humans to bears, birds, vegetation, and the trout, Arctic char, and grayling that fill the rivers and subsist on the flesh and eggs of the returning salmon. This area is home to the world-famous brown bears of Katmai, who are the most photographed bears in the world.

Dan and Lori Michaels have long made their lives here as guides and lodge owners, and Crystal Creek has a longstanding reputation

RIGHT: *Crystal Creek Lodge overlooks the Naknek River.*

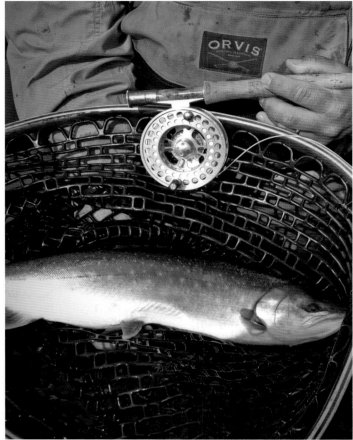

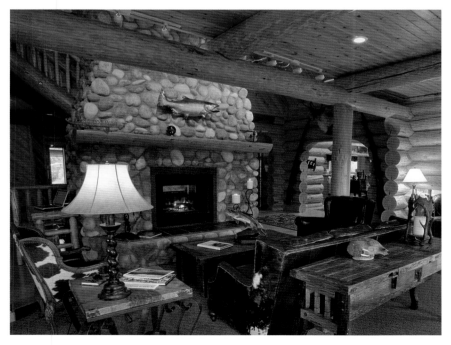

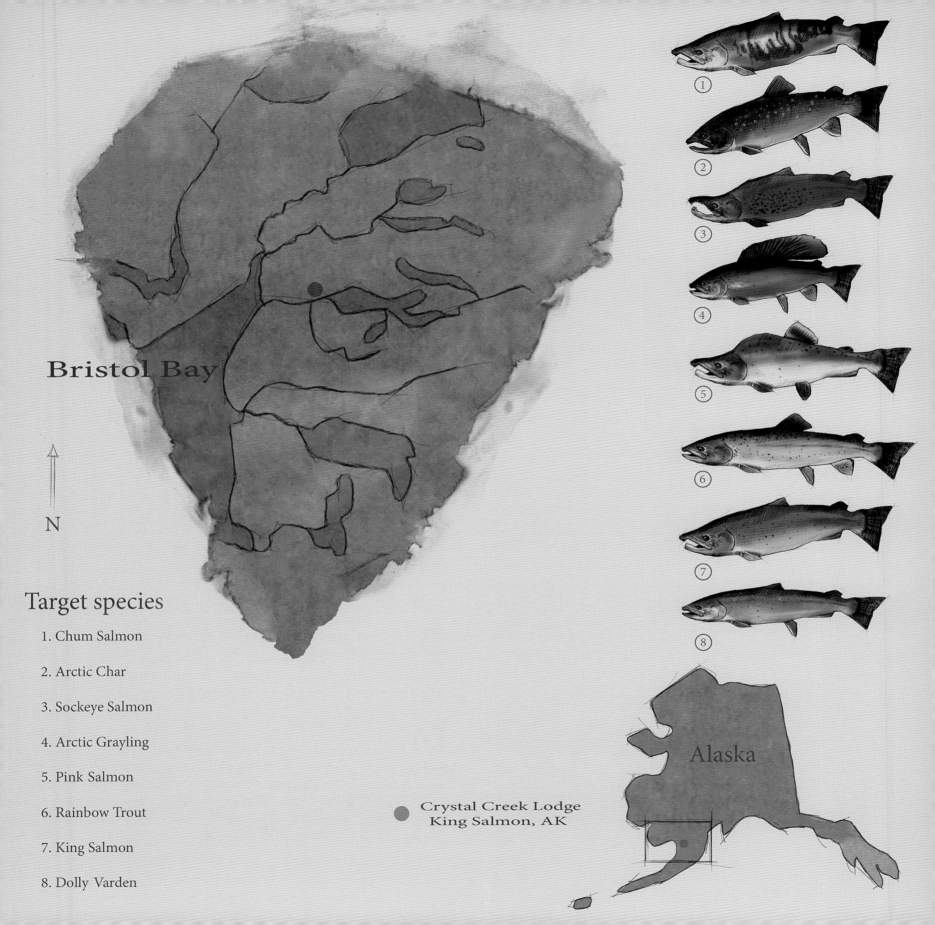

Bristol Bay

N

Target species

1. Chum Salmon

2. Arctic Char

3. Sockeye Salmon

4. Arctic Grayling

5. Pink Salmon

6. Rainbow Trout

7. King Salmon

8. Dolly Varden

Crystal Creek Lodge
King Salmon, AK

Alaska

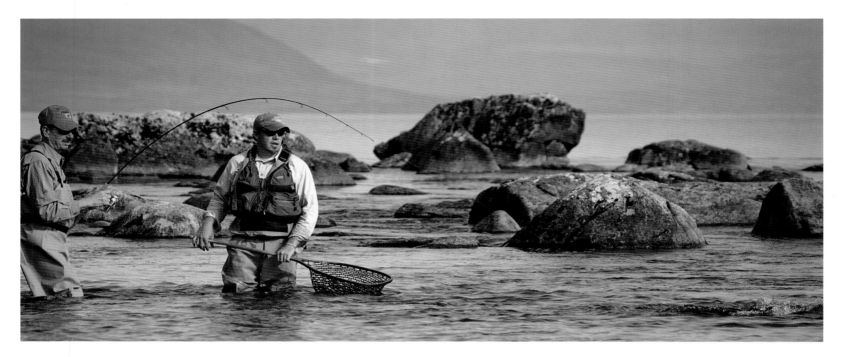

as one of the finest Alaskan sporting lodges available, having been endorsed by the Orvis Company for nearly two decades. Their dedication to the Alaskan experience, coupled with the spectacular location, provides adventure anglers and hunters with some of the best wild sport available anywhere.

The rivers and streams of the Katmai are some of the most prolific trout waters in the world. Rainbow trout (20- to 30-inch class) are very common in most of these streams and the Naknek is one of the few rivers in the world that holds a year-round population of wild trout in the 30-inch-plus range. These trout, char, and grayling have a limited window of opportunity to feed and the result is big, aggressive fish that offer remarkably bountiful fishing.

The lodge is built of massive Douglas fir and river rock, offering more than 10,000 square feet of space for 14 guests. Warm and richly decorated, the lodge offers all the amenities expected of a world-class resort and wholly unexpected in the remote Alaskan bush. Anglers are flown by floatplane to six major wilderness river systems and countless minor tributaries and streams, all within a 30–40 minute flight. If they desire, guests can avoid seeing the same water twice and can return countless times and fish different water each day.

In addition to the spectacular fishing, guests can partake in one of Dan and Lori's great loves—upland bird hunting for ptarmigan using well-trained English pointers. These covey birds are the quail of the tundra; their explosive white-winged flight is not only beautiful but more than challenging for hunters. After September 1, the ducks and the geese of the Pacific flyway are available for hunting, offering sportsmen a fishing and hunting experience that is impossible to duplicate in terms of pure numbers of fish and fowl.

Crystal Creek is not a lodge created by wealth, but a lodge born of the experience and work of two of the most respected guides in the Alaskan wilderness. It is a true sportsman's wild experience, guided and directed by the builders, owners, and operators of this beautiful lodge.

ABOVE: *Anglers spend a day searching for silver salmon in the Becharof National Wildlife Refuge.* OPPOSITE: *The peaks of the Alaska Peninsula Mountain Range provide a backdrop for the perfect cast.*

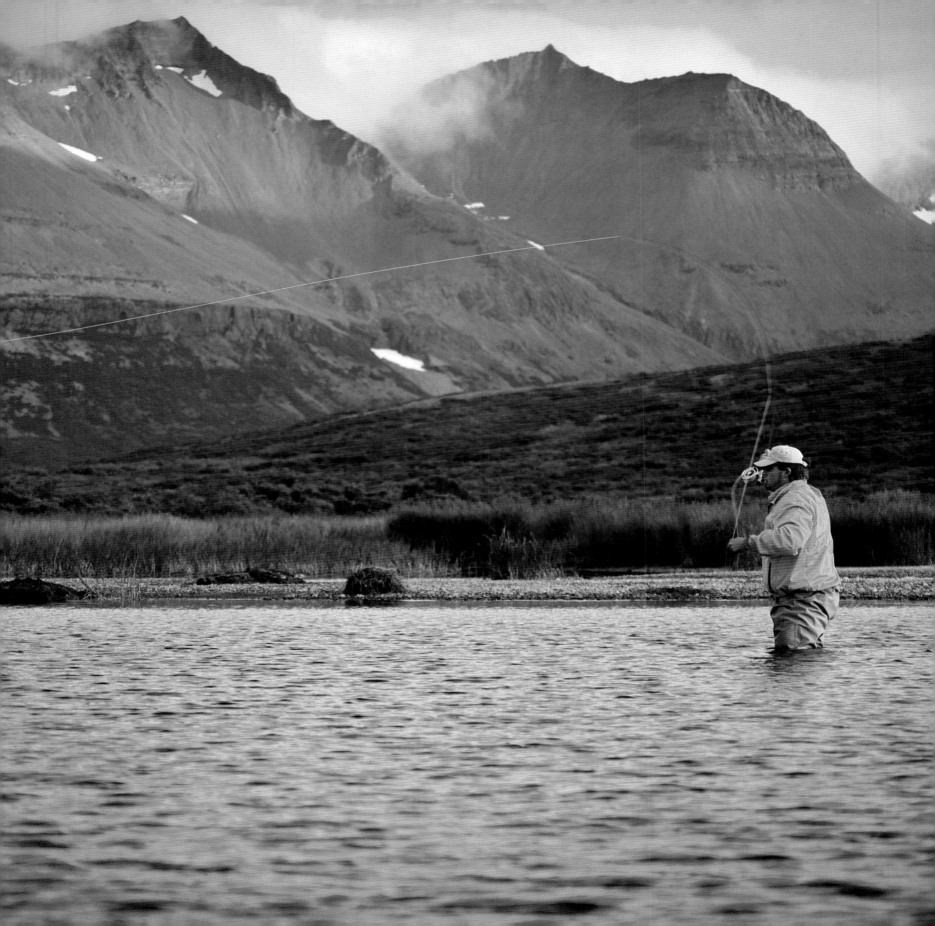

Tikchik Narrows Lodge

DILLINGHAM, ALASKA

Located in the wilderness of Wood–Tikchik State Park
Founded in 1969

Easily the greatest concentration of game fish in the world is the Bristol Bay region of Alaska. Aside from the five species of Pacific salmon that return to the rivers of Bristol Bay each year, there are at least seven species of freshwater game fish including the rainbow trout, grayling, Arctic char, Dolly Varden, lake trout, and northern pike. With 40 boats strategically placed on six major river systems and numerous streams and lakes in the region, and serviced by four floatplanes, Tikchik Narrows Lodge may have access to more fish and water than any other fishing lodge.

Each year these rivers are full of returning salmon that are the lifeblood of the region. Salmon have been called "10-pound bags of fertilizer," for their eggs and flesh that renew the area each year and support almost every species found in the region, from bears to birds and even the vegetation that lines the banks of the rivers. Without these salmon, the region would become a cold and desolate wasteland. The freshwater species benefit no less than any other

RIGHT: *A familiar yellow and blue Beaver from Tikchik Narrows flies over the lodge.*

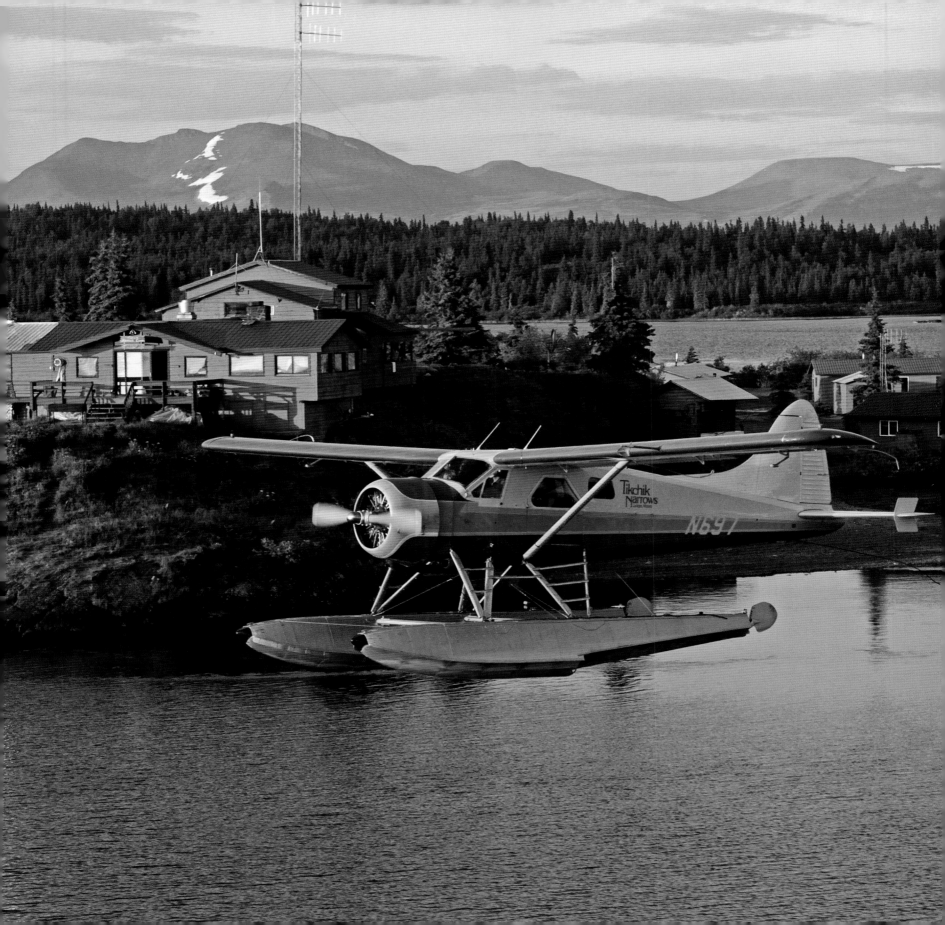

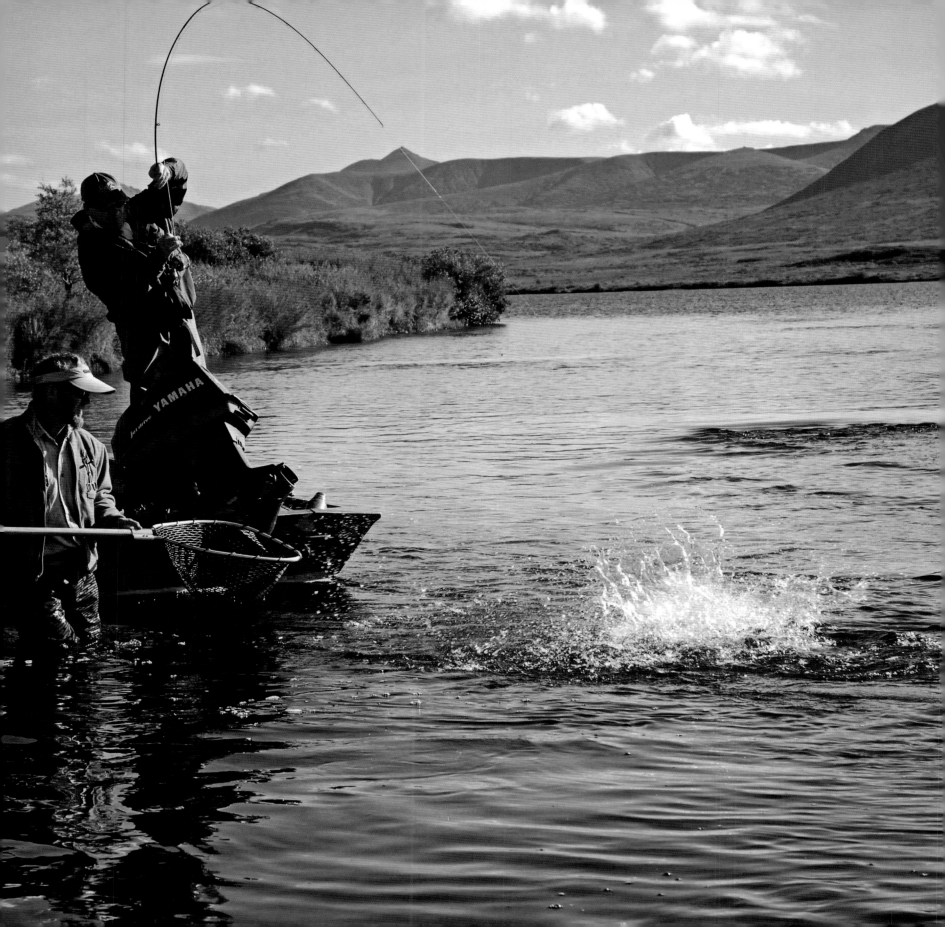

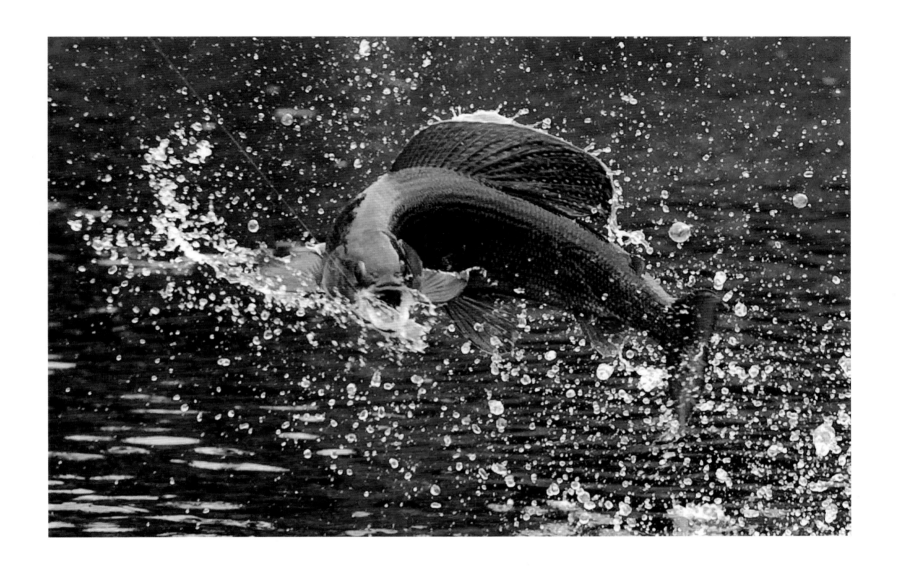

OPPOSITE: *Longtime head guide Chip King waits to land a fish.* ABOVE: *A beautiful Arctic grayling puts on an aerial show.*

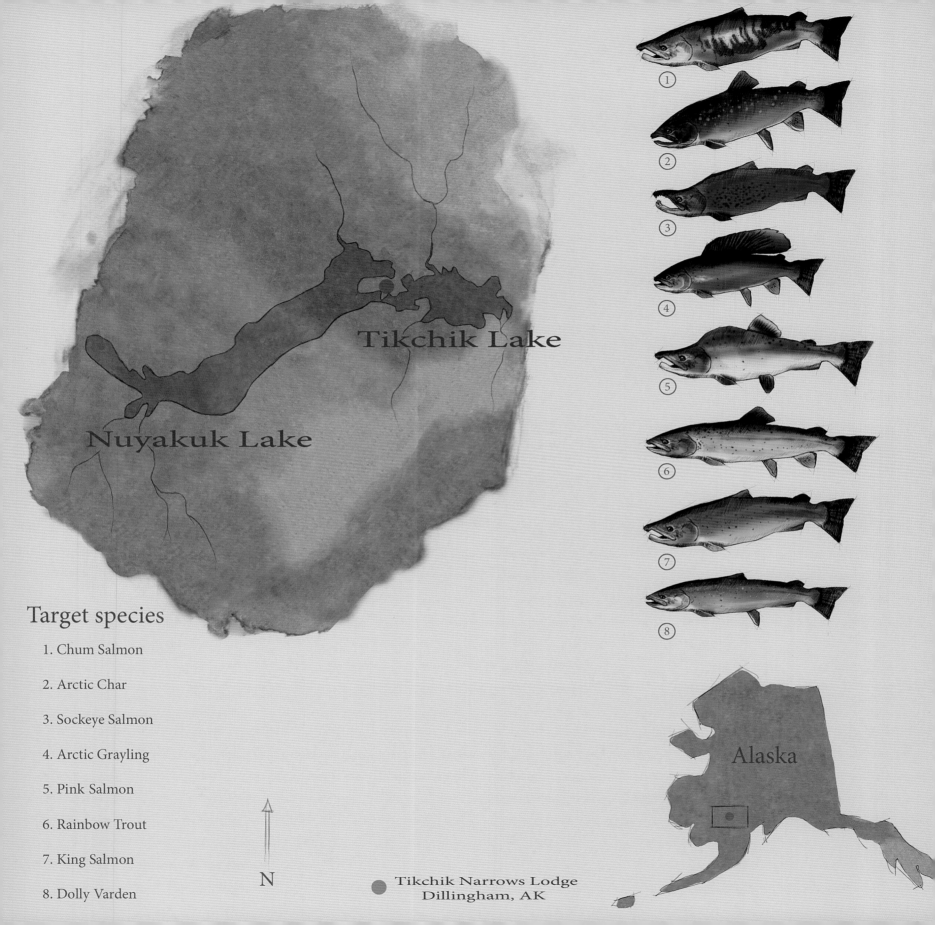

Tikchik Lake

Nuyakuk Lake

Target species

1. Chum Salmon

2. Arctic Char

3. Sockeye Salmon

4. Arctic Grayling

5. Pink Salmon

6. Rainbow Trout

7. King Salmon

8. Dolly Varden

N

Alaska

Tikchik Narrows Lodge
Dillingham, AK

creature in that they feed well on the eggs and flesh of the dying salmon. The result is large fish—very large fish—that are voracious feeders. Ultimately, the big winner is the angler. Not only do anglers have the opportunity to catch myriad numbers of big, hard-fighting fish, but they get to do it while watching what is still one of the greatest spectacles Mother Nature has to offer. Standing in a river choked blood-red with salmon and catching rainbows the size of large footballs is difficult to adequately describe. One must simply go there and do it to understand.

Tikchik was started in 1969 by Bob Curtis, a pioneer in Alaskan sportfishing. At the time he owned Wood River Lodge on the Agulowak, but in his years of flying the region he always considered the Narrows to be the best fishing in the area, and the great peninsula that juts into the lakes the perfect place for a fishing lodge. In 1986, he sold Tikchik Narrows to Bud Hodson, another longtime guide who has been working in the area for more than 32 years and flying for 28 years. His experience is one of the critical factors to the continuing success of Tikchik Narrows.

For the angler, the opportunity to sit in the lodge in the evening and decide where to go and what fish to target verges on a dilemma, for the options are so many and the opportunities so great. It's one of the few difficult decisions during the fishing experience at Tikchik Narrows. In the morning after breakfast, the angler gets to step into a legendary aircraft—the DeHaviland Beaver—fly at the altitude of eagles, survey the wilderness from the best seat imaginable, and then touch down in places few men get to see. Tikchik Narrows Lodge knows this and knows it well for they are one of the pioneers and ultimately experience is the greatest asset of all.

ABOVE: *A king salmon offers a spectacular fight to this angler.* FOLLOWING SPREAD: *A lodge guest catches a silver salmon in the Kulukak River in the Togiak National Wildlife Refuge.*

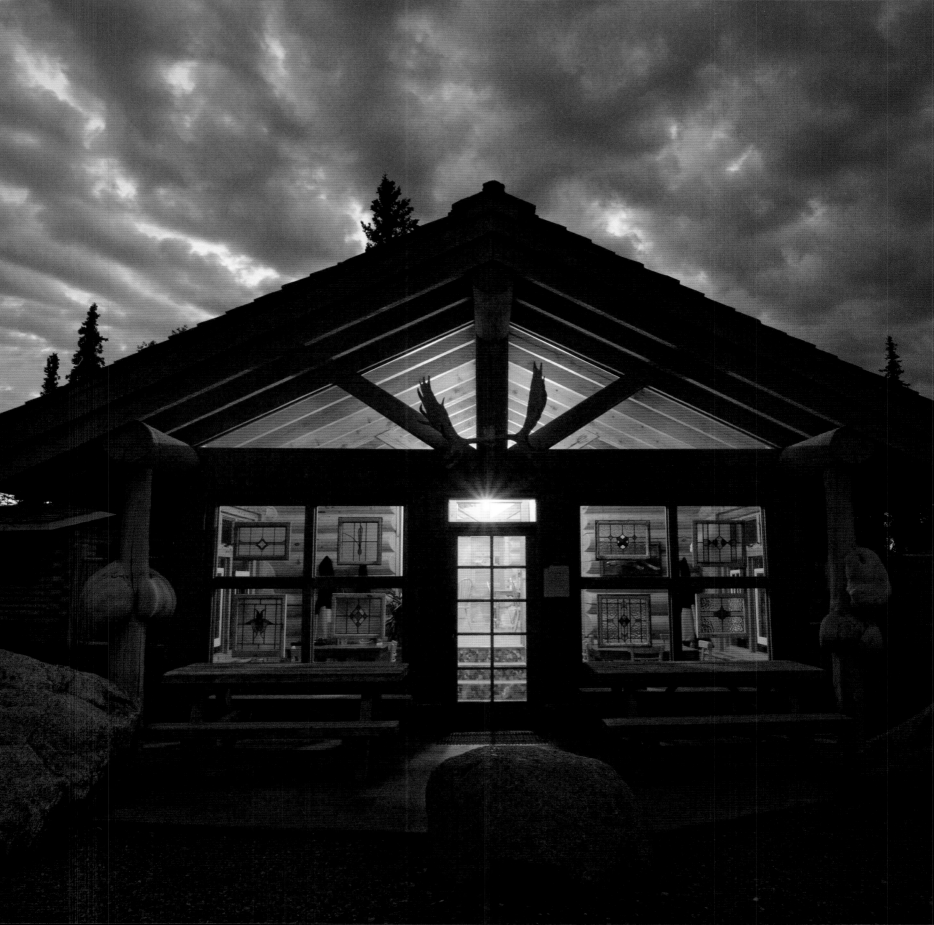

Tower Rock Lodge

SOLDOTNA, ALASKA

Located on seven acres of wilderness near the Kenai River
Founded in 1989

The world record king salmon (97 pounds) was caught right in front of Tower Rock Lodge's boat dock. That alone is impetus enough for the trophy angler to come to this remarkable lodge. Even better, unlike many other remote Alaskan lodges, Tower Rock is easily accessible by car from Anchorage. A scenic three-hour drive eliminates the necessity of flight after flight; once there, however, the Alaskan wilderness is as magnificent as ever and the fishing as good as it gets. Tower Rock Lodge's motto is "fish so big you don't have to lie about 'em." The fact is they have the results to prove it.

The lodge building has its own history; it was built out of timbers salvaged from the old McNeil Libby Kenai Fish Cannery constructed in 1898. Alongside these old timbers are 40 tons of river rock from Prince William Sound, creating one of the most beautiful lodges in Alaska. Located on seven acres bordering 650 acres of Alaska Park Land, the lodge is only 12 miles from the outlet of the Kenai River, offering fresh tidal salmon just beginning their runs up the river. One of the benefits of this location is the fact that fishing begins the minute anglers leave the dock. There are no long trips or plane rides necessary and fishing time is optimized. Breakfast is early, dinner is late, and there's nothing but fishing in between.

The region features two runs of kings, the first beginning in May and the second, and most popular, in July. Sockeyes show up in mid-June and the silvers start their run in late July. All this time the rainbows and Dolly Varden (up to 30 inches or better) are hanging out under the salmon, feeding on the eggs and providing some of the best trout fishing Alaska can offer. Then there are the halibut. The halibut season runs throughout the summer and

OPPOSITE: *Evening light welcomes hungry anglers to the Orvis Dining Cabin at Tower Rock Lodge for some Thai-inspired Alaskan fare.*

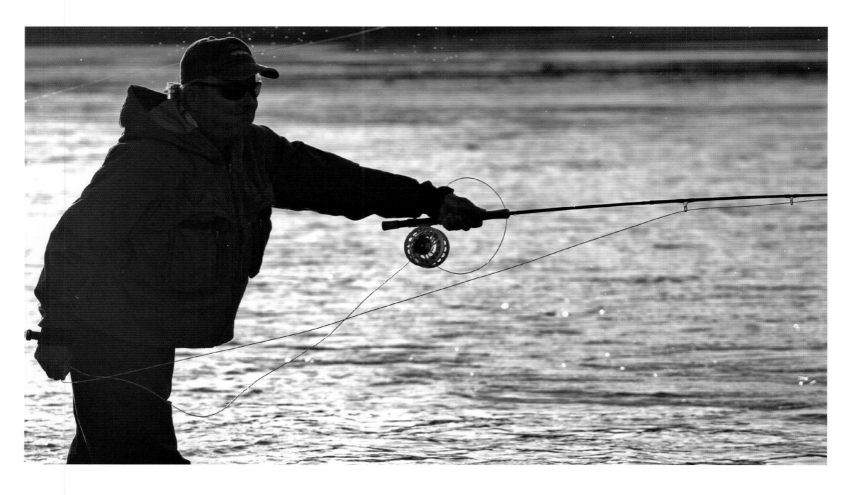

hooking into one of these barn doors can mean anything from 10 pounds to 400 pounds. Combined with king fishing, this can create a day to remember for any angler.

The big lodge is complemented by a separate dining lodge, the Orvis Log Dining Facility, along with a number of well-appointed log cabins with covered front porches for guests to kick back at the end of the day. Mark Tuhy, one of the owners, is a French-trained chef. His cuisine is well noted among Alaskan lodges as some of the best in the state. His specialty is Thai cooking and he gives the local fare of caribou and fish a bit of a hot, southeast Asian twist that has won awards from *Condé Nast*.

Tower Rock Lodge offers a complete Alaskan experience; in fact, if you feel like it, you can even go pan for gold. Chances are you won't get rich, but with 1.4 million sockeye salmon running by the lodge, not to mention the kings and silvers, you'll be rich enough.

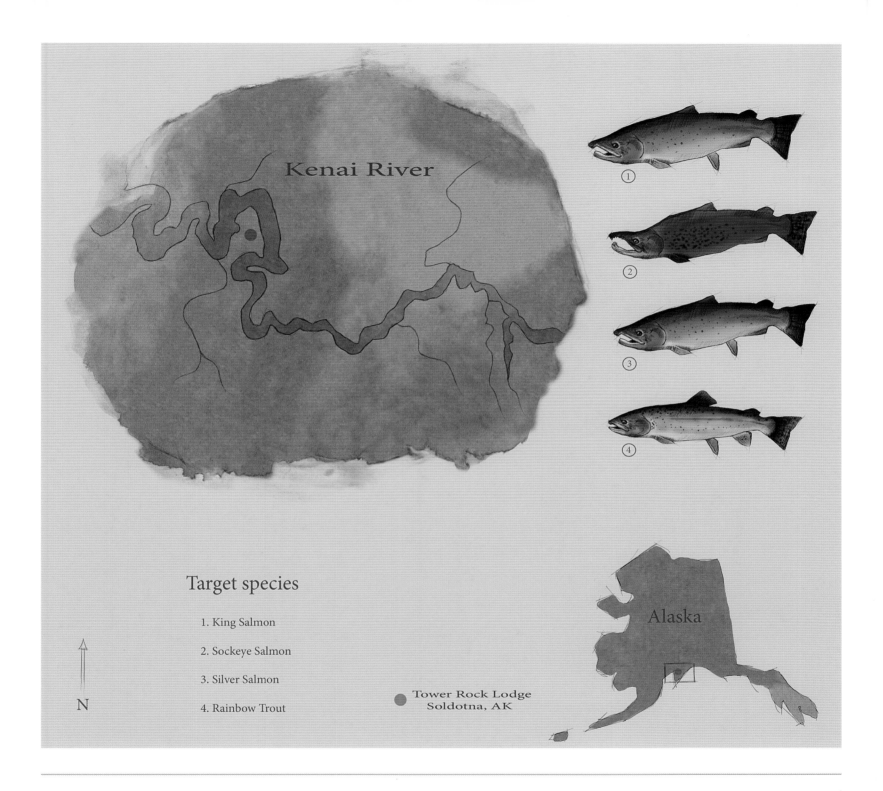

Kenai River

Target species

1. King Salmon

2. Sockeye Salmon

3. Silver Salmon

4. Rainbow Trout

● Tower Rock Lodge
Soldotna, AK

N

Alaska

OPPOSITE, TOP: *An angler casts on the Kenai River.*
OPPOSITE, BOTTOM: *The covered porches of Tower Rock's cabins provide a great place to end the day with a drink and a good cigar.*

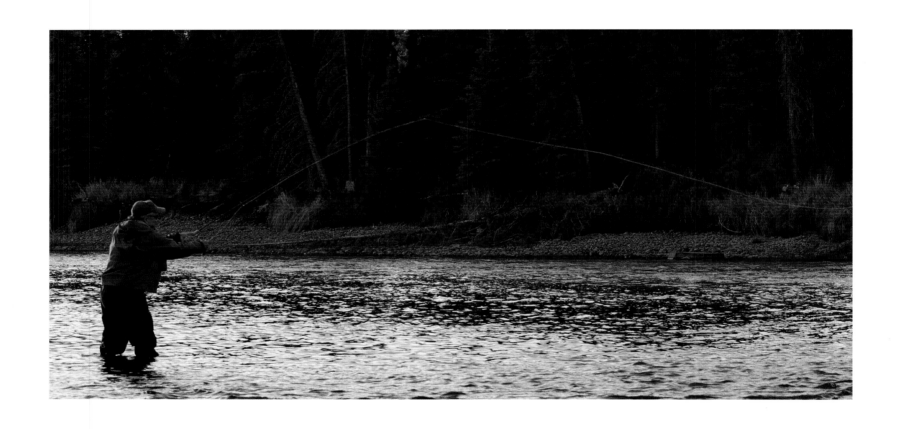

ABOVE: *An angler fishes the Kenai River, home to a world-record 97-pound king salmon.*
OPPOSITE: *Drift boats break for lunch on the Kasilof River.*

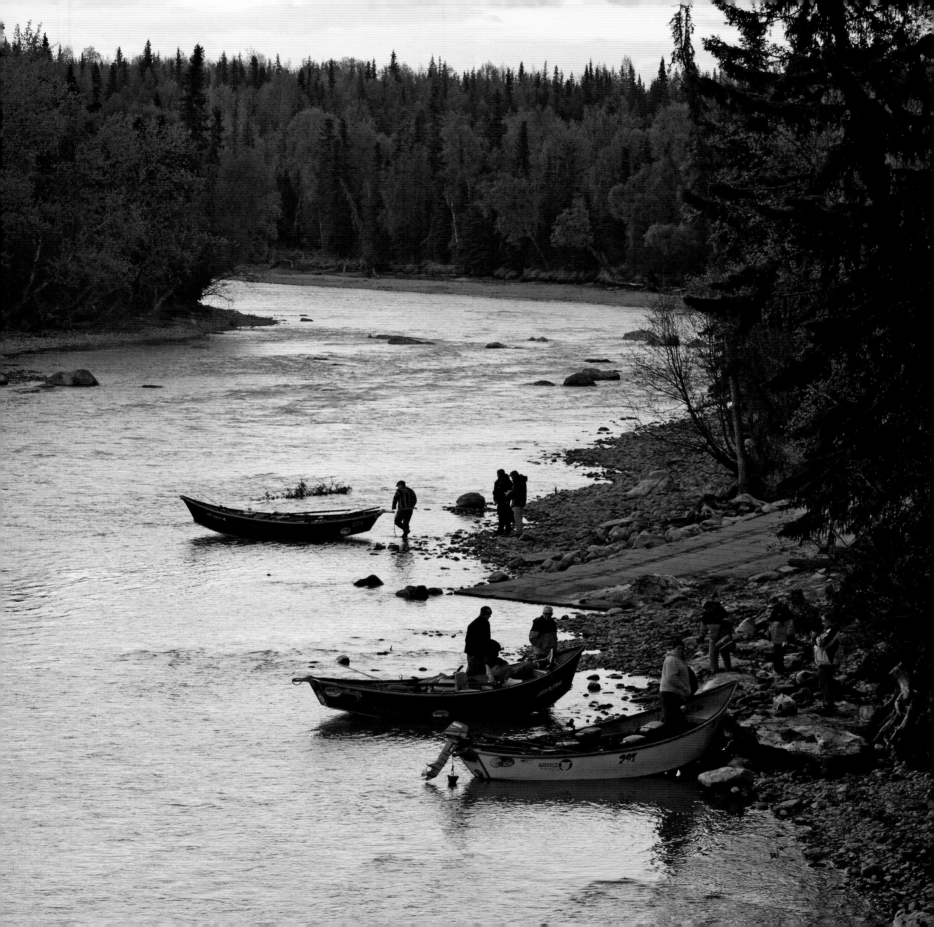

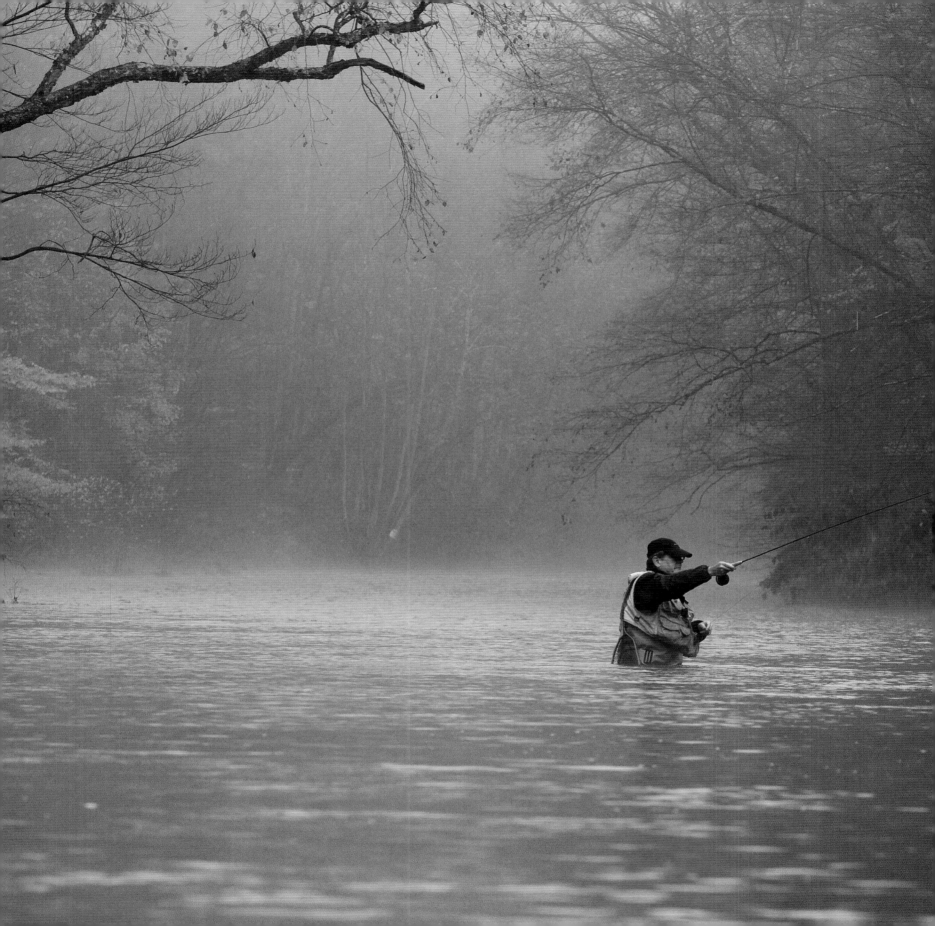

The Northeast

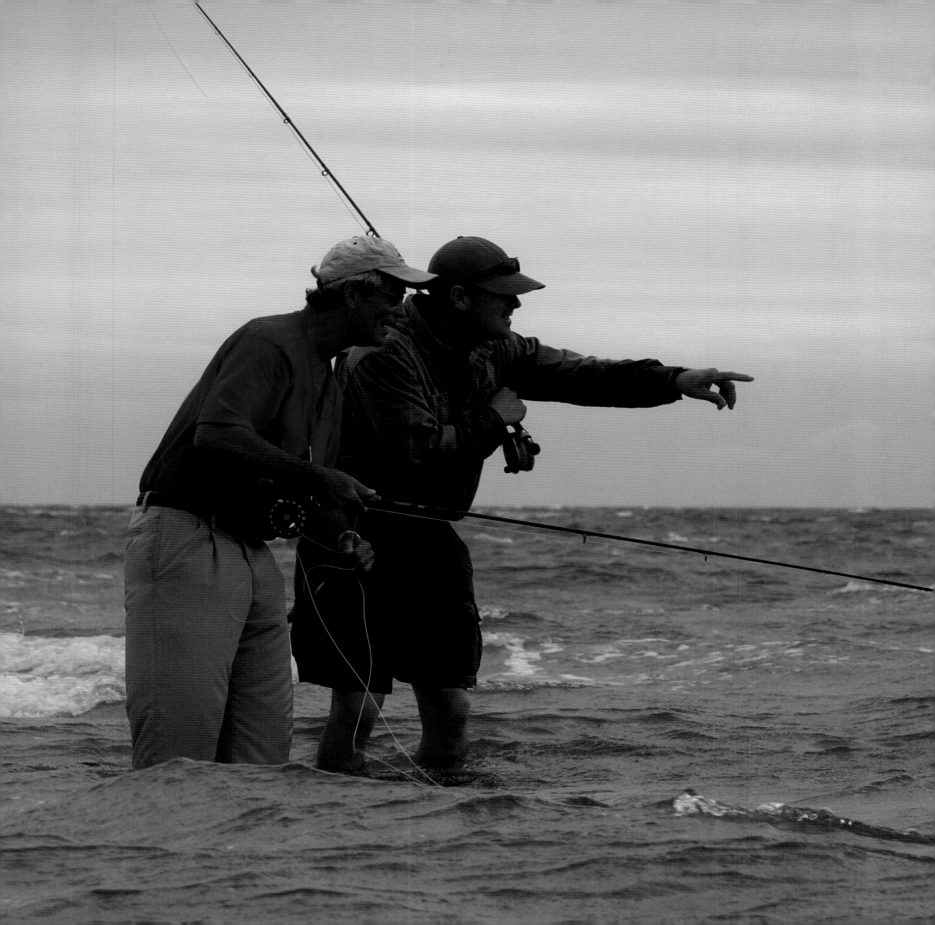

Chatham Bars Inn

CHATHAM, MASSACHUSETTS

Located on a private beach in the heart of Cape Cod
Founded in 1914

When Henry Beston wrote his seminal naturalist work *Outermost House* on Cape Cod in the mid-1920s, the Cape was a windswept and lightly populated part of the country consisting of a few farms and fishing villages that dotted the coastline. Just below where Beston built his tiny cottage on the dunes of Eastham, the Chatham Bars Inn, located at the "elbow" of the Cape where it turns north and faces the Atlantic and within walking distance of the quaint town of Chatham, was already a work in progress, having opened its doors in 1914. Today it is one of the finest hotels in the world and one of the best family resorts in the eyes of *Travel and Leisure*, *Condé Nast Traveler*, *Gourmet*, and others.

Facing the Atlantic on 25 acres, the old main inn was restored in 2007 to its original grandeur with most of the rooms having terraces facing the ocean. Private cottages dot the property and offer a greater feeling of seclusion with access to the almost quarter-mile of private beach, and for the ultimate in seclusion,

PAGES 40–41: *An angler enjoys the fall colors as he fishes the West Branch of the Delaware River.* LEFT: *Guide Todd Murphy points out stripers in the Cape Cod surf to veteran angler Kenny Abrames.*

there are spa suites, 600-square-foot suites dedicated to the comfort and pleasure of the guest with fireplaces, steam showers, hydrotherapy, and massage tables right in the room. Needless to say the food here is ridiculously good, particularly if seafood is a favorite, and the old-style Cape Cod clambakes in the sand are something to behold.

For the angler, Cape Cod is paradise. Surrounded by water filled with striped bass, bluefish, bonito, false albacore, and on up to giant bluefin tuna, fishing is as inextricably intertwined with the culture of the Cape as sand. These were the home waters of the cod and haddock fishermen who regularly made the perilous journey to fish the Grand Banks.

The Cape is synonymous with striped bass, and each year millions of these great fish move up and around the Cape in their annual migration from the Chesapeake spawning grounds to the estuarial feeding grounds of New England. They can be taken from the beach or a boat and are the favorite targets of surfcasters along the shores of the Cape. Along with them come the voracious bluefish, whose aggressive feeding tactics make for some of the best surface fishing there is and offer some incredible action whether caught in the surf or from a boat. And then in the late summer and early fall come the tuna, perhaps the greatest and most powerful game fish of all. Fishing for bluefin tuna is an experience not to be forgotten; often while out chasing tuna, anglers are treated to pods of whales that inhabit the coastline during the summer months.

The New England coast is as steeped in fishing history as any part of the country. It was here the country was founded and it was fishing that fed it in its formative years. A visit to Chatham Bars Inn—which is open year-round—offers some of the best saltwater fishing in the world, not to mention a world-class hotel and a sense of history that goes back to the very infancy of this country.

TOP LEFT: *The Northeast's favorite saltwater game fish is the striped bass.*
TOP RIGHT: *These cottages at Chatham Bars Inn overlook the waters of Cape Cod.*

Chatham

N

Target species

1. Atlantic Bonito

2. Striper

3. False Albacore

4. Bluefin Tuna

5. Bluefish

Chatham Bars Inn
Chatham, MA

Massachusetts

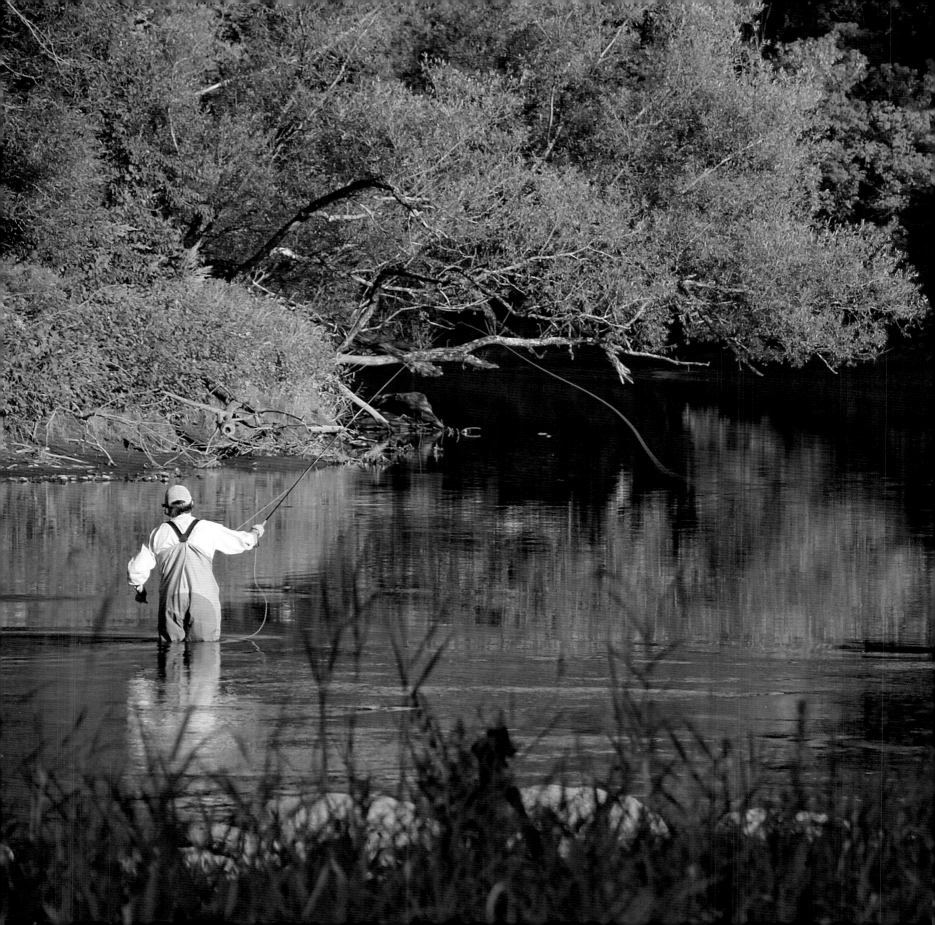

The Essex, Vermont's Culinary Resort & Spa

ESSEX (BURLINGTON), VERMONT

Located near the Winooski and Lamoille rivers in rural New England
Founded in 1989

The name "Vermont" is a combination of two French words, "vert" meaning green, and "mont" meaning mountain, thus "green mountain." For most, the word Vermont conjures images of a pastoral retreat, a place where time and progress have not wreaked the havoc they have in many parts of the country, particularly in the East. Vermont is the poster child for the slow, rural lifestyle that all harried individuals envision for themselves at one moment or another: small villages with country stores and rolling fields dotted with cows. Interestingly enough, for the most part the state lives up to its name. It is the least populous state in New England with just over 600,000 residents sprinkled throughout the countryside; Burlington, the largest city of 40,000, is roughly equivalent in population to a few blocks in Manhattan.

The Essex is a paean to this lifestyle, a big, rambling resort situated near Burlington with beautiful views of the New England landscape. The surroundings may not be awe-inspiring in the sense of the western mountains, but they offer serenity and reassurance that such pastoral places still exist. The Essex fits here, architecturally and culturally, for it is also a proud Partner in Education with the New England Culinary Institute and Vermont has gained worldwide recognition for the quality of its niche, small-farm agriculture.

If there was ever a place for the angler who loves to cook or just eat well, the Essex is the best of both worlds, offering excellent trout fishing and the opportunity to fine-tune culinary skills as well as enjoy the rewards of the resort's focus on culinary excellence. The trout season here is long and productive with three river systems, the Winooski, the Lamoille, and Otter Creek, all available

OPPOSITE: *An angler casts to the rise on Otter Creek.*

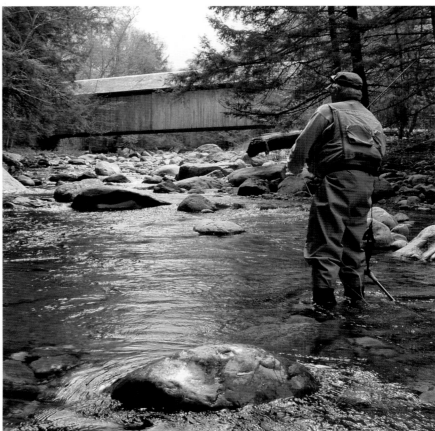

just a short distance from the resort. Spring brings abundant eastern hatches and great rainbow fishing. As the weather warms, anglers move up into the mountain tributaries where the native brook trout fishing is legendary. Small streams with light rods and overly aggressive brook trout are one of New England's hidden angling treasures. The fall brings the big browns into the tributaries to spawn and suddenly small rods are put to a great test on large fish in small water.

When the day is done on the stream, the eating begins in earnest and guests can sample the finest results of the kitchens at the Essex. The opportunities for culinary education and the

enjoyment of the results are endless: one can even hire a private chef to prepare intimate dinners.

Combined with a new 22,000-square-foot spa, 120 guest rooms, an executive golf course, massive climbing walls, and even an on-site hot air balloon, there is more to do here than one can appreciate in one visit. Imagine having breakfast prepared in the gondola of a hot air balloon while soaring over this rural gem. Only here. This is a place for the angler who appreciates more than just the fishing. This is a place where the angler/gourmand will find the two loves of his or her life abundantly offered in a setting that reassures him or her that there is a slower way.

TOP LEFT: *These tools are all that are necessary for Vermont's small streams.*
TOP RIGHT: *A lodge guest fishes a pool for brookies near a covered bridge, a Vermont landmark.*

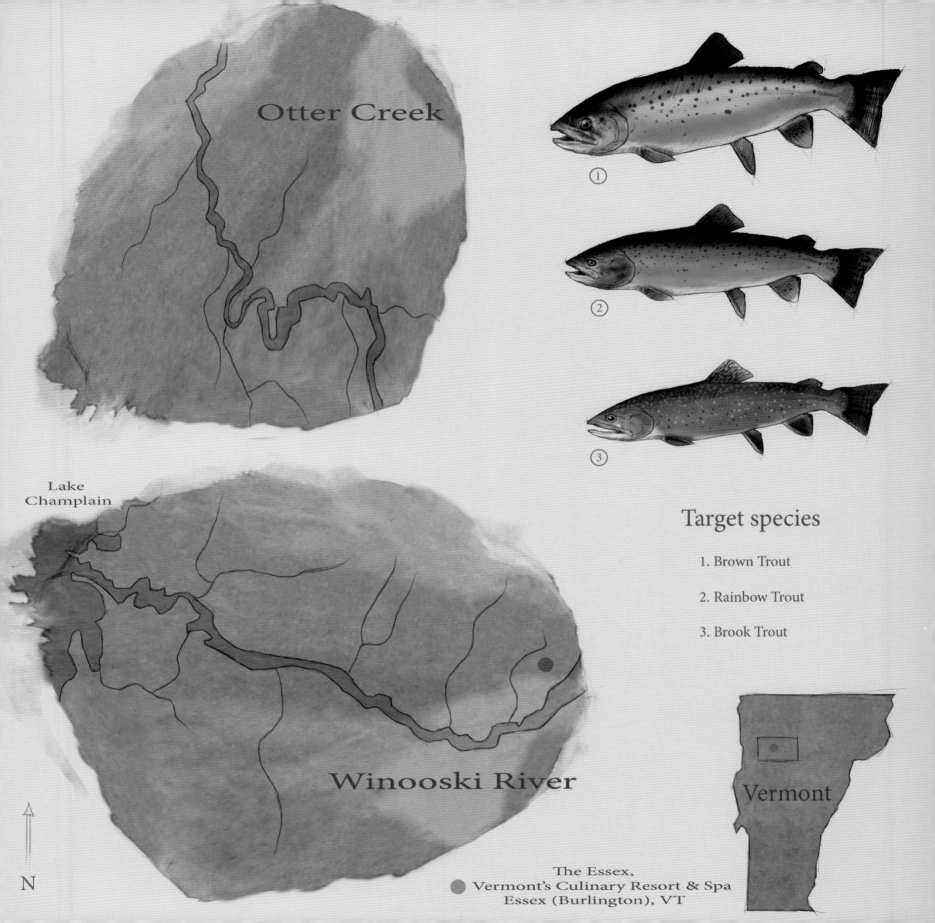

Otter Creek

Lake
Champlain

Winooski River

Target species

1. Brown Trout

2. Rainbow Trout

3. Brook Trout

Vermont

The Essex,
Vermont's Culinary Resort & Spa
Essex (Burlington), VT

N

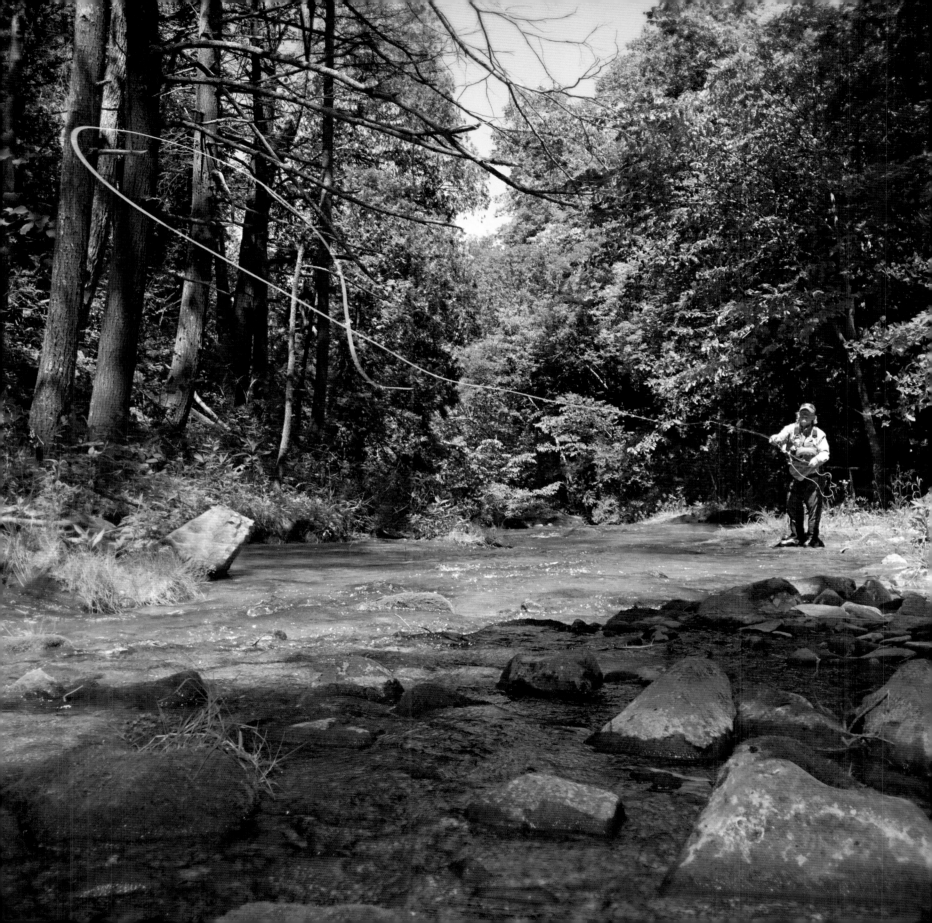

The Homestead

HOT SPRINGS, VIRGINIA

Located near the laurel-lined streams of the Allegheny Mountains
Founded in 1766

In the western part of Virginia, the Allegheny Mountains run southwest and look east over the Shenandoah Valley toward the Blue Ridge. This region is blessed with natural mineral springs that are the foundation for some of the oldest and most elegant resorts in the United States. The Homestead is one of these. Since before the Revolution, people have come here seeking the restorative powers of these springs.

In 1842, Dr. William Burke wrote a book called *The Mineral Springs of Virginia* in which he said, "The treament of acute diseases is the province of the physician . . . it is when disease generates into a chronic form . . . that nature the most beneficent physician presents from her generous bosom those pure streamlets that restore health, vigor, and elasticity to the individual. The Springs of Western Virginia form a group unrivaled in this."

He went on to say that the fact that the springs are in such a beautiful place had a great deal to do with this and quoted Sir Walter Scott: "The invalid often finds relief from his complaints, less from the healing virtues of the Spa itself, than because his system of life undergoes an entire change; in his being removed from his leger [sic] and account books—from his legal folios and progress of title deeds . . . from whatever else forms the main course of his constant anxiety at home."

Sir Walter's words still ring true today, if not more so, and it was on this premise that the great healing resorts became such an

OPPOSITE: *An angler casts his line into an Allegheny brook trout stream.*

Cascades Stream

①

②

③

Target species

1. Brown Trout

2. Rainbow Trout

3. Brook Trout

N

The Homestead
Hot Springs, VA

Virginia

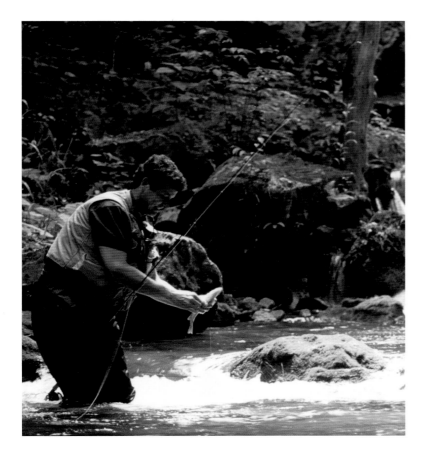

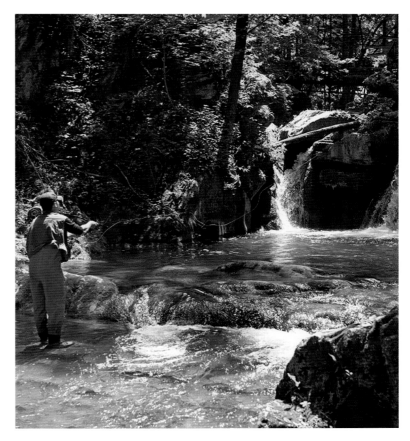

important part of American life. While resorts are now common-place, they were far from it in the 18th and 19th centuries and even the early 20th century. The Homestead was a place for presidents, kings, the wealthy, and those in need of taking the waters for their health. Its history is deep and rich. Today the Homestead offers 483 historically elegant rooms surrounded by 4,000 acres and every conceivable recreational activity one can imagine.

A fishing lodge? Not in the strict sense of the word, but for those who wish to enjoy what these mountains have to offer, the laurel-lined streams of the Allegheny Mountains offer the chance to catch rainbows and native brookies. The Homestead has four miles of blue-ribbon catch-and-release water on the property and access to other waters in the area. Working a mountain stream from pool to pool, fishing streams cooled and protected by old growth forest, and casting to brook trout with light tackle are some of the great joys of the Appalachian angler. At the Homestead you can do this at a resort whose elegance is a tangible result of more than 200 years of patronage by those who sought a reprieve from the troubles of their daily lives both in the natural surroundings of these misty mountains and in the healing waters that emanate from them.

TOP LEFT: *A resort guest releases a native brook trout.* TOP RIGHT: *This stream is classic eastern brook trout water.*

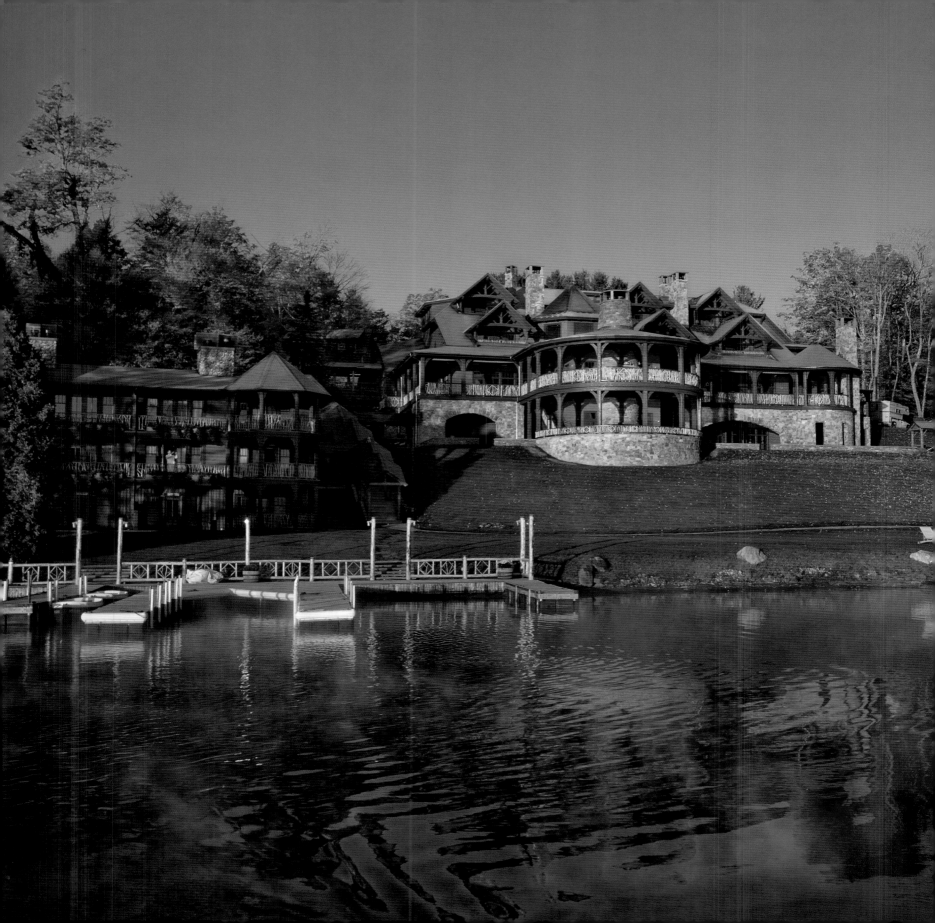

Lake Placid Lodge

LAKE PLACID, NEW YORK

*Located on the shores of Lake Placid
in the heart of the Adirondacks
Founded in 1882*

Every fishing lodge has a signature. For some it is the extraordinary quality of the fishing, for others it may be the location, perhaps the longevity and expertise of the guides, or even the food. While all these qualities are present at Lake Placid Lodge, the centerpiece of this legendary location is the lodge building itself.

The lodge has been in existence for more than 120 years, set on the shores of Lake Placid looking across the lake to Whiteface Mountain. The Adirondack Mountains are an extraordinary wilderness of woods and waters. Only a few hours north of New York City, the area encompasses six million acres of wilderness, larger than Yellowstone, Yosemite, and the Grand Canyon combined. What makes it so unique is the remarkable combination of mountains, rivers, and streams, with 46 mountains higher than 4,000 feet, 31,500 miles of streams, and 2,300 lakes and ponds. An outdoorsman's paradise, the Adirondacks drew the wealthy in large numbers during the 19th and early 20th century. They built summer retreats of stone and timber that became known as "great camps." An instantly recognizable style of architecture emerged, known as the Adirondack style, with stone, birch bark, twig, and massive timbers as the foundation elements. As the style emerged, the artisans evolved. It is in this development of the Adirondack style that Lake Placid Lodge stands alone among fishing destinations.

After standing for 123 years, in 2005 the original lodge burned

OPPOSITE: *This beautiful New York lodge, designed and built by Adirondack artisans, sits on the edge of Lake Placid.*

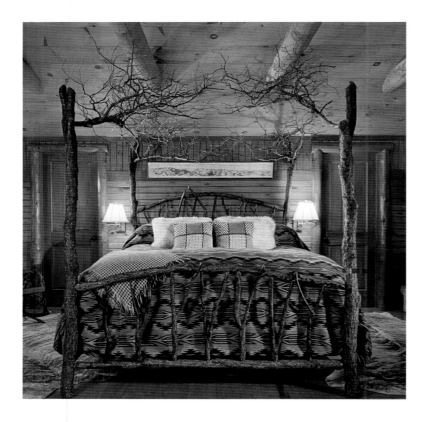

down in minutes. It was a great loss of architectural history, but owners David and Christie Garrett decided within two days that rather than try and replicate it, they would utilize the Adirondack artisan culture to rebuild what would become a 30,000-square-foot work of art. The new lodge was built in the great camp architectural style, and more than 30 artisans and 12 stonemasons were brought in and given artistic license within the confines of the architect's plans. Each room in the lodge, as well as each of the 17 lakeside cabins, was given to an artist to design and build. The 48 fireplaces are all different and each has the unique signature and style of the stonemason who built it. The detail is staggering, right down to the hand-carved chains that hold the lamps, and the massive handmade beds of log, vine, and twig that are the centerpieces of each room's décor. The result is easily the most comprehensive display of Adirondack artistry imaginable. There is not a square inch of the 30,000 square feet that is not an artist's vision. Add to that David Garrett's personal collection of Hudson Valley School 19th-century landscapes, and you have a place whose artistic value is difficult to comprehend.

For the angler, the Adirondacks offer an extraordinary amount of water. Within minutes is the West Branch of the Ausable, a storied Adirondack river that flows north and falls 4,000 feet over 40 miles, creating a spectacular habitat for trout. But it is the sheer volume of the aforementioned water that offers anglers untold opportunities from big lakes to untouched ponds and more streams than anyone could fish in a lifetime.

There is a distinct culture here of old Adirondack guides, great camps, wooden boats, and wilderness that is unlike any other place in the world. It begins with the mountains and waters and expresses itself in the artistic style of nature as the medium. Lake Placid Lodge takes Relais and Châteaux hospitality, an unparalleled wine cellar, great cuisine, and a location of startling beauty and history, and showcases all of those things in what might be one of the largest single works of art in existence.

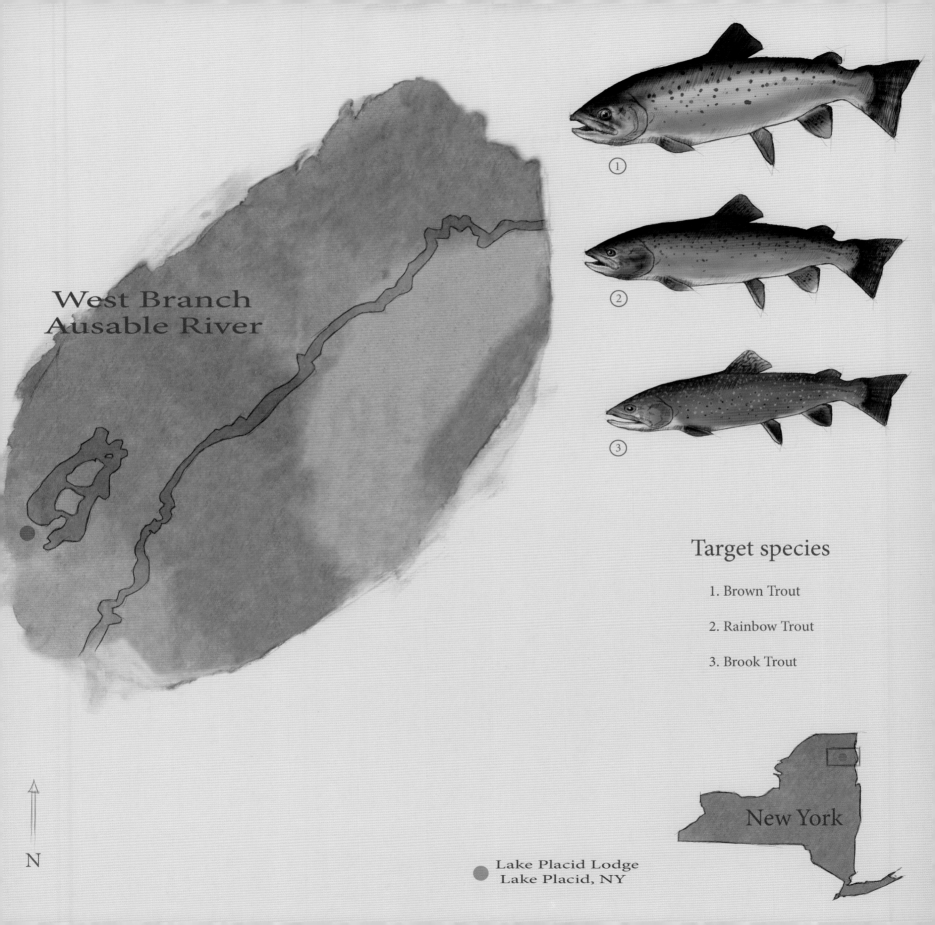

West Branch Ausable River

Target species

1. Brown Trout

2. Rainbow Trout

3. Brook Trout

New York

N

Lake Placid Lodge
Lake Placid, NY

Libby Camps

ASHLAND, MAINE

*Located on Millinocket Lake
near the highlands of Baxter State Park
Founded in 1890*

There are many perceptions of Maine, perhaps the most prevalent being rocky coasts and lobsters. Many fail to realize that Maine is by far the largest New England state, and much of it is wilderness. Look at a map of Maine and you will see that most of the population is centered in the south and east. Move north and the people go away.

Located in this lost region in a 4.5-million-acre privately owned wilderness is Libby Camps, situated on Millinocket Lake in a wild country of woods and water between the highlands of Baxter State Park and the deep forests of Aroostook County. Since 1890, this great sporting tradition has been in the same family and has catered to sportsmen in the great north woods of Maine. Founded by present owner Matt Libby's grandfather, great-uncle, and great-grandfather in 1890, Libby's has eight simple but comfortable cabins, handcrafted from peeled spruce and fir logs, lit by gas lamps, and heated by woodstoves. Situated just back from the water on a slight rise, the big bay windows of each cabin stare squarely at the lake. A mixed wood of birches and pines has grown up all around

RIGHT: *The sun sets over Millinocket Lake.*

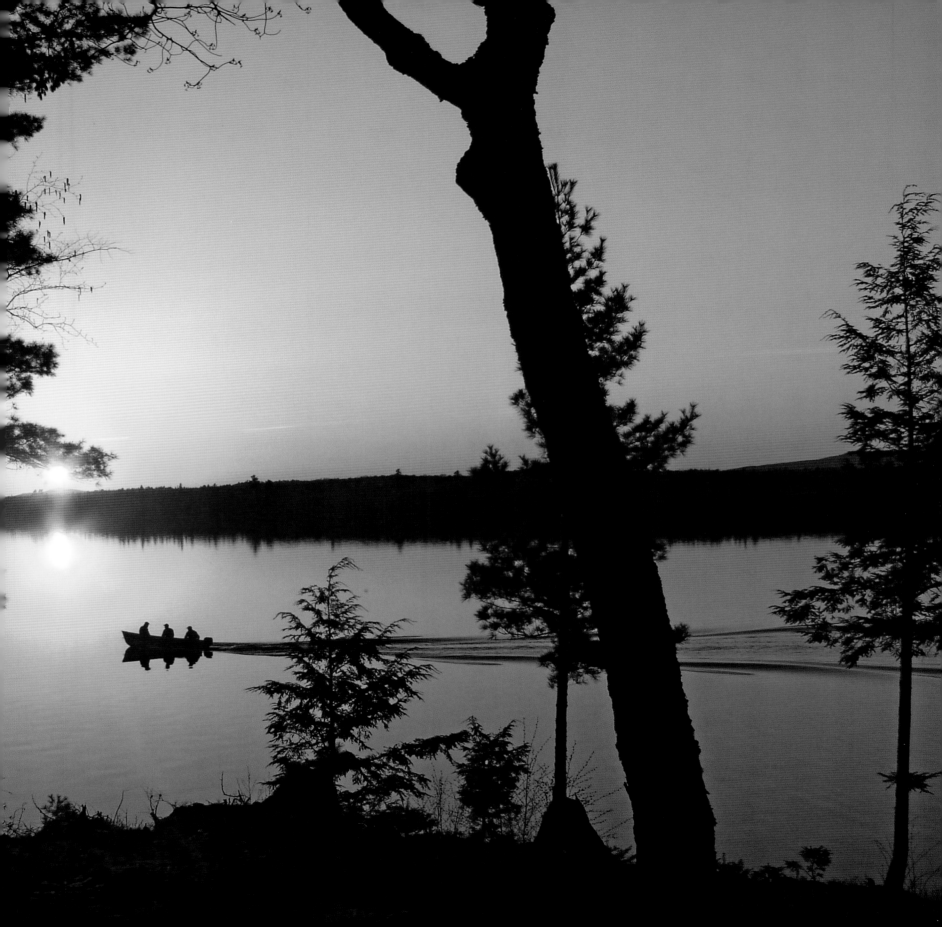

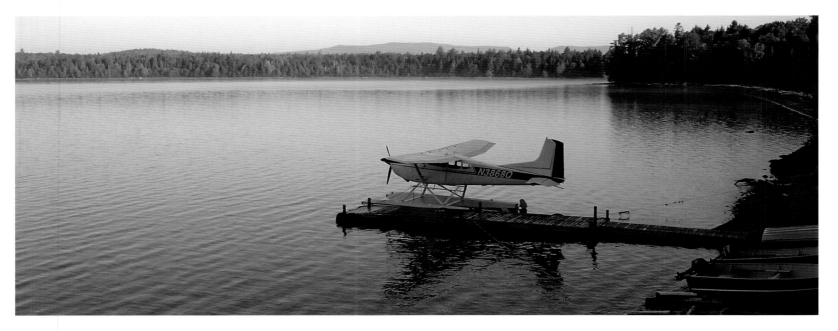

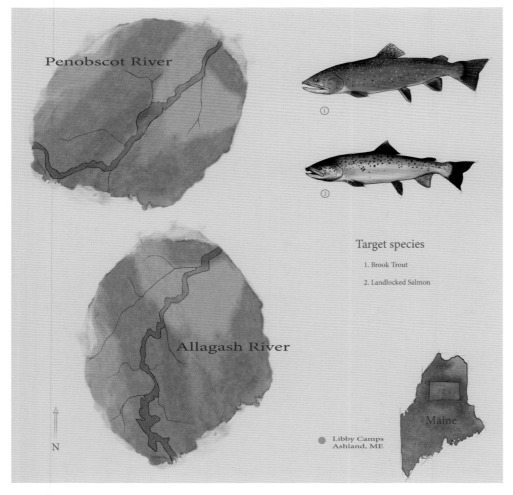

Penobscot River

Target species

1. Brook Trout

2. Landlocked Salmon

Allagash River

Maine

Libby Camps
Ashland, ME

N

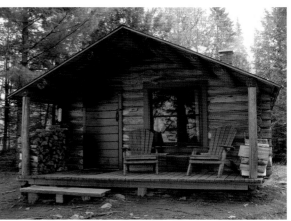

TOP: *A Cessna floatplane waits to take anglers to remote camps.* ABOVE: *The cabins at Libby Camps are classic northern Maine fish camp facilities.* OPPOSITE: *A lodge guest fishes the fast water of the East Branch of the Penobscot River for landlocked salmon.*

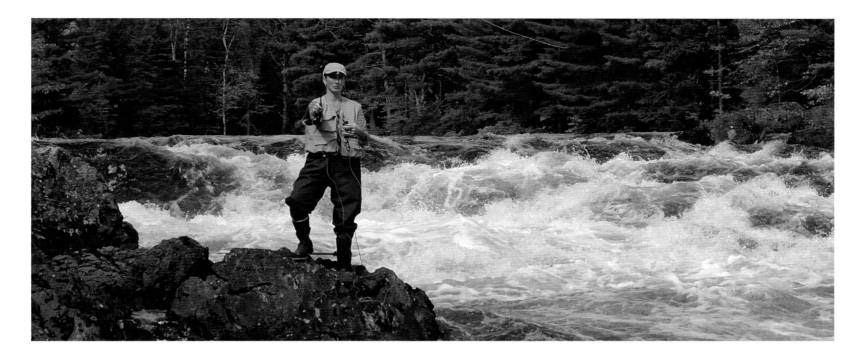

them, and the cabins are well-spaced for privacy. A network of trails connects the lodge and the cabins. The nearest town, Ashland, is 45 minutes away by logging road and is home to only 1,500 people.

Libby Camps is not a luxury resort by any stretch of the imagination, nor does it desire to be. It is a fish camp first and foremost: while all of the necessary amenities are present, they are not superfluous. Guests come here to catch fish, sleep well, eat very well, and then catch more fish. Anything else is unnecessary. The focus is on brook trout and landlocked salmon in the dozens of nearby streams and ponds. The lodge's seaplanes access 10 outpost camps and 80 canoes and boats on more than 30 different ponds, so anglers can fly out to remote ponds and rivers daily. Three of Maine's finest wilderness rivers, the Aroostook, the Allagash, and the Penobscot are within 20 miles of the lodge. A short flight into a remote pond or stream for the day or for an overnight at an outpost cabin is unique in the East to this lodge. It is common to see no more than 12 anglers in the camp at one time, even in prime time, because of the use of overnight outpost camps.

If Maine isn't remote enough, Libby Camps can put you in its most remote camps in Labrador, so you can fish for huge native brook trout. Libby's was the Orvis-Endorsed Fly-Fishing Lodge of the Year in 2006–2007 and it is also an Orvis-Endorsed Wingshooting Lodge.

Libby Camps is one of only four lodges that carry the double endorsement, and its woodcock and grouse hunting are exceptional. There are literally thousands of miles of private logging roads, which range from those accessible by all vehicles to grown over roads accessible only by 4x4. These roads are open to hunting and make exceptional edge cover for grouse. The woodcock hunting is just as good, and, generally, limits are taken within a few miles of the camp. In a time when grouse and woodcock hunting are sadly diminishing in lower New England, Libby Camps offers an experience that makes "the good old days" a reality.

Libby Camps is the sporting experience as it was intended years ago when anglers first started venturing up into the wilds and asking the natives where to go fishing. Not much has changed here. Its hospitality is simple and straightforward. It spares nothing to get anglers on great fishing, the food is exceptional, and the beds are comfortable. There is not much else an angler needs or wants. Libby's has never lost focus on what makes a fishing lodge great and it is well into its fifth generation proving it.

The Lodge at Glendorn

BRADFORD, PENNSYLVANIA

Located in the Allegheny National Forest
Founded in 1929

Y ou would never know it's there. A small sign points down a nondescript little back road near the Allegheny National Forest of north central Pennsylvania. Perhaps that's part of the charm of this hidden gem. It has no need to tout its existence, for those who understand and appreciate the implications of Relais and Châteaux membership will find it.

The little road winds through the Appalachian forest with its mountain laurel understory, until suddenly a grand and imposing gate appears, hanging on massive stone structures. It is the first clue to what lies within.

This is the estate of Clayton Glenville (Bondieu) Dorn, an industrialist who made his fortune in the paraffin-rich oil fields of Pennsylvania and who in 1928 acquired the land that was to become Glendorn, his generational family retreat. Glendorn was built over the years in what can only be called Appalachian opulence—great stones and timbers, old brick, chestnut, cypress, white oak, redwood, slate, Dutch tiles, and a craftsman's attention to detail that is rare if not lost in modern times. The materials themselves are of another age, built by men who had time and pride, and the passage of time has aged the estate to a level of perfection that rivals the wines in the cellar. The experience is as close to the European estate experience as can be found in North America.

The main lodge is an imposing central structure surrounded by the outlying cabins and buildings, which were built and named by members of the family: Dale's Cabin, Jill's Cabin, Roost, Clayt's Cabin, Richard's Cabin, Guesthouse, Forest Hideout. Each of these

OPPOSITE: *A small cabin sits on the edge of Lake Bondieu at the Lodge at Glendorn.*

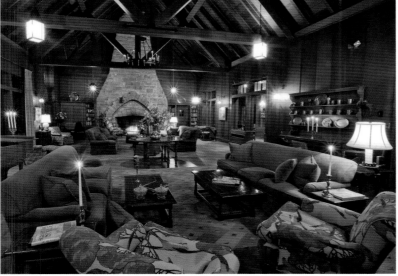

is unique in its design and décor, some a bit more rustically luxurious than others depending on the tastes of the family member. But this is the real charm of the property. This is their home and everything in it from the grand piano in the main lodge to the knickknacks on the windowsills, the games on the table, and the books on the shelves was put there not by some commercial designer, but by the family. Guests are invited into their home and for the duration of their visit, are treated as a part of the family.

Running through the property is Fuller Brook, one of those wonderfully hidden Pennsylvania trout streams that is narrow enough to jump across in places and yet holds very big trout. For three miles, it is perfect water for the small stream angler who loves the short rod stalking of big fish in tight places: an environment where the reward is far greater than the expectation and brookies, browns, and rainbows are all present in both abundance and size. There are also a number of trout ponds on the property where lovers of stillwater angling can spend the afternoon on the bank or in a boat casting to rising fish. Hatches are prolific and the fish are remarkably willing. For those fishermen with greater aspirations, the Great Lakes steelhead runs from April to October are close by and along with lake run browns and coho salmon offer some of the best big game fishing in the East.

Between the extraordinarily good fishing on-site and Relais and Châteaux hospitality, Glendorn resides at the top of any list for those who pursue the elegant estate sporting tradition experience found in Europe or Great Britain, yet it lies but a few hours drive from the largest population concentration in the United States.

TOP: *One of the Dorn family cabins is now used as lodging for Glendorn guests.*
ABOVE: *The exposed wood beams and the stone fireplace are the highlights of the main room at the lodge.*

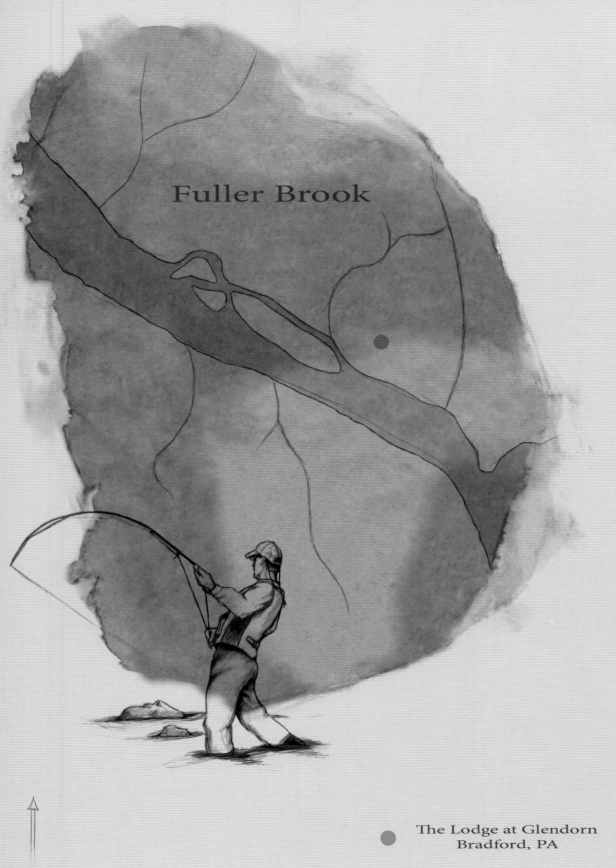

Fuller Brook

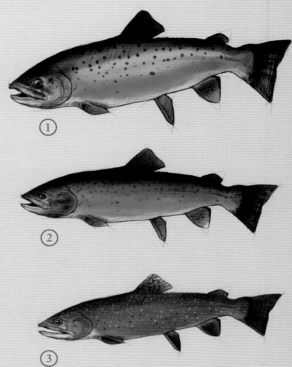

①

②

③

Target species

1. Brown Trout

2. Rainbow Trout

3. Brook Trout

● The Lodge at Glendorn
Bradford, PA

Pennsylvania

N

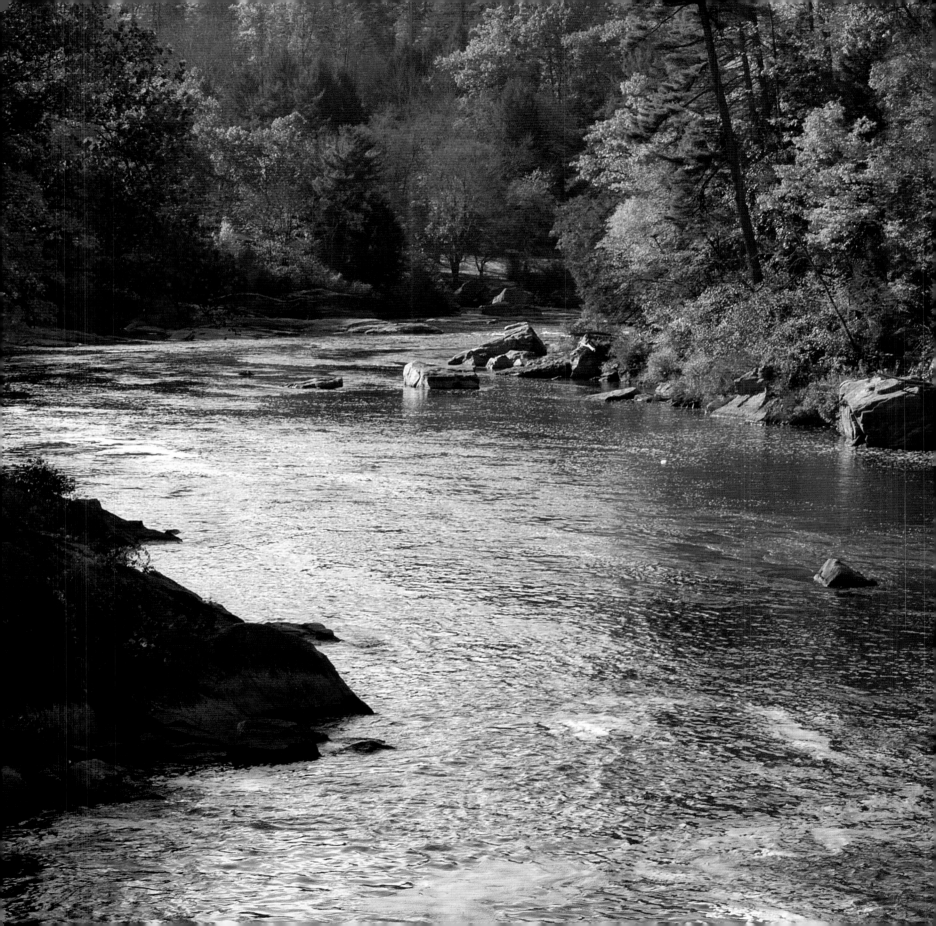

Nemacolin Woodlands Resort

FARMINGTON, PENNSYLVANIA

*Located in the Laurel Highlands of the Allegheny Mountains
Founded in 1987*

One could call it a landlocked cruise. A place where once you enter the gates, there is no reason to ever leave. A cruise offers this by necessity; Nemacolin offers this by desire as one of the most complete and extraordinary resorts in the United States. While there are other resorts of this type that offer myriad things to do and multiple dining and lodging options, Nemacolin does it at an impressive level, offering both the rare and coveted Mobil Five-Star and AAA Five-Diamond ratings for various categories at the resort.

Tucked away in the southwest corner of Pennsylvania, Nemacolin lies in the Allegheny Mountains where Pennsylvania tucks itself into the arms of West Virginia. It's called the Laurel Highlands because of the prolific mountain laurel that provides the understory for the hemlock and hardwood forests that surround it. A region of great natural beauty as well as historical and cultural significance, the Laurel Highlands were the inspiration for Fallingwater, Frank Lloyd Wright's seminal work of architecture. Nemacolin's Five-Diamond-rated Falling Rock Hotel is inspired by this work. George Washington began his military career at nearby Fort Necessity, but it is the forested highlands, shredded by freestone streams and the promise of great trout fishing, that draws the angler.

The fly-fishing headquarters at Nemacolin is located in the 7,000-square-foot lodge it shares with the Shooting Academy, one of the premier sporting clay facilities in the country. Anglers can

OPPOSITE: *Water gently flows around the bend of the Youghiogheny River.*

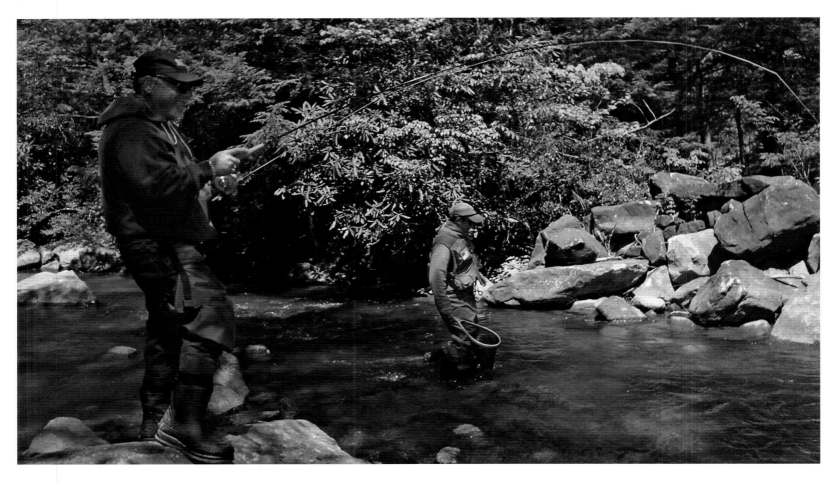

choose from a number of Pennsylvania's best trout streams, including the Youghiogheny River, a wild and beautiful waterway that runs north from Maryland and flows into the Monongahela just before it joins with the Allegheny to form the Ohio River. The Yough, as it's called, has in parts a western feel of big water, big river fishing with steep forested hillsides rising from the water. There is Meadow Run, Dunbar Creek, and Beaver Creek, where it is not uncommon to see rainbow trout more than 20 inches long. Fishing from pool to pool on Beaver Creek shaded by the hardwoods and hemlocks is true eastern fly fishing at its best with browns, brookies, and rainbows in good numbers and ample hatches in May and June of Hendricksons, Cahills, Drakes, and March Browns.

For the sportsman who visits Nemacolin, there are so many pursuits that it can be overwhelming, including shooting and driving TOMCARS across ridiculously awkward and challenging terrain.

TOMCARS were originally designed as military vehicles and take well to the rugged terrain. For one who has always wanted to really see what an off-road vehicle can do, this is perhaps the most enticing offer at the resort. And then there is the decadent side of life. Nemacolin sports the largest wine cellar in Pennsylvania with more than 17,000 bottles of wine and Lautrec, a Mobil-rated five-star restaurant whose dining experience is considered an entire evening's entertainment and is the only such rated restaurant between Philadelphia and Chicago.

Nemacolin is not for the die-hard angler. It is for the lover of those things epicurean who, as it happens, likes to fish, or shoot, or drive someone else's car over a cliff. While solitude is not the norm, standing in an Allegheny Mountain trout stream, watching a fish rise just up the stream, is a nice way to soothe the soul after satisfying the palate.

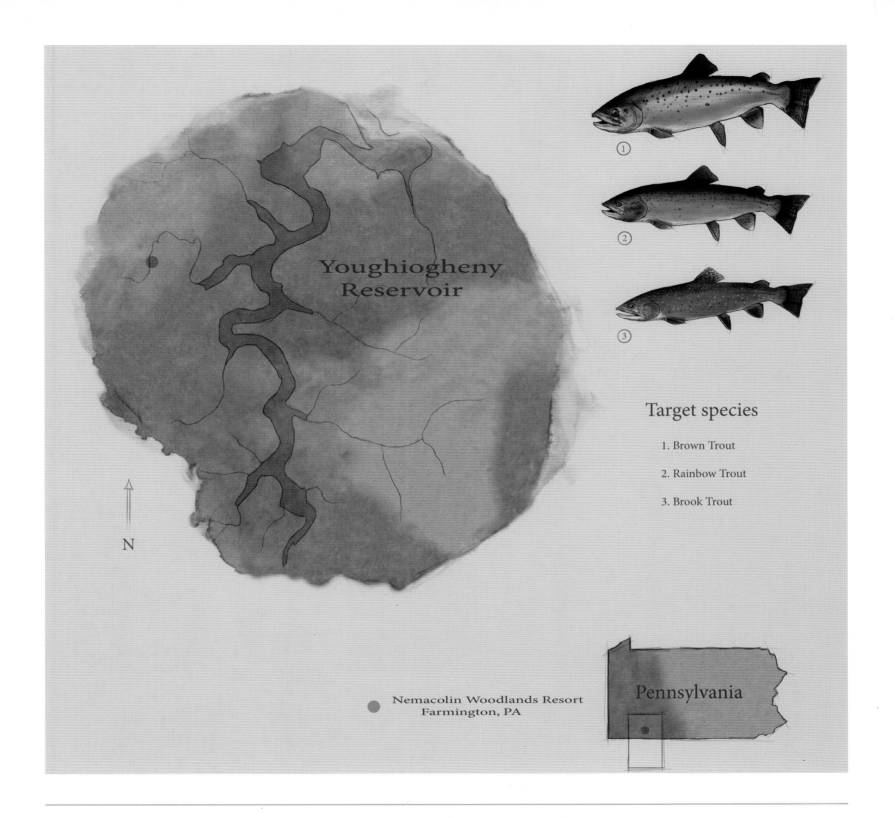

Youghiogheny
Reservoir

N

Target species

1. Brown Trout

2. Rainbow Trout

3. Brook Trout

Nemacolin Woodlands Resort
Farmington, PA

Pennsylvania

OPPOSITE: *An angler hooks up on a laurel-lined trout stream in the Allegheny Mountains of southern Pennsylvania.*

Weatherby's

GRAND LAKE STREAM, MAINE

Located on Grand Lake Stream in the Downeast Lakes Region
Founded in 1870

Tradition plays a very important role in the sporting pursuits of fishing and hunting, perhaps because they've been with us so long. Because of the importance of tradition, the longer a lodge exists, the more history and tradition it accumulates and the more beloved it becomes.

While Native Americans and settlers wrestled for control of the West and fishing lodges on the great western rivers were still decades away, sport anglers were traveling to Maine and the Adirondacks from the population centers of the Northeast in search of good fishing and hunting in the north woods.

Grand Lake Stream is considered one of the best rivers in the country for landlocked salmon, freshwater cousins of the Atlantic salmon. The river runs between West Grand Lake and Big Lake,

and located right on the river is Weatherby's, one of the most storied lodges in Maine. Anglers have been coming to Grand Lake Stream for nearly two centuries, and Weatherby's began taking its first sports more than a century ago. Since that time it has grown to the status it claims today.

There is great history here, including the development of the Grand Lake square-stern canoe, or "Grand Laker," used here for decades. These big, beamy canoes are long (often 20 feet or more), wide, and stable enough to smoothly handle the chop on a windy lake, yet still be maneuvered through the boulder-strewn shorelines when necessary. At the same time, they offer plenty of room to fish. The canoes still ply these waters, not because of some historical necessity to keep them around, but because nothing has come along

OPPOSITE: *Waders and rods lean against the porch walls of this classic Maine fish camp.*

that works as well as the original. Together with a registered Maine guide at the helm, there is perhaps no greater north woods icon.

The resort itself is built around the main lodge, constructed in the early 1870s as a home for the superintendent of the local tannery. The largest and most imposing structure in the town, the "White House," took in its first sportsmen soon after, and the story of Weatherby's commenced. Over the years the lodge expanded and individual cabins were built or moved there, each with its own unique bit of architectural style, but all with great fish camp amenities—screened porches, fireplaces or woodstoves, and comfortable beds. Add in the plentiful Maine cuisine, and there is not much to want for here.

Then there's the fishing. Trolling in the lakes for salmon and lake trout begins in May with ice-out. The salmon then begin to move into Grand Lake Stream, which has been restricted to fly fishing only for more than 100 years. Between the smelt, spawning sucker, and insect hatches, the fishing remains good into July. Then in September and October the fish return to the river to spawn, offering spectacular fishing in Maine's autumn weather. If that isn't enough, the smallmouth fishing is excellent, particularly in June when they will recklessly attack top water flies.

Weatherby's is a fish camp in the grandest sense of the word. It encompasses a century of fishing tradition in a part of the world where the outdoorsman is preeminent in the social order of things and the registered Maine guide is considered the most honorable of endeavors. There is no pretense here, no wine tastings, no spa. There is simply the pursuit of the sporting traditions in their simplest and purest form.

TOP: *This cabin, one of several at Weatherby's, is called "The Rose."*
LEFT: *Maddie waits for the anglers to come home.*

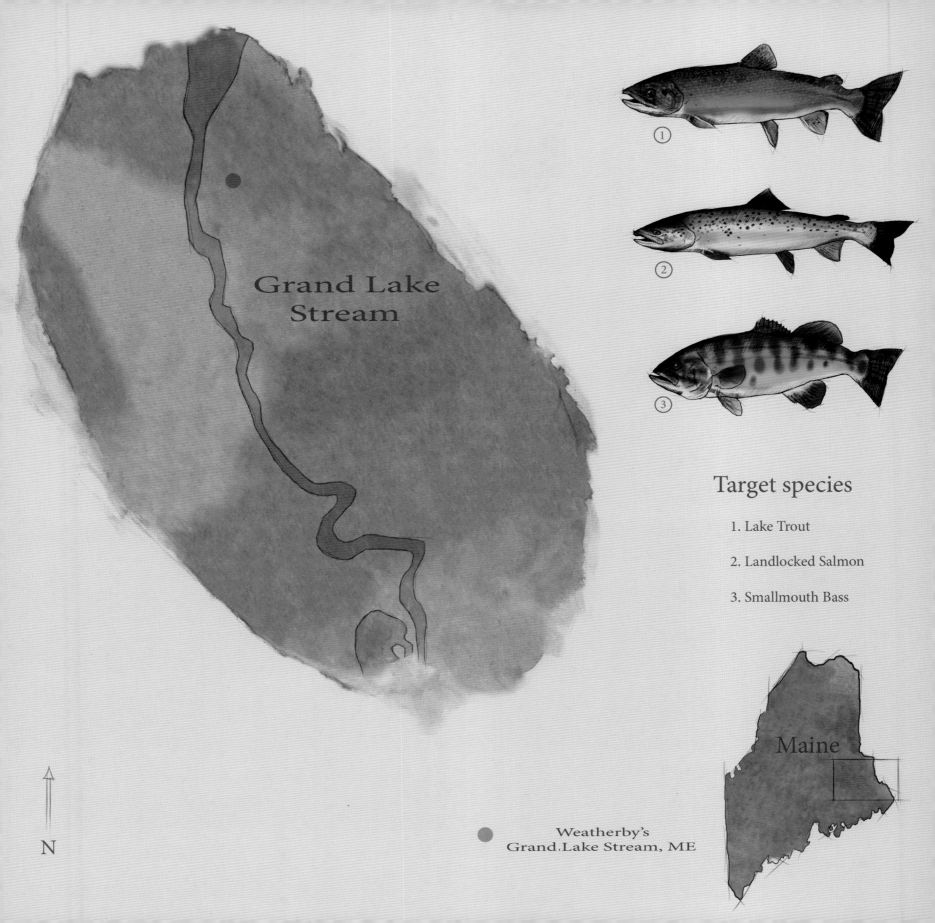

Grand Lake
Stream

Target species

1. Lake Trout

2. Landlocked Salmon

3. Smallmouth Bass

Weatherby's
Grand Lake Stream, ME

Maine

N

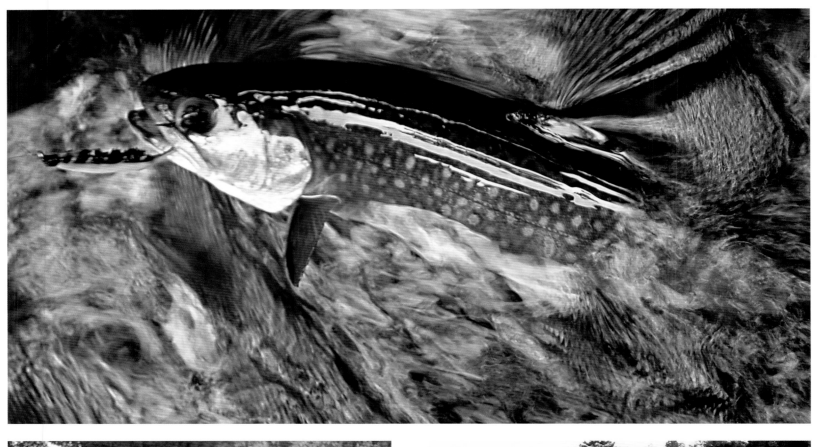

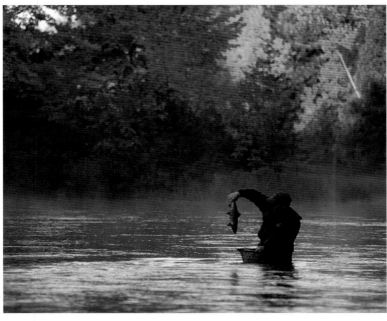

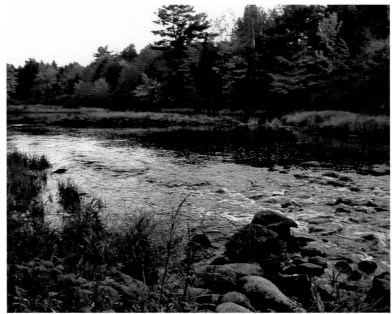

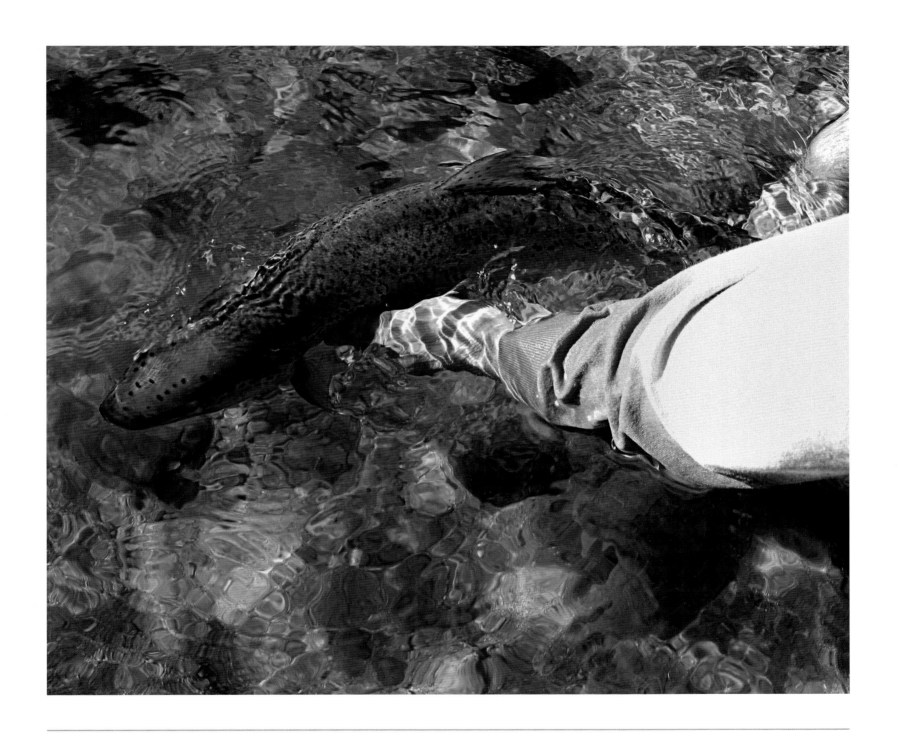

OPPOSITE, TOP: *A brook trout falls for a big streamer.* OPPOSITE, BOTTOM LEFT: *An angler inspects his early morning catch before returning it to the river.*
OPPOSITE, BOTTOM RIGHT: *Fall colors brighten up the banks of Maine's Tomah Stream, home of wild brook trout and smallmouth bass.*
ABOVE: *A landlocked salmon returns to the river.*

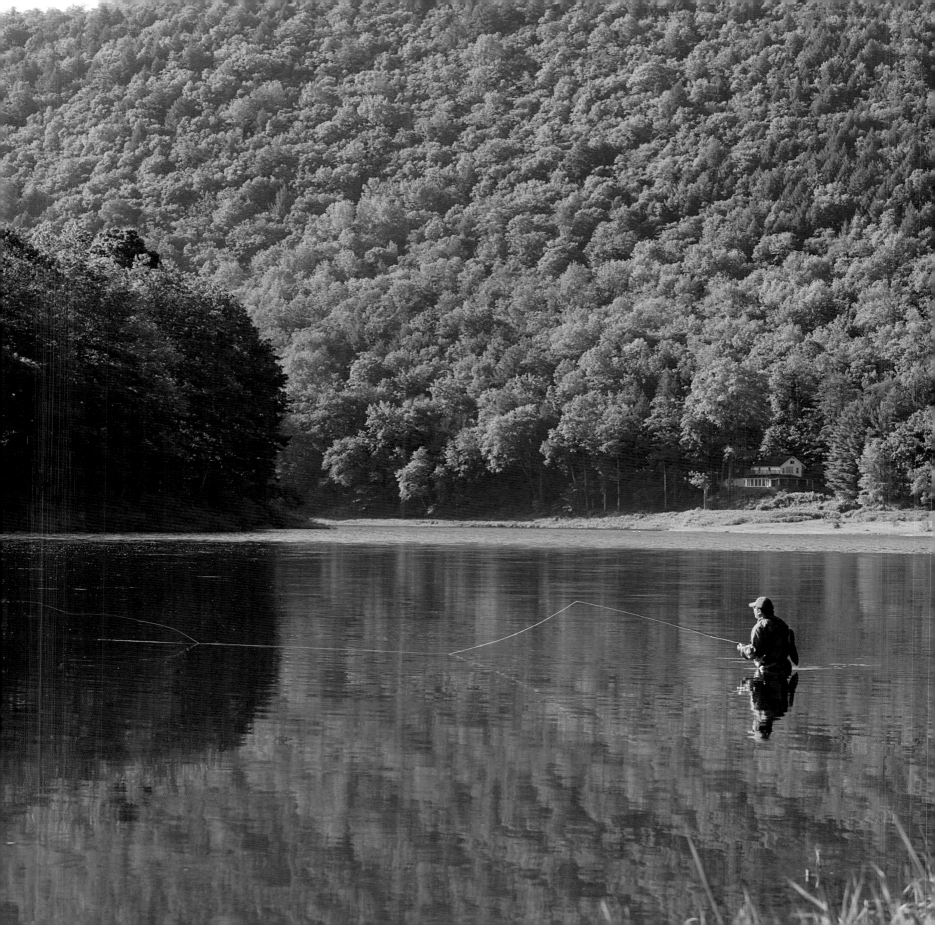

West Branch Angler and Sportsman's Resort

HANCOCK, NEW YORK

Located on the banks of the West Branch of the Delaware River
Founded in 1991

The Delaware River is perhaps most famously known as the river Washington crossed to defeat the Hessians at Trenton, but further north in the upper reaches of the river, where it flows between the Endless Mountains of Pennsylvania and the Catskills of New York, the Delaware River system includes the West Branch, the East Branch, and the Main Stem, all of which include about 150 miles of blue-ribbon wild trout water.

This part of the world is the cradle of modern fly fishing, where anglers such as Theodore Gordon, the father of American fly fishing, did their groundbreaking work in the development of the dry fly to match the remarkable array of insects of the Neversink, Beaverkill, and Willowemoc, all tributaries of the Delaware system.

Located on the famous West Branch of the Delaware is West Branch Angler and Sportsman's Resort, a true dyed-in-the-wool fishing camp for anglers who want to experience perhaps the best large fish, small dry-fly fishing in the East. To say this is a technical river is perhaps an understatement as the hatches are incredibly prolific and span a list of many of the traditional hatches that have enthralled fly fishermen for generations.

Beginning with brown stones in the early spring and proceeding through a laundry list of blue wing olives, black caddis,

OPPOSITE: *An angler stands in the middle of the main stem of the magnificent Delaware River.*

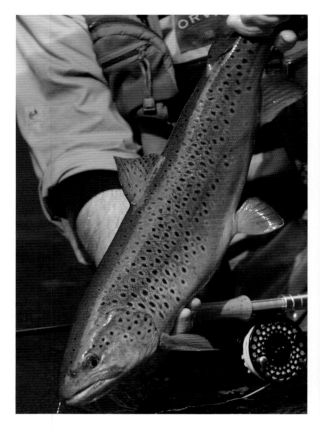
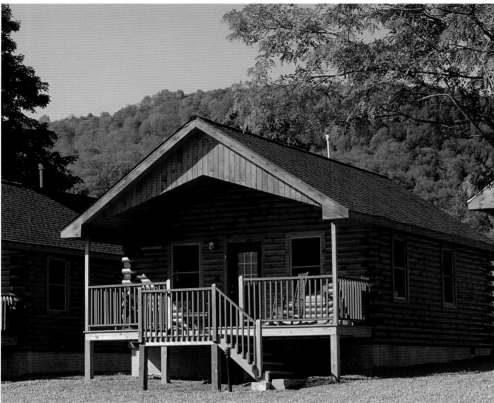

blue quill, quill Gordons, Hendricksons, sulfurs, and on down the list to the drakes and March Browns, the Delaware is a match-the-hatch angler's dream. What makes it more interesting is that the profuse nature of the hatches offers the fish so many opportunities that success on the river is not easy. However the rewards of big, strong, wild rainbows and browns running up to 24 inches (and above on occasion), on very small flies down to size 24, are more than worth the challenge.

The Delaware is the closest thing to a western river found in the East. Big, wide, wadeable, and driftable throughout all of its great trout water, it is truly one of the leading trout rivers in the United States. The river winds through the mountains in a succession of riffles and pools with major hatches of the three major insect species—stones, mayflies, and caddis—coming off in some form or another from spring through the fall. In fact, *Outdoor Life* once ranked it second only to the Big Horn. High praise indeed.

West Branch Angler sits on a 300-acre parklike setting right on the bank of the river, with fishing just out the front door of the cabins that line the river. The main lodge, where the restaurant, bar, and full-service fly shop are located, overlooks the river and the cabins. Twelve of the cabins are newly renovated and offer the simple yet comfortable amenities that anglers want. Starting with the Grand View cabins and working up through the CEO cabins, there is an accommodation here for every taste, but make no mistake: this is an angler's resort pure and simple, sitting on the banks of a true angler's river.

TOP LEFT: *A finicky Delaware brown trout sees more insects and imitations than just about any other fish. This one made the wrong choice.* TOP RIGHT: *These cabins face the West Branch of the Delaware river; the fishing is just steps away.*

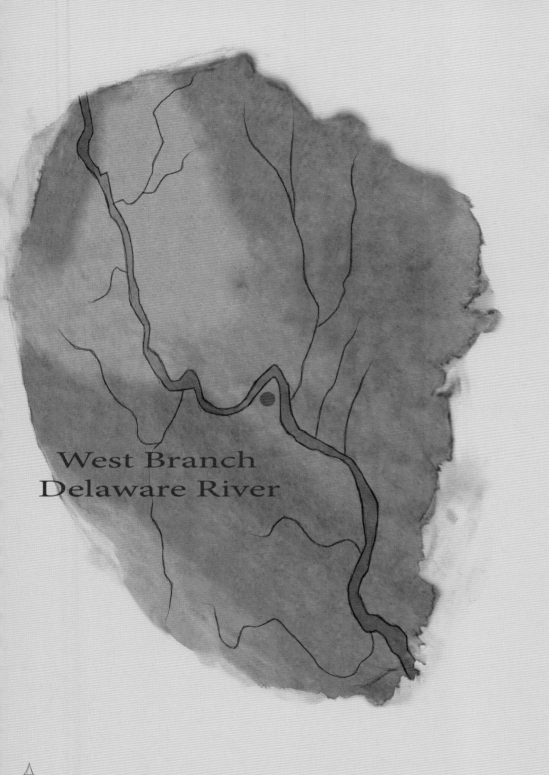

West Branch Delaware River

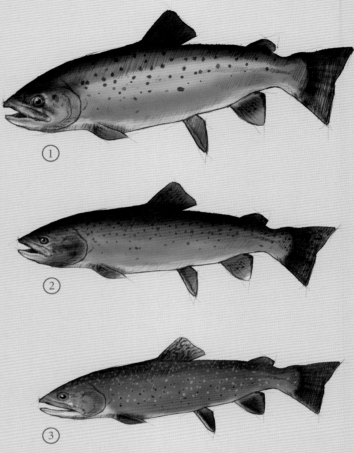

①

②

③

Target species

1. Brown Trout

2. Rainbow Trout

3. Brook Trout

New York

N

● West Branch Angler and Sportsman's Resort
Hancock, NY

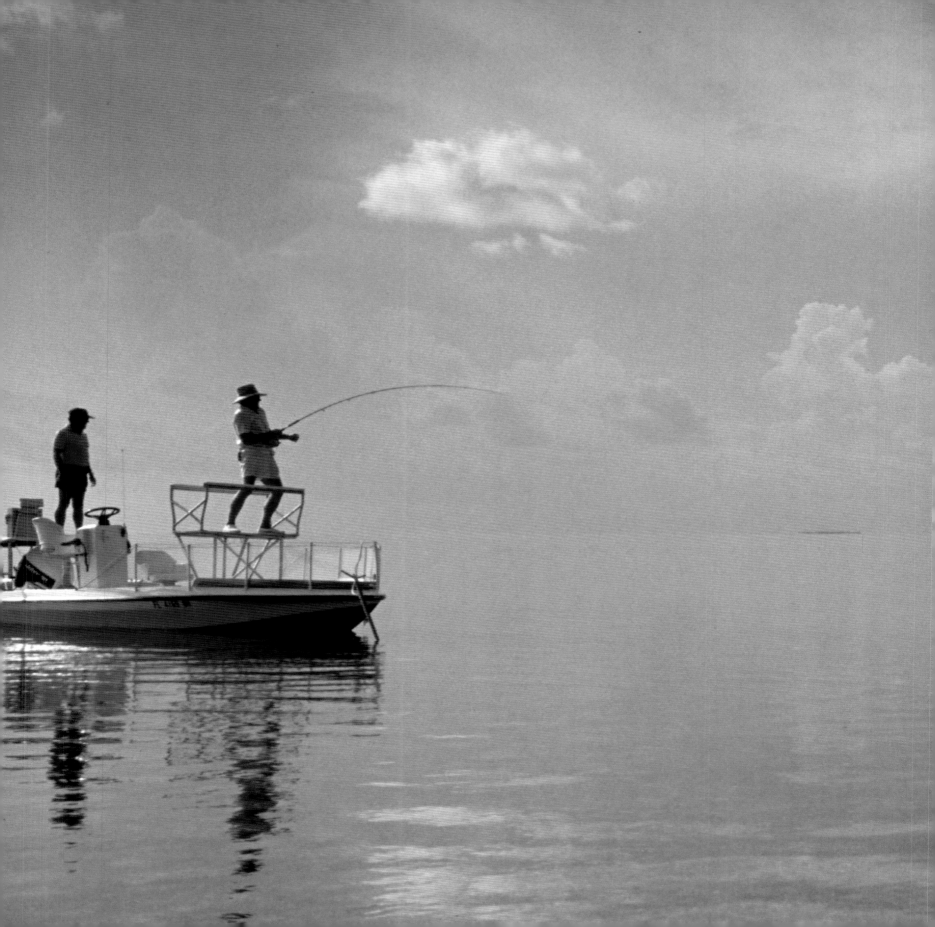

The South

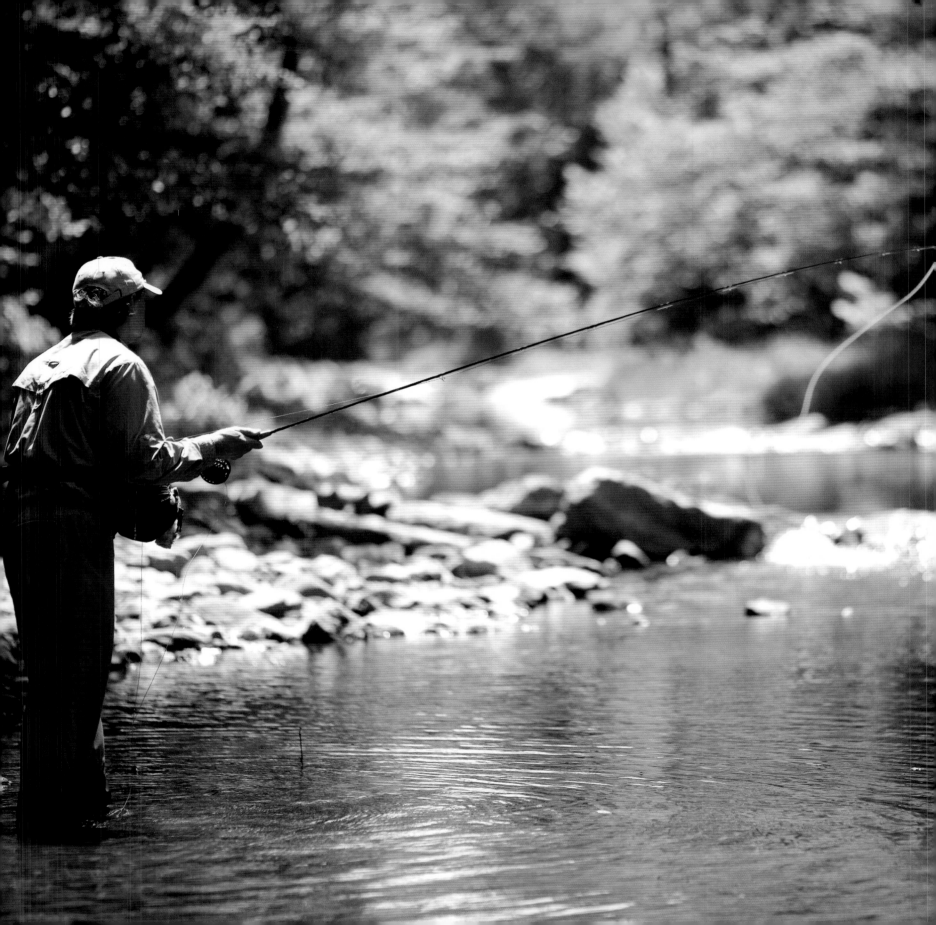

Blackberry Farm

WALLAND, TENNESSEE

Located in the foothills of the Appalachian Mountains
Founded in 1976

These mountains are ancient, perhaps some of the oldest in the world. Long before the upstart Rockies rose in the West, the Appalachian chain was already past its prime. Looking out over the mountains, one can see them rolling in blue waves toward the horizon with mists hugging the deep hollows, hiding the remnants of a mountain civilization that survived the modern world for longer than most. Deep in the laurel-shrouded hollows, the sons of Culloden established their highland culture, and it is still seen in the traditional dances and music of the region.

Tucked away in the foothills of these mountains is one of the great surprises in travel. One wouldn't expect to find the level of hospitality offered at Blackberry Farm at the end of a nondescript mountain road, which seems to harbor nothing special until suddenly this combination of English country estate and Appalachian culture spreads out before you over the hills and hollows of this little valley.

Sprawling over 4,200 acres, Blackberry Farm is a luxurious Relais and Châteaux resort with a stunning list of awards from *Zagat* to *Condé Nast* to *Travel and Leisure* that rank them as number one in the world for service and cuisine. Suffice it to say, this is one of the premier resort properties by the standards of those who know.

Interesting that such a property would be tucked away in a

PAGES 80–81: *Anglers struggle with a tarpon off the Florida Keys.*
OPPOSITE: *An angler fishes Hesse Creek at Blackberry Farm.*

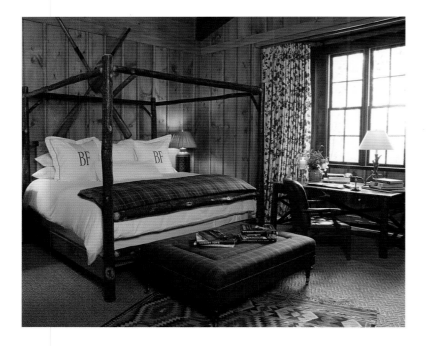 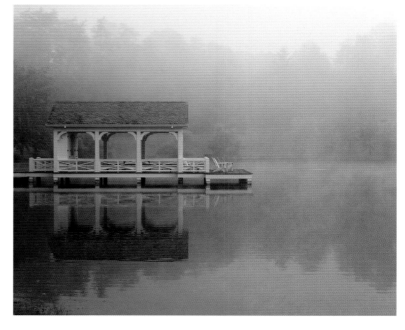

Tennessee hollow, but perhaps that is the beauty of it. Like many resorts of this ilk, there is no ostentatious sign at the end of the road, no need to advertise that the end of the road is paradise. Those in the know understand that the experience visitors receive is second to none.

For the angler, there is some of the finest trout fishing the eastern United States can offer, with more than 700 miles of pristine mountain water just up the road in Smoky Mountain National Park, as well as miles of the Clinch and Holston rivers. On the property are two ponds, but the jewel is Hesse Creek, flowing through the valley under a canopy of trees and holding rainbow and brown trout from eight inches to eight pounds. This is a miracle mile of trout fishing; one can move quietly from one pool to another pulling out fish after fish without ever leaving the property.

The Gray Drake, the cabin that houses Blackberry Farm's fishing operation, is worth the trip for those who love mountain architecture. Perched on the banks of Hesse Creek, the setting alone is enough to make one never want to leave.

Blackberry Farm has won the Orvis-Endorsed Lodge of the Year award twice. The fishing is excellent, the service is beyond description, and the cuisine and wine cellar are as good as you will find in the world. Once it's been visited, superlatives seem trite in trying to describe the Blackberry experience. It is one of the world's great travel secrets, tucked away in the world's oldest mountains.

TOP LEFT: *This is one of the many exquisite bedrooms at Blackberry Farm, one of the top-rated hotels in the world.* TOP RIGHT: *The boathouse on the bass lake at Blackberry Farm is surrounded by Smoky Mountain mist.*

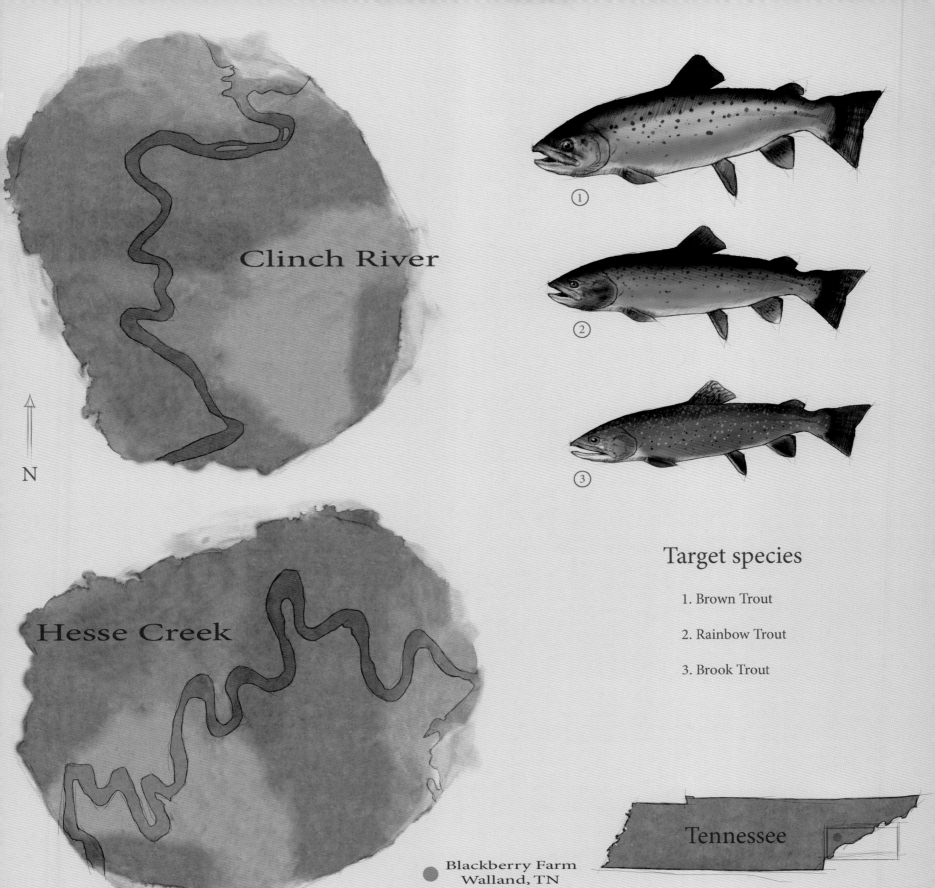

Clinch River

N

Hesse Creek

Target species

1. Brown Trout

2. Rainbow Trout

3. Brook Trout

Tennessee

Blackberry Farm
Walland, TN

Chetola Resort at Blowing Rock

BLOWING ROCK, NORTH CAROLINA

*Located in the misty hollows
of the Blue Ridge Mountains
Founded in 1846*

The Blue Ridge Mountains are the first bulwark of the Appalachian chain that stretches from Georgia to Pennsylvania. These are ancient mountains even by mountain standards, much older than the Rockies or the Sierras. While they have been worn down to smaller versions of their original massive size, the Appalachian mountains are still hauntingly beautiful, with dark forested peaks rising from deep misty hollows. In places these valleys and hollows are so difficult to access that even as late as the mid-20th century, the old mountain culture still spoke and wrote the original King's English. This is a difficult land mostly settled by the sturdy Scots and Irish; the influence of their culture is easily recognizable in the music, dance, and lineages of the Appalachian region.

Blowing Rock is one of the most beautiful spots in the Blue Ridge. Located less than two hours from Charlotte, where the mountains rise like a wall from the rolling Piedmont, Blowing Rock became a refuge of sorts over the years, from the ravages of

RIGHT: *The grounds at Chetola Resort on a sunny day.*

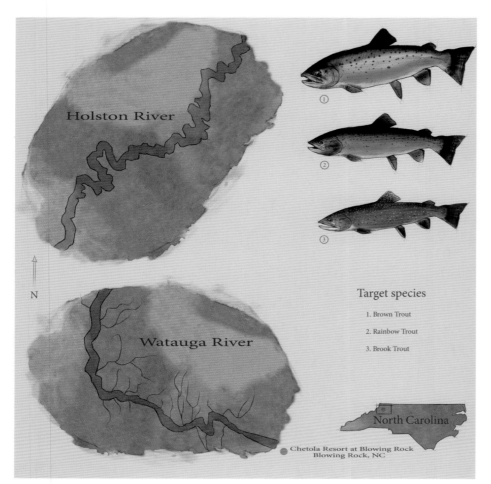

Holston River

Watauga River

N

Target species

1. Brown Trout

2. Rainbow Trout

3. Brook Trout

North Carolina

Chetola Resort at Blowing Rock
Blowing Rock, NC

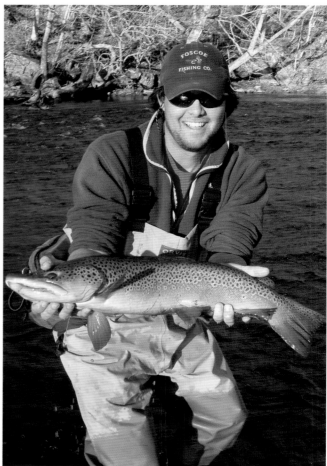

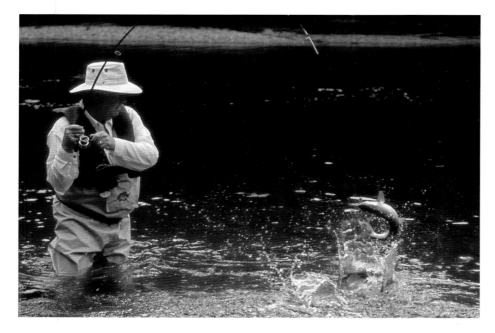

ABOVE: *A satisfied angler shows off his catch—a big brown trout from the Watauga River.* LEFT: *An angler is treated to a flying rainbow.* OPPOSITE: *The Appalachian Trail crosses the Watauga River, pictured here, at the Watauga Dam in eastern Tennessee.*

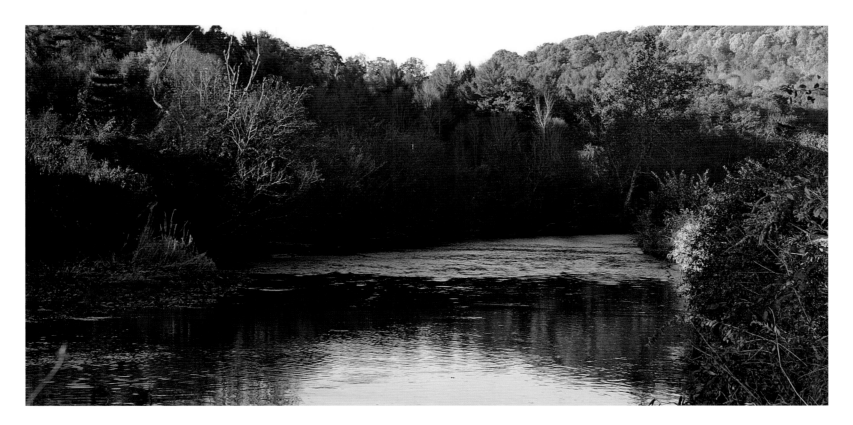

the Civil War, from the heat of the lowlands, and finally from the crowded cities.

Chetola translated from the Cherokee means "haven of rest"; over the years it has served that purpose to a number of families, from the Estes who first settled it to the Snyders, a wealthy family who brought Chetola into its golden age and turned it into the grand estate that stands today. It was long the centerpiece of Blowing Rock society, and its celebrations and parties were legendary.

Today, Chetola is one of the most beautiful resorts in the Blue Ridge. Its history and charm have been carefully maintained to preserve the feeling of a big family retreat, but with all the accoutrement of a world-class resort. The centerpiece of the resort is the original Manor House Estate, redone in conjunction with artist and designer Bob Timberlake. Timberlake is famous for art and furniture designs that reflect the southern mountain culture. Each room in the manor house has been personally designed by Timberlake and named after former owners of the estate and prominent figures in the region's history.

For the trout fisherman, the Blue Ridge Mountain chain offers up hundreds of small streams and rivers trickling down through the dark hollows, the water springing from the mountains, staying cool and clear through the dark understory of mountain laurel. This is a prime native brook trout habitat and offers the opportunity to stalk the wildest trout in North America. These little brookies are voracious eaters whose feeding opportunities are limited in the cold dark waters of these small streams. Stalking these trout from pool to pool with light tackle is one of the great pleasures of dry-fly angling. But even larger trout have found their way into these mountains in the larger rivers and tailwaters such as the Wautauga and South Holston rivers. The constant flow of cool water from the base of the dams on these rivers provides some of the best trout habitats in the East, with ample hatches and trophy browns.

There is an intangible quality to these mountains. They are not grand and spectacular in the sense of the larger western chains, but they offer something deeper to those who venture into their hollows.

The Marquesa Hotel

KEY WEST, FLORIDA

*Located in a tropical paradise between
the Gulf of Mexico and the Atlantic Ocean
Founded in 1988*

At the southernmost point of the United States lies Key West, the last link in the chain of islands that drift southwest from the tip of the Florida mainland. A tropical paradise to be sure, but one overflowing with the history of larger-than-life characters and all the myths and legends they bear with them, from Hemingway and Buffett, to Bogey and Bacall, to pirates and smugglers. Everything resonates when visiting this mysterious and merry little outpost warmed by the Gulf Stream and cooled by the trade winds that drove the sailing ships of Europe to these latitudes. Its history is punctuated by hurricanes, expatriates, and intrigue, all in a setting that lures the adventurous—the junction of two seas in a siren climate that captivates its visitors with thoughts of reckless abandonment of their ordinary lives. It is easy to get lost here and even more intriguing to imagine it.

Centered in the midst of this paradise is the Marquesa Hotel and the Café Marquesa, just a block off famed Duval Street and a few blocks from the Gulf of Mexico on one side and the Atlantic Ocean on the other. Three of the buildings in the four-building complex were built in the 1880s, and the main building is listed on the National Register of Historic Places. The other two 1880s structures are prime examples of the wood-frame architecture found in the Bahamas and the West Indies. Surrounded by tropical flowering plants and orchids, the hotel is a singularly perfect example of the tropical culture in the wildly romantic early days of the Keys.

OPPOSITE: *The turquoise waters of Booby Cay in the Florida Keys are surrounded by lush vegetation.*

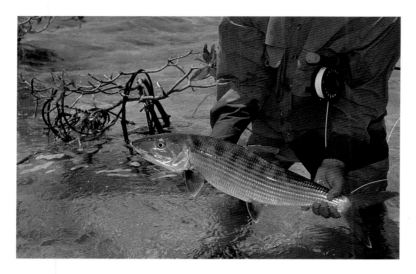

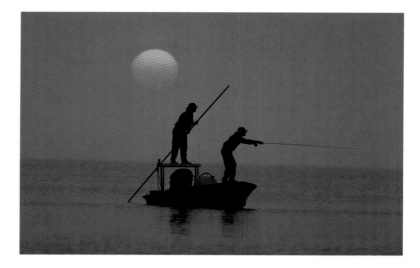

That the Marquesa is a world-class resort hotel is undeniable given the awards and decorations bestowed on it, including the AAA Four-Diamond award every year since it opened, Top 100 U.S. Hotels from *Condé Nast Traveler*, World's Best Hotels from *Travel and Leisure*, and many more. The Four-Diamond Café Marquesa is just as highly decorated and has been featured in *Gourmet, Bon Appetit*, and *The New York Times*.

For the angler, the Florida Keys are home to the Grand Slam species of bonefish, tarpon, and permit on the flats and to the remarkable offering of offshore species from cobia and dolphin to tuna and sailfish. For the fly fisherman, there is perhaps no greater accomplishment than the slam. These fish must be seen and stalked in shallow waters. The presentation must be perfect. There is little blind luck here. The reward is speed, for flats fish have nowhere to go in their adrenaline run but out, and it all happens in a place so beautiful that leaving is painful.

Fishing in Key West is legendary, not only for its profuse nature, but because of its storied past and the larger-than-life figures who lay claim to angling history from this port. Ernest Hemingway fished here and from his adventures came *The Old Man and the Sea, Islands in the Stream*, and *To Have and Have Not*. For the visiting angler, this heritage lies just off the docks of Key West, the blue and turquoise waters that hold so many great species of game fish in such great numbers. For the ultimate Key West angling adventure, staying at the Marquesa Hotel, dining at the Marquesa Café, and fishing the waters of Hemingway's heroes is an angling experience that may ultimately not let you go.

TOP LEFT: *A bonefish is released into the mangroves.* TOP RIGHT: *The sun rises over the flats.* LEFT: *The historic Marquesa Hotel and Café Marquesa sit just one block away from the famous Duval Street.*

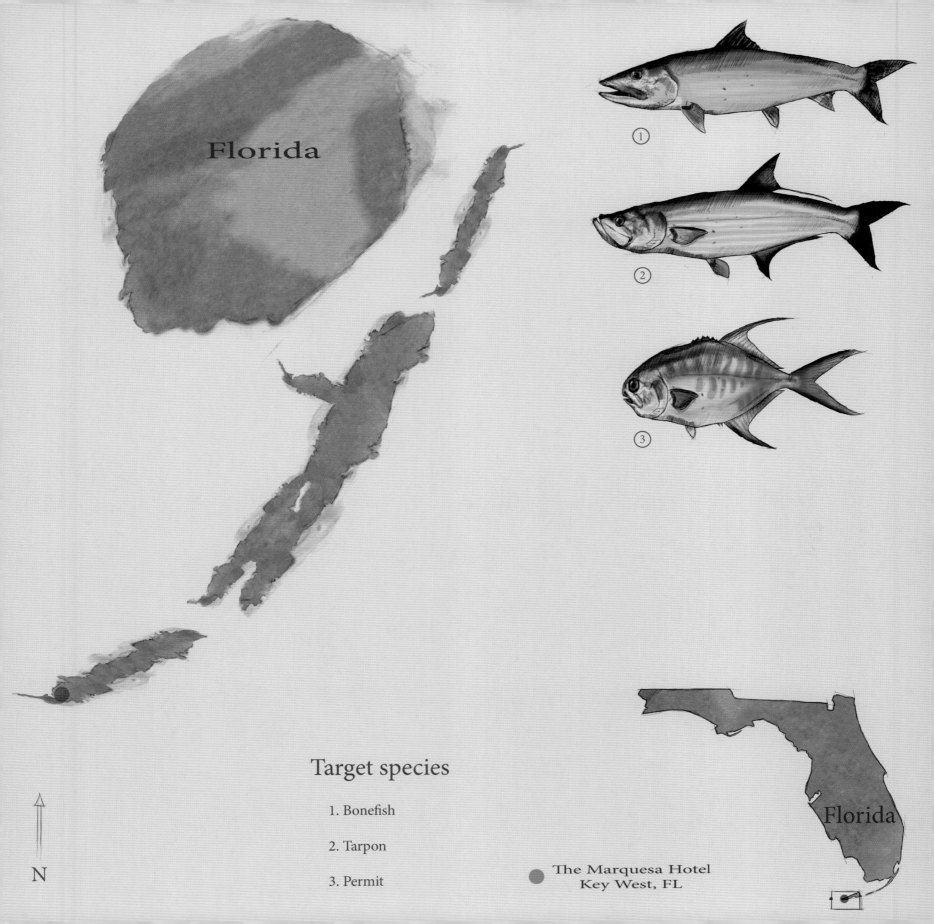

Florida

①

②

③

Target species

1. Bonefish

2. Tarpon

3. Permit

● The Marquesa Hotel
Key West, FL

N

Florida

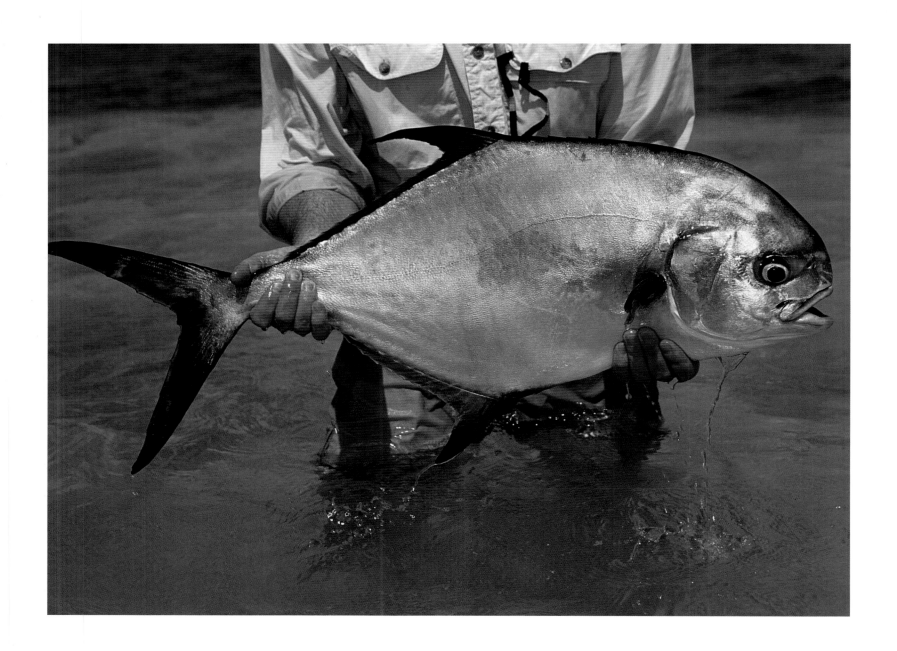

ABOVE: *The elusive permit is perhaps the hardest to catch of the tropical Grand Slam species, due to its shy and wary behavior. There are those who have devoted their lives to catching just this fish.* OPPOSITE: *A tarpon does what tarpons do best—puts on an aerial show for the angler in this crystal-clear theater.*

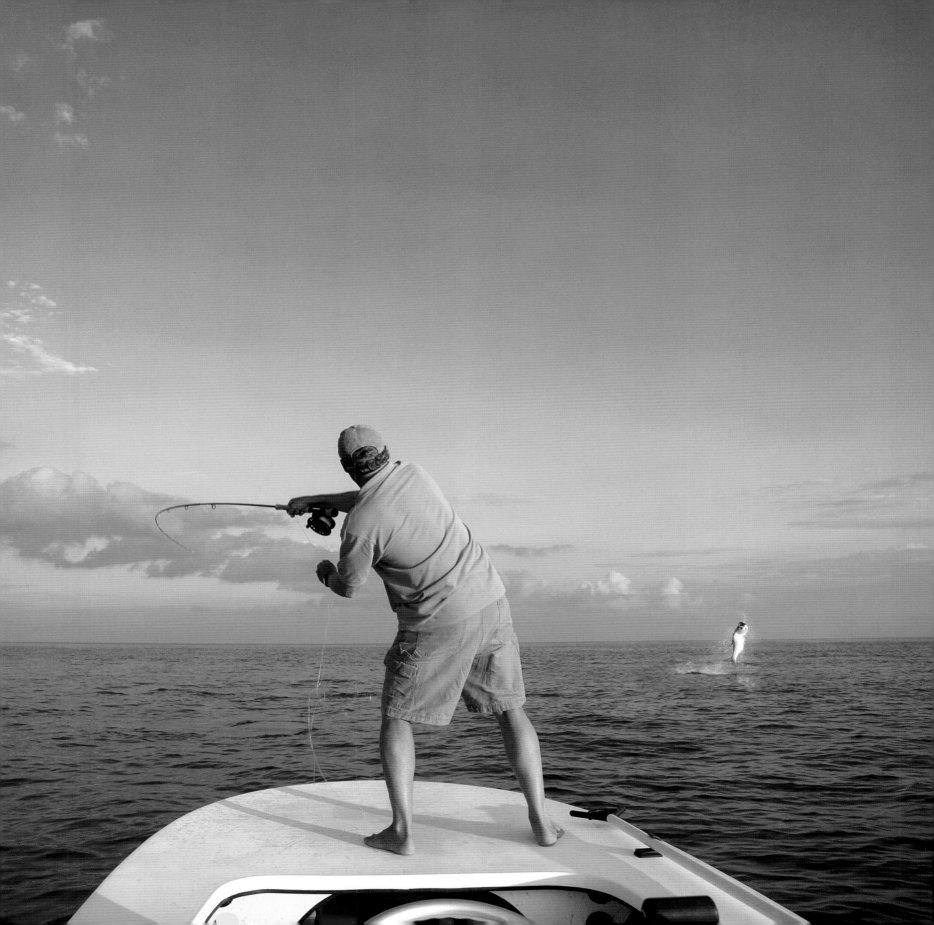

Ocean Reef Club

KEY LARGO, FLORIDA

Located in the mangrove backcountry of the Florida Keys
Founded in 1945

Early in the morning, the sun rises from the Atlantic behind a towering thunderhead on the horizon. Suddenly, in some precise alignment of water and light, distinctly brilliant rays emanate from around the cloud and light the ocean with a million diamonds—natural perfection money can't buy, grandly illuminating what money can buy. The Florida Keys are paradise to be sure, but there is an even greater paradise locked away behind the gates of one of the most exclusive enclaves in the country—Ocean Reef Club.

While it takes a great deal of wherewithal (and an invitation) to belong to Ocean Reef, one can take advantage of the fishing operation (endorsed by Orvis), which given the club's miles of flats and close proximity to the Gulf Stream, is without question epic.

Ocean Reef was founded in the 1940s, a small enclave carved out of the mangrove backcountry near Key Largo. Facing the Atlantic, it is now a generational hallmark for its families, offering a way of life that is stunningly beautiful in its simplicity and staggeringly complex in what it offers and how well it is run. This is a place where wealth is taken for granted (as is evident in every aspect of the oper-

RIGHT: *This aerial view shows the sprawling Ocean Reef Club.*

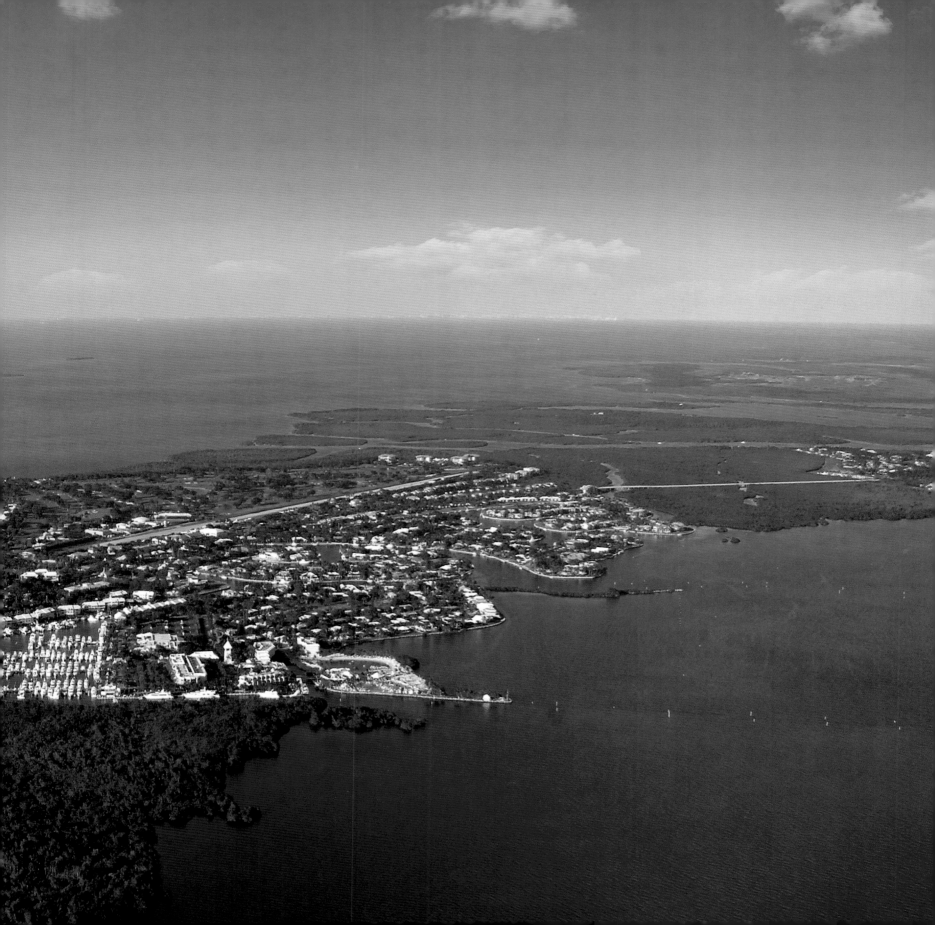

ation), but in an atmosphere so relaxed that stress seems anathema to the entire community from top to bottom. Kindness and friendliness emanate equally from members met on the street to those sweeping the walks. Utopia perhaps? Certainly as close as one can get without stepping beyond the bounds of reality. Once there, there is no reason to ever leave, for the community is complete, from the concert hall with the likes of Tony Bennett entertaining to the hospital, fire and rescue, airport, arts center, and library. Guarded by one-road-in and one-road-out on one end, and surrounded by ocean and mangrove backcountry on the other, there is a reason they call this the safest community in the country.

The harbor defines the personality of this little paradise. A gleaming alabaster city of spotless yachts and massive sportfishermen, the wealth is obvious. In the spotlessness of the boats and harbor the management and care are on display, and in the sheer volume of boats the passion of these people for their waters is clearly visible.

For the saltwater angler, this is a place of legendary angling feats by the greatest names in sportfishing history, from Joe Brooks to Ted Williams. It's hard to imagine that there could be flats fishing or backcountry fishing better than this for tarpon, permit, bonefish, and snook. The reef offers hogfish, snapper, and grouper. Offshore, which is a misnomer here as the Gulf Stream is just a few minutes away, offers sailfish, dolphin, king mackerel, and tuna. The harbor is full of experienced captains on everything from 16-foot flats boats to 50-foot sportfishing yachts. Each morning anglers of every ilk—from professionals to those who've never held a rod—board the fleet, bearing the never-ending optimism of the angler on a new day. The big boats parade out of the channel and the flats boats cruise through the village canals until quite suddenly civilization disappears and they enter the endless creeks and channels of the mangroves, headed for a paradise of seemingly endless turquoise flats.

Whether the optimism is fulfilled or not, the setting itself is worth the price of admission. While paradise is a word often overused, there are places such as Ocean Reef Club that do it justice.

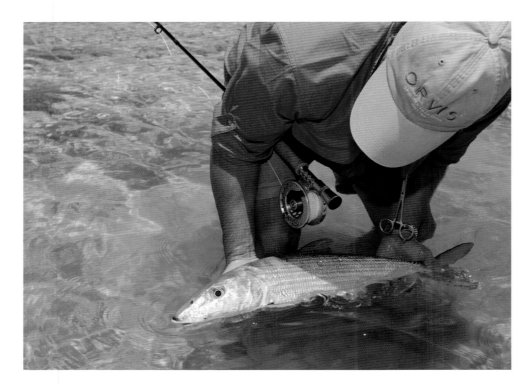

LEFT: *A bonefish heads back to the flats.*

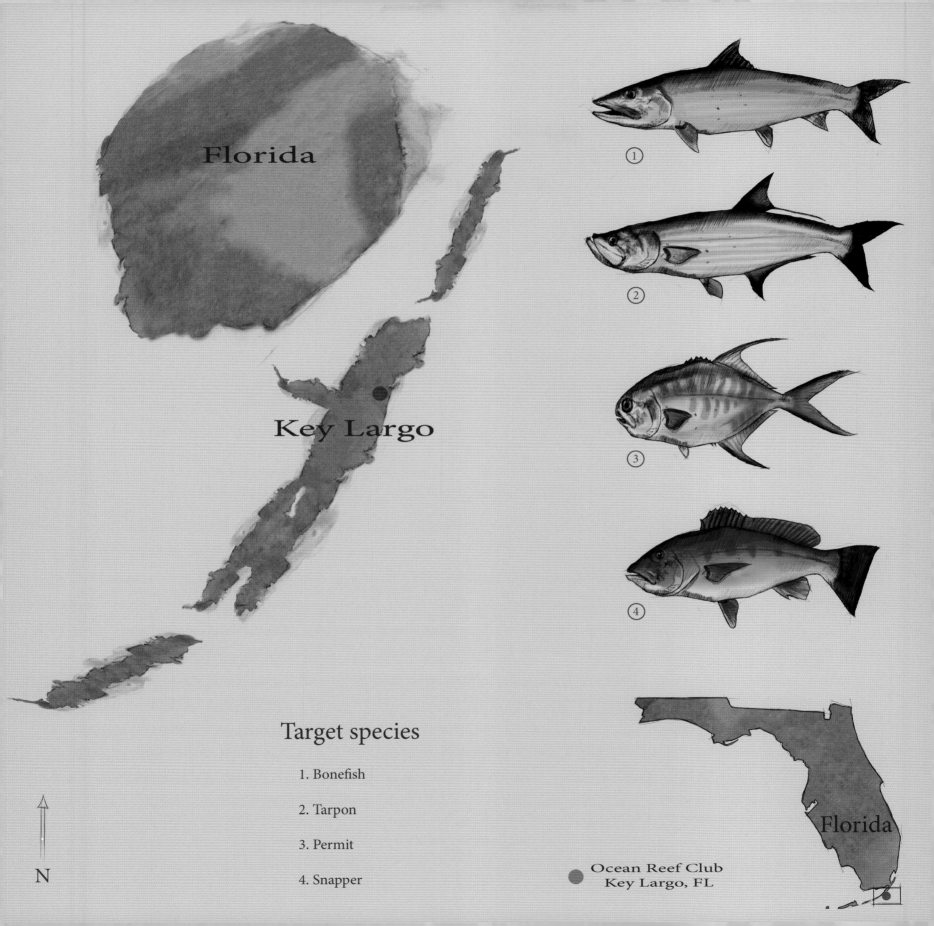

Florida

Key Largo

Target species

1. Bonefish

2. Tarpon

3. Permit

4. Snapper

Ocean Reef Club
Key Largo, FL

Florida

N

WaterColor Inn & Resort

SANTA ROSA BEACH, FLORIDA

Located on the white beaches of the Florida Panhandle
Founded in 2002

T he Gulf Coast of Florida, particularly the panhandle region, still holds on to some places that remind us of what old Florida used to be. Florida was once a place that could rival any Caribbean island for "laid back" and "don't care," attributes that are scarce in today's fast-paced world. Deep inside all of us, or those of us who still have any sense, there is a desire for some of that, a need to kick back and forget what time it is. In the Florida of old much of the state was that way; today, there are still pockets of resistance that hold on to the old ways, in particular, the Keys and the Panhandle.

WaterColor Inn and Resort lies in the Panhandle along beaches that must be the whitest in the world. In the middle of the day the whiteness of the beach is almost blinding, and by contrast turns up the greens and blues of the Gulf to stunning hues. There is still a paradise here, you just have to want to find it.

WaterColor Inn and Resort is a luxury escape for those looking for a vacation destination to unwind and indulge in a natural paradise. It is situated on 499 acres, with 1,400 linear feet of beachfront on those white sand beaches, and encompasses a coastal pine forest alongside a natural and rare coastal dune lake. Nearly 50 percent of the property is devoted to open space and preservation areas.

The accommodations are spectacular, with all the rooms looking at something beautiful to ease the tired mind, but the food

OPPOSITE: *A boat docks at the WaterColor Inn's boathouse.*

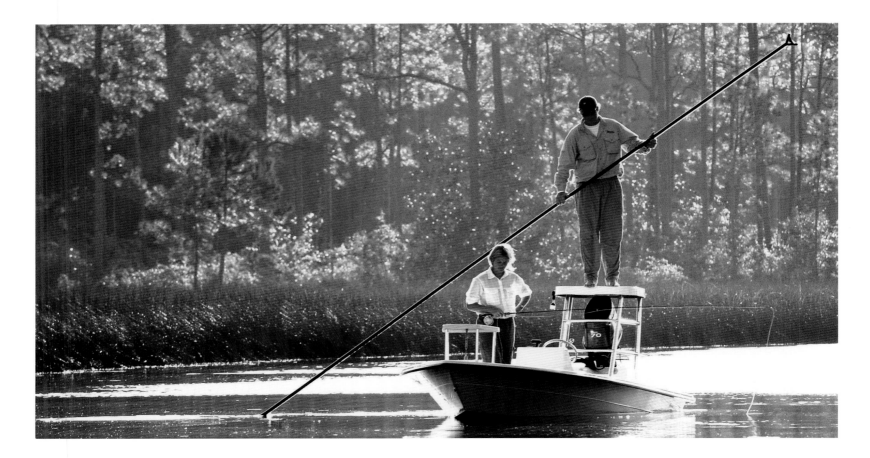

is just as big a draw. There is nothing quite like Gulf Coast cooking, and when done in AAA Four-Diamond style overlooking this particular piece of sand and water, it's hard to be disappointed.

Now for the important part: the fishing. If nothing else was available and a shack was all there was, the place would be worth the trip simply for the fishing. A number of the best saltwater game fish inhabit these waters: redfish, tarpon, and little tunny or bonito, all of which are prime targets for fly fishermen. Hooking into any one of these is an instant test of drag capability and the quality of the reel on the rod. Don't come down here with a cheap reel or you will find it smoking and in pieces fairly quickly. What's great about this

resort and the aptly named Old Florida Outfitters, which runs WaterColor Inn's fishing charters, is the broad network of guides that cover the entire north Florida Gulf Coast. From this more than comfortable base of operations, an angler has access to more water than he can fish.

There are all sorts of other activities at this resort, from golf to kayaking, activities for kids, tennis, all the usual suspects, and that's a good thing for the passionate angler with a family. This is a place that can satisfy everyone in very high style, and at the same time test the angler against some of the toughest piscatorial adversaries swimming in saltwater.

TOP: *An angler stalks redfish in the marshes on the Florida Panhandle.*

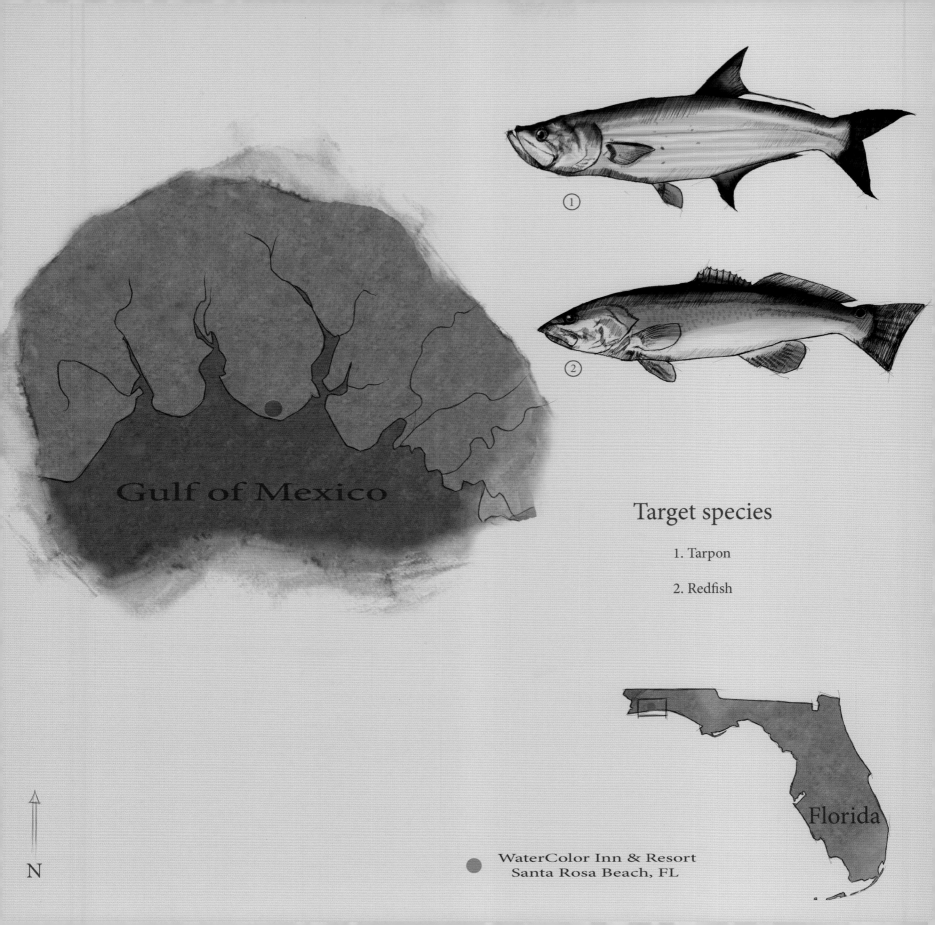

Gulf of Mexico

Target species

1. Tarpon

2. Redfish

Florida

WaterColor Inn & Resort
Santa Rosa Beach, FL

N

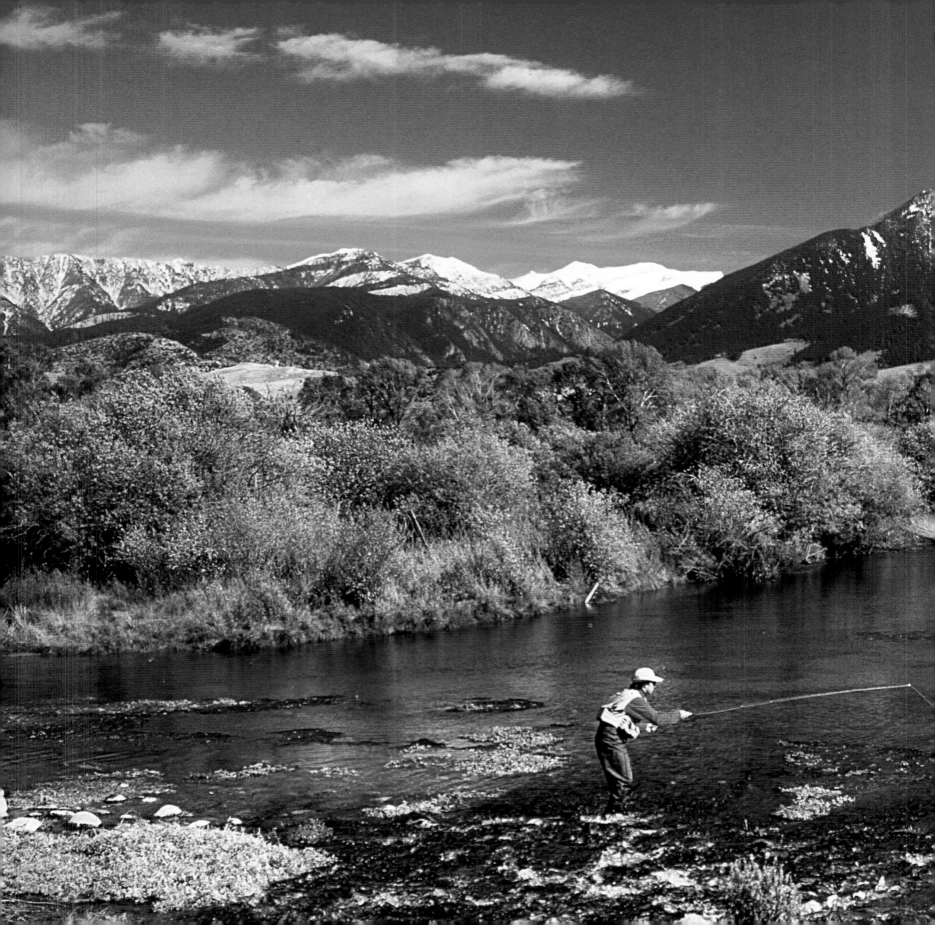

The Rockies

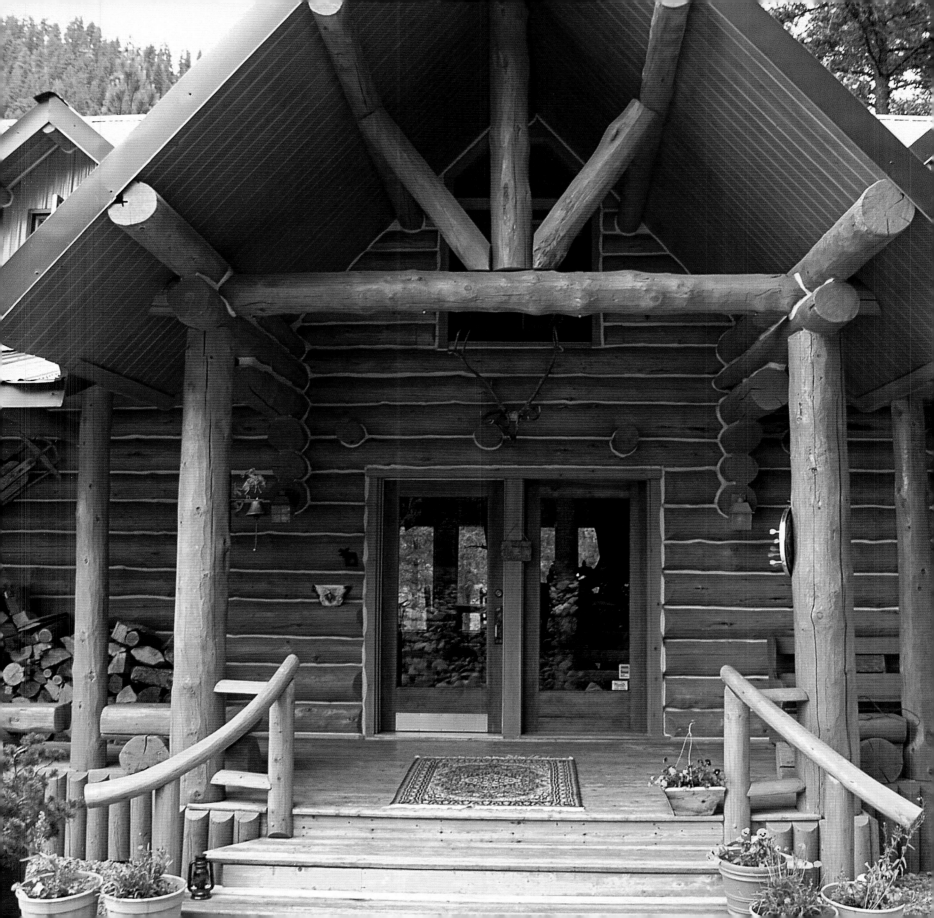

The Blue Damsel Lodge

CLINTON, MONTANA

Located on the banks of Rock Creek in western Montana
Founded in 2003

Norman Maclean wrote elegantly about this part of the world in his seminal work, *A River Runs Through It*. The fact is, many rivers run through this part of the Lolo National Forest in western Montana. The Blue Damsel Lodge is a magnificent log structure situated on the banks of Rock Creek, a beautiful blue-ribbon trout stream. Every lodge is unique in some way, but the Blue Damsel is truly extraordinary in the craftsmanship with which the original lodge was built. Not only is it a substantial and traditional lodgepole pine structure; the builder is also an artisan who quite literally built art into the structure. Beautifully carved trout swim up the banister, full wall murals of the Montana wilderness highlight the main walls, and the tile and stonework give an individual and artistic character to each room of the structure.

The lodge is set in a grove of pines just 50 yards from Rock Creek. One only has to walk out of the lodge and across the meadow, rod in hand, to experience the peace of standing in a Montana trout stream. The entire setting is carved from the wilderness so that, rather than standing apart, it fits into the surrounding ecosystem as if it were meant to be there.

Montana is arguably the epicenter of trout fishing. Perhaps there are undiscovered places that are better, but ask most trout fishermen where they would choose to go first and Montana is the name you will hear. This particular area of Montana, the west cen-

PAGES 104–105: *An angler casts into Armstrong's Spring Creek, just south of Livingston, Montana.* OPPOSITE: *The front entrance to the Blue Damsel Lodge sits on the banks of Rock Creek in Blackfoot River country.*

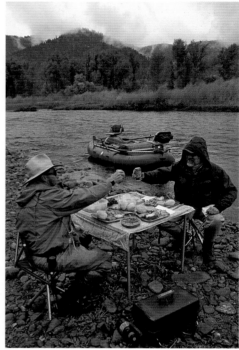

tral area that borders Idaho, offers more than two million acres of national forest land. West of the continental divide, its rivers feed into the mighty Columbia River system. The area is home to native westslope cutthroat, rainbows, browns, and brook trout with diverse types of fishing from streamer to delicate dry. There are 400 miles of floatable water within striking distance of the lodge—400 miles of pristine Montana trout water, including the other home rivers of the Blue Damsel, Maclean's legendary Big Blackfoot River, the Bitterroot, and the Clark Fork of the Columbia.

Even spectacular scenery, great fishing, and a magnificent lodge are incomplete without a proper host. Keith Radabaugh spends his life in the outdoors and formerly led anglers all over the world in search of great fishing adventures. Since the inception of the Blue

Damsel, he has guided the experience of each and every guest with a philosophy that each guest is different and each experience must therefore be tailored to that guest.

"We keep our eyes open and just kind of go by feel with each client and stay focused on their enjoyment during their stay. It's our job to try to help shape the experience, our honor to gain an understanding of the experience from the guest's perspective, and our reward is fantastic and measurable—kind words, meaningful handshakes, and forged new friendships," said Keith.

The Blue Damsel is aptly named. It is more than just a log lodge in the wilderness. There is a wild elegance to this place that, like the striking color of its namesake, offers the guest something uniquely beautiful at every turn. The fishing isn't bad either.

TOP LEFT: *The banister at the Blue Damsel Lodge is part of the built-in artwork of the unique structure.* TOP RIGHT: *The streamside lunch is one of the staple features of great fishing lodges and their guides.*

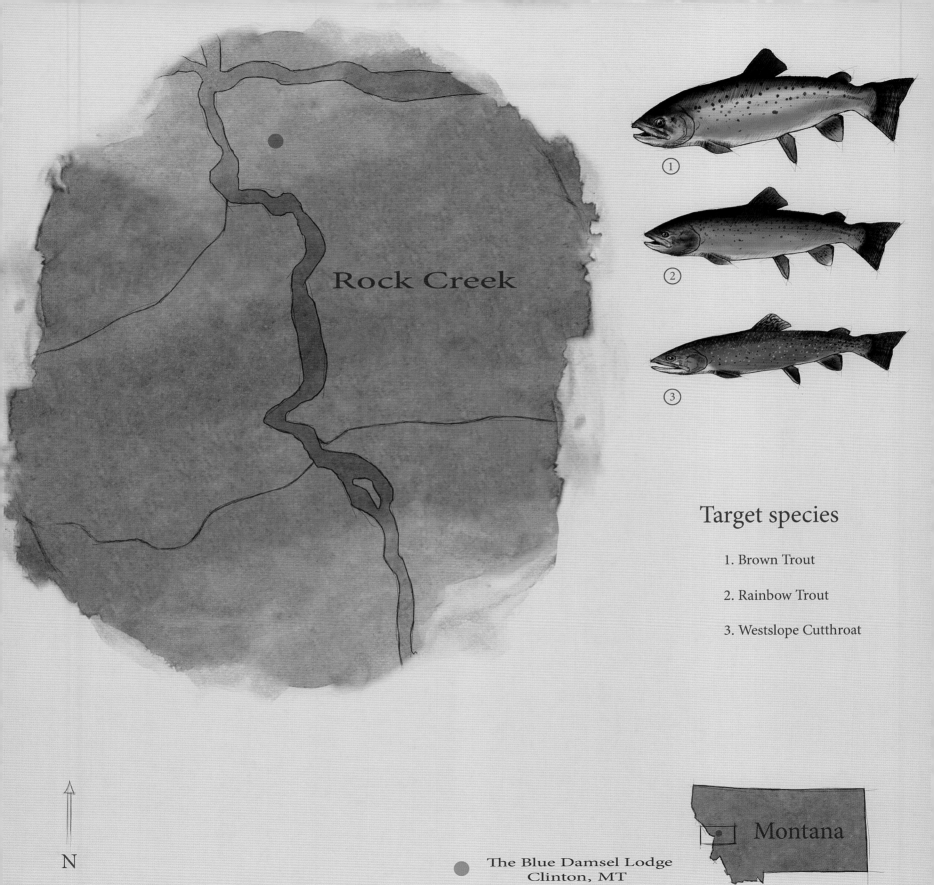

Rock Creek

① ② ③

Target species

1. Brown Trout

2. Rainbow Trout

3. Westslope Cutthroat

N

The Blue Damsel Lodge
Clinton, MT

Montana

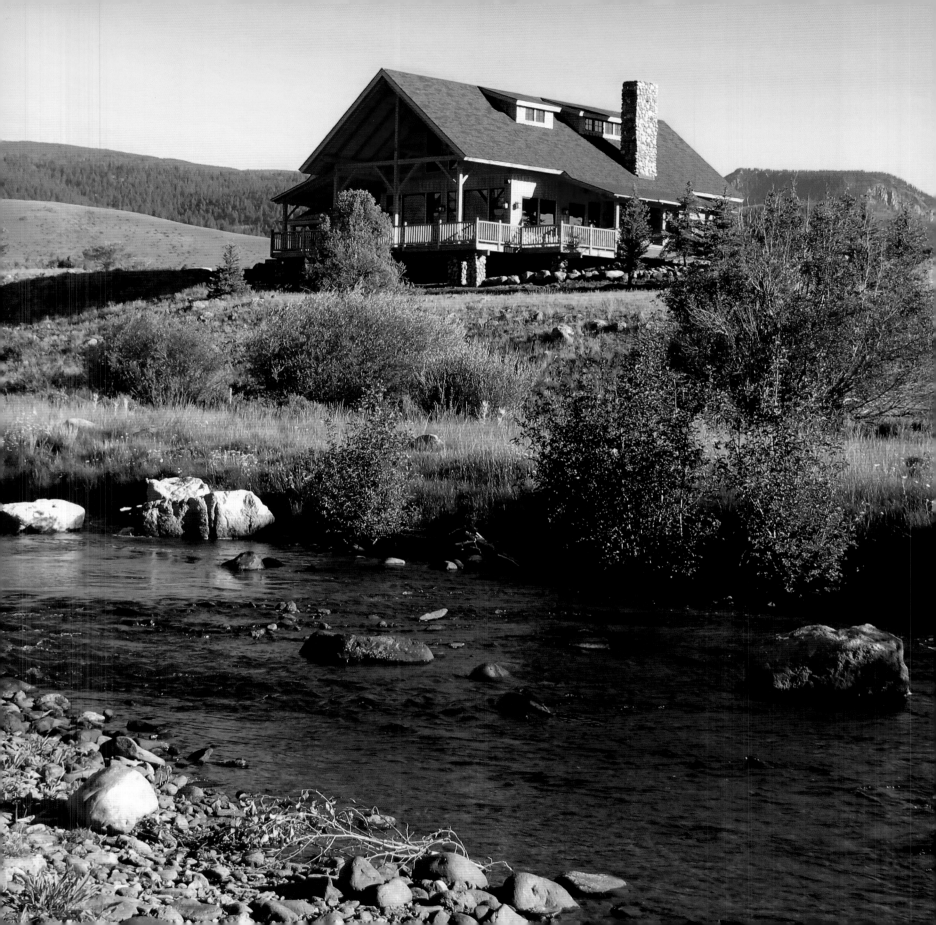

Broadacres Ranch

CREEDE, COLORADO

*Located in the middle of the San Juan National Forest
near the Rio Grande River
Founded in 1891*

While there are more than a few extraordinary fishing lodges in this country, many of them are shiny and new. There's nothing wrong with that, but there is something nicely intangible about a lodge that has history, and not just as a fishing lodge, but as a ranch or a farm that's seen its share of the American experience. While it doesn't make the fishing any better or worse, it does allow the angler, sitting on the porch after a day on the river, to reflect on his or her surroundings and the lives lived and the hardships faced in these remote places. It is just an added touch that makes the entire experience a bit more satisfying.

Broadacres Ranch is such a place. A ranch in the absolute sense of the word, it was homesteaded in 1885 by a Scottish immigrant named John Grant. Near Creede, Colorado, a former silver mining boomtown that saw the likes of Bat Masterson and Doc Holiday, the ranch lies in the southwestern part of the state and sits in the middle of the San Juan National Forest, a place of extraordinary size and grandeur. The ranch operated for years under various owners, but in 1998 it was purchased by a family who dedicated themselves to restoring the ranch and its buildings with adherence to its architectural history—while at the same time endowing it with modern features to create a world-class fishing resort.

The accommodations are for the most part restored buildings on the ranch, now named after famous flies. There is Blue Quill, Green Drake, and Royal Humpy (a restored former wrangler's cabin), to name a few. The ranch is laid out to offer its guests the most privacy possible. Recently Glenmora Lodge, overlooking the

OPPOSITE: *One of the cabins at Broadacres Ranch sits above Shallow Creek.*

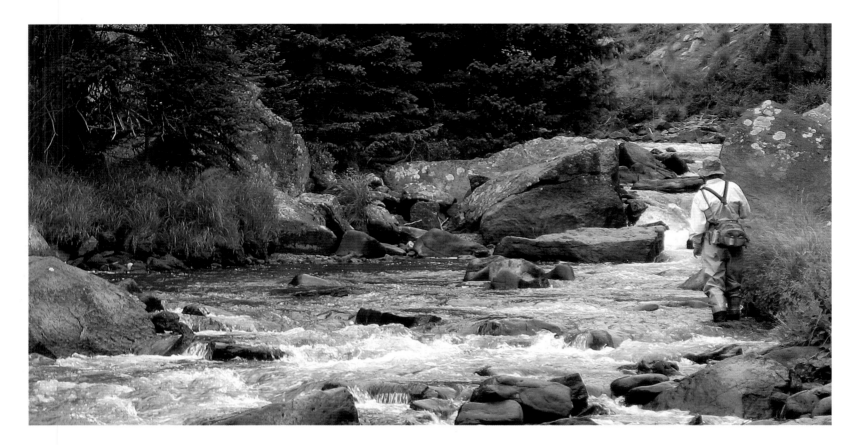

Rio Grande River, was built for the dining pleasure of the guests. (The name comes from the original name of the ranch given to it by Grant, after his home in Scotland.)

Which brings us to the fishing. Just 25 miles from the headwaters of the Rio Grande, the lodge owns 1.5 miles of river that have seen extensive habitat enhancement, providing riffles and pools full of thriving rainbows and browns. There is enough water here to keep any angler satisfied, but in addition there is Shallow Creek, a freestone tributary that offers another 1.5 miles of pocket water. Hatches on these waters are abundant, and big yellow stones are followed by mayflies and caddis, as well as other species of stoneflies and terrestrials throughout the season. For the dry-

fly angler there is nothing better than pool after pool of insect-laden water.

If stillwater is something of interest, there are 11 acres of lakes and ponds where an afternoon in a float tube is about as good as it gets. And then there is the backcountry: an angler can fish more than 50 miles of backcountry tributaries or take a float trip down the upper part of the Rio Grande. Given the amount of water, the variety of fishing, and the spectacular country where it all resides, it is not surprising that Broadacres has gained a stellar reputation. Add to that a little history and reflection on those who came before, built this ranch, and carved out this wilderness and you have a fishing lodge that offers a bit extra in the experience.

ABOVE: *An angler works up a backcountry tributary of the Upper Rio Grande.* OPPOSITE, BOTTOM LEFT: *Pocket water in rivers such as this can offer big trout behind every rock and must be thoroughly explored.* OPPOSITE, BOTTOM RIGHT: *Shallow Creek offers riffle water in abundance.*

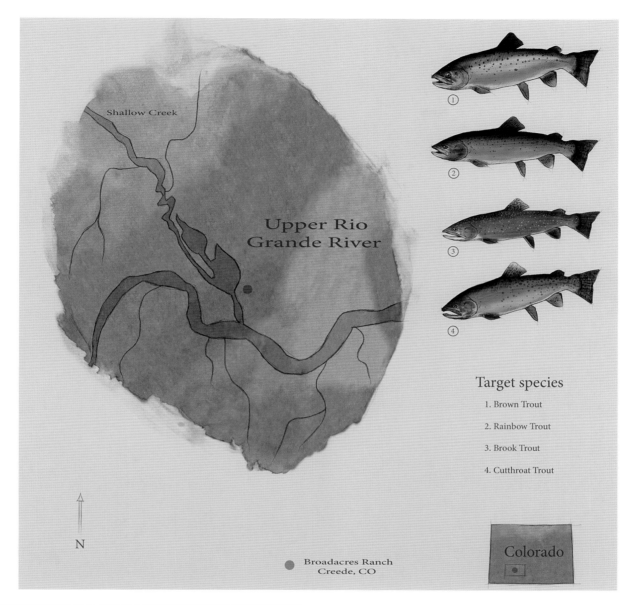

Shallow Creek

Upper Rio
Grande River

N

Broadacres Ranch
Creede, CO

Colorado

Target species

1. Brown Trout

2. Rainbow Trout

3. Brook Trout

4. Cutthroat Trout

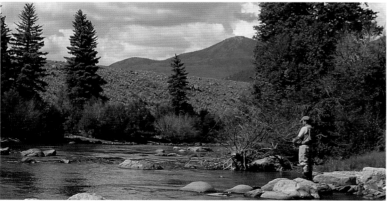

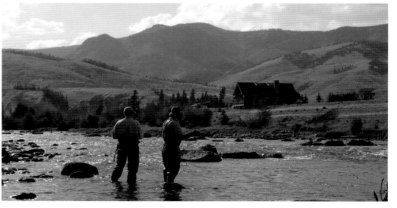

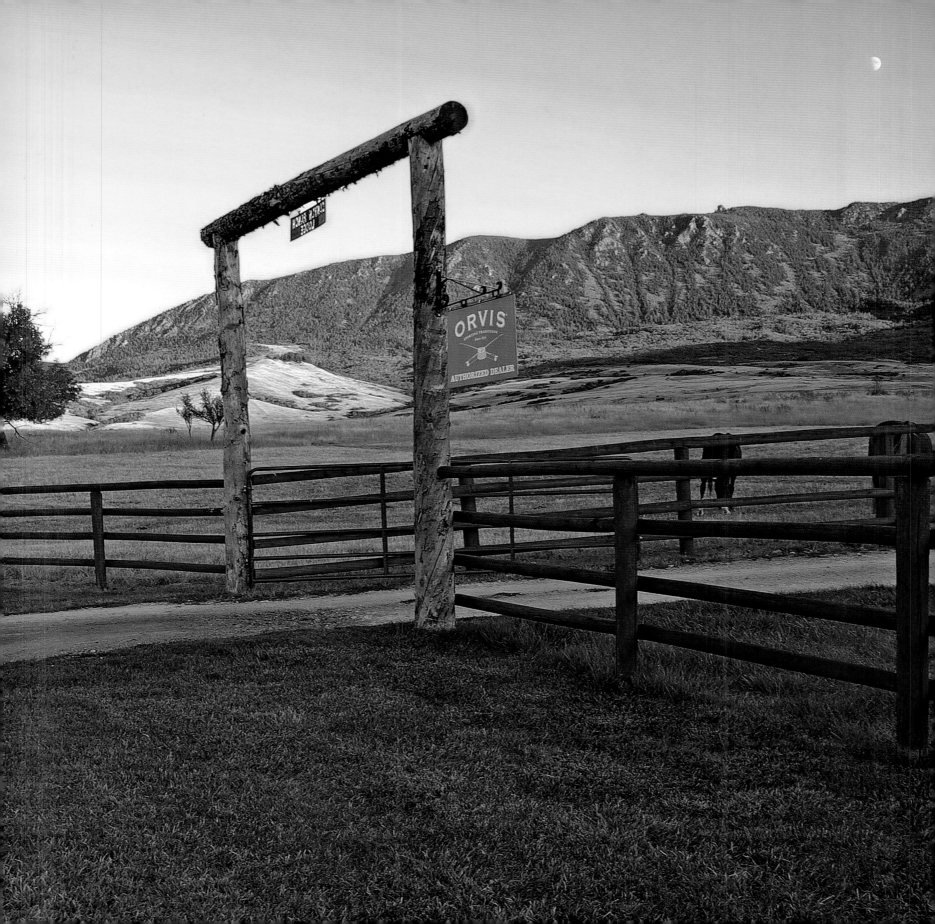

Canyon Ranch

BIG HORN, WYOMING

Located on 3,000 acres near the Big Horn River
Founded in 1889

I f the guest list is indicative of the experience, then Canyon Ranch can honestly put itself at the top of anybody's list. Queen Elizabeth and Prince Phillip, French President Valery Giscard d'Estaing, and a who's who of American corporate and political leaders have graced the grounds of this great ranch, not only because of its spectacular Wyoming beauty, but also because of the family that's owned it for four generations.

In 1888, a young Englishman named Oliver Wallop came to Wyoming and eventually established Canyon Ranch to breed horses. His reputation grew. Along with his brother-in-law he raised horses for the British Army during the Boer War. Wallop's ranch became well-known and attracted luminaries such as Teddy Roosevelt, Buffalo Bill Cody, and many others who came to enjoy

the ranch, the shooting, and the quality of the horses. Interestingly, Oliver eventually became the eighth Earl of Portsmouth, but he remained at the ranch until his death in 1942. His son continued to manage the ranch and the list of visitors grew. Wallop's grandson Malcolm served 18 years in the U.S. Senate. Now the fourth generation—Paul and his wife Sandra—continue the traditions on one of the most storied and magnificent ranches the American West has to offer.

Situated on 3,000 acres, the lodge features all the amenities that one could want. Perhaps most appealing is the unobstructed view of the Big Horn Range, but if you are looking for something that goes beyond special, there is Johnny's Cabin, a remote cabin located above the lodge with a 100-mile view. There is no electricity, but

OPPOSITE: *The entrance to Canyon Ranch frames a spectacular view of the Big Horn Mountains.*

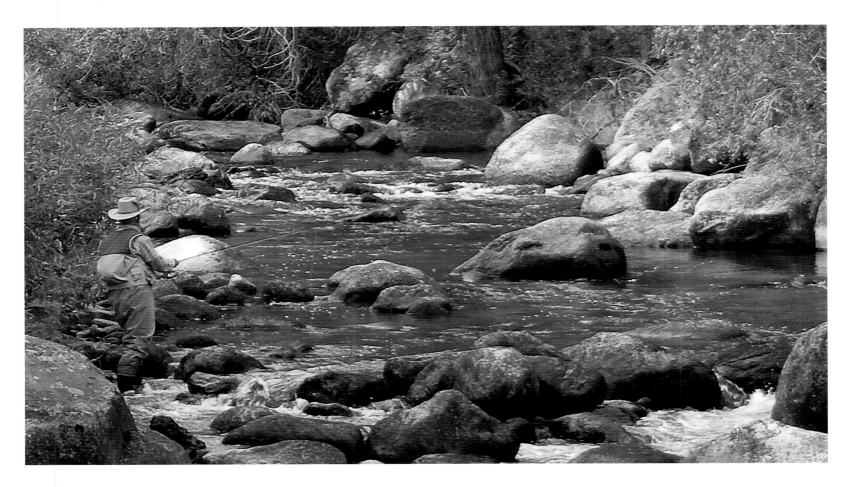

gas provides all that is needed. If you've ever experienced the charm of a gaslit cabin in the wilderness, you will understand completely. It is the ultimate retreat for one who wants to get away, and you will see no one unless you want to.

As for the fishing, there is the Big Horn, which is legendary. But it is the unknown waters near the ranch that offer the kind of fishing that Paul loves most, the alpine streams and lakes, the ranch ponds, the lesser known waters that in his opinion offer the greatest reward.

"I prefer to fish for wild fish in wild places. I have fond memories of large trout I have caught in well-known waters of the West, but the experiences I relish and stories I tell most often come from days catching fish in remote waters where beautiful surroundings and the day's adventures make the trip memorable. This is not to say that I dislike catching big fish. Rather, I enjoy the thrill of catching any fish that is a 'trophy' in relative terms, to the waters of the day. I am always excited by the chance that the one fish, which has beaten the average and outgrown the general population, will rise from the depths of a picturesque 'hole' and take my fly," said Paul.

Canyon Ranch has seen kings and potentates, but the beauty of it is that the same experience that enthralled those anglers is available to anyone, and the fourth generation of Wallops will ensure that the experience is no different. What more can one ask?

ABOVE: *An angler fishes pocket water on Big Goose Creek.*

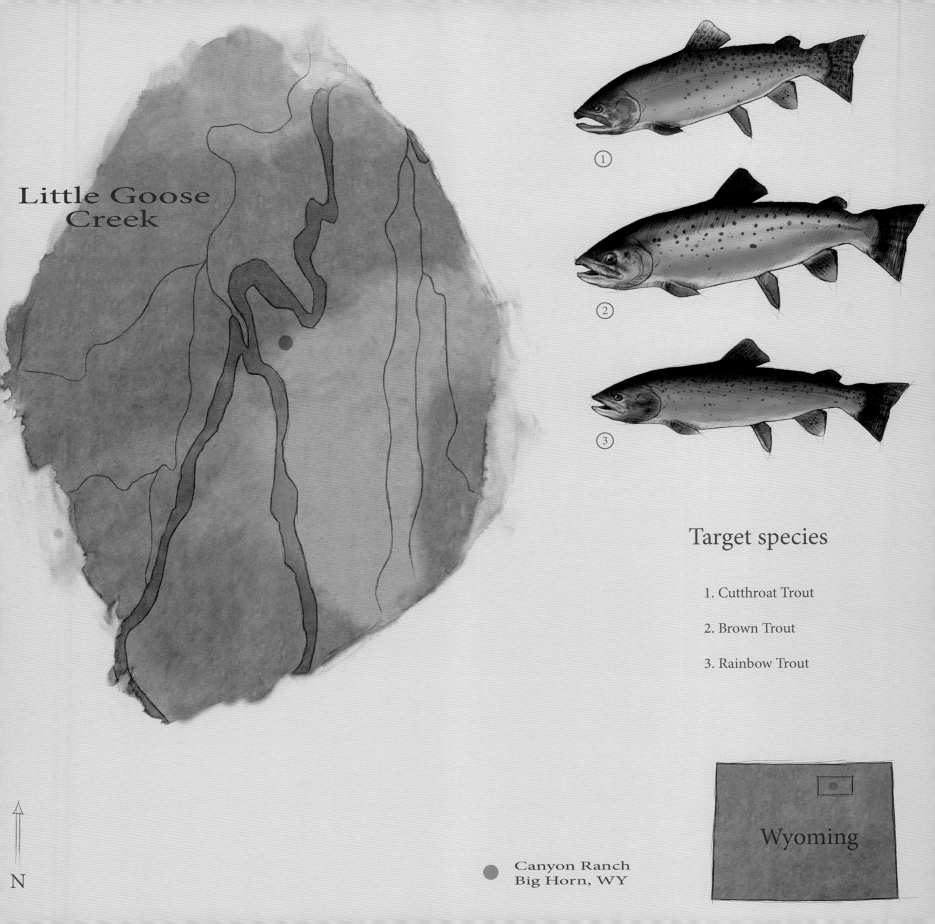

Little Goose Creek

Target species

1. Cutthroat Trout

2. Brown Trout

3. Rainbow Trout

Wyoming

Canyon Ranch
Big Horn, WY

N

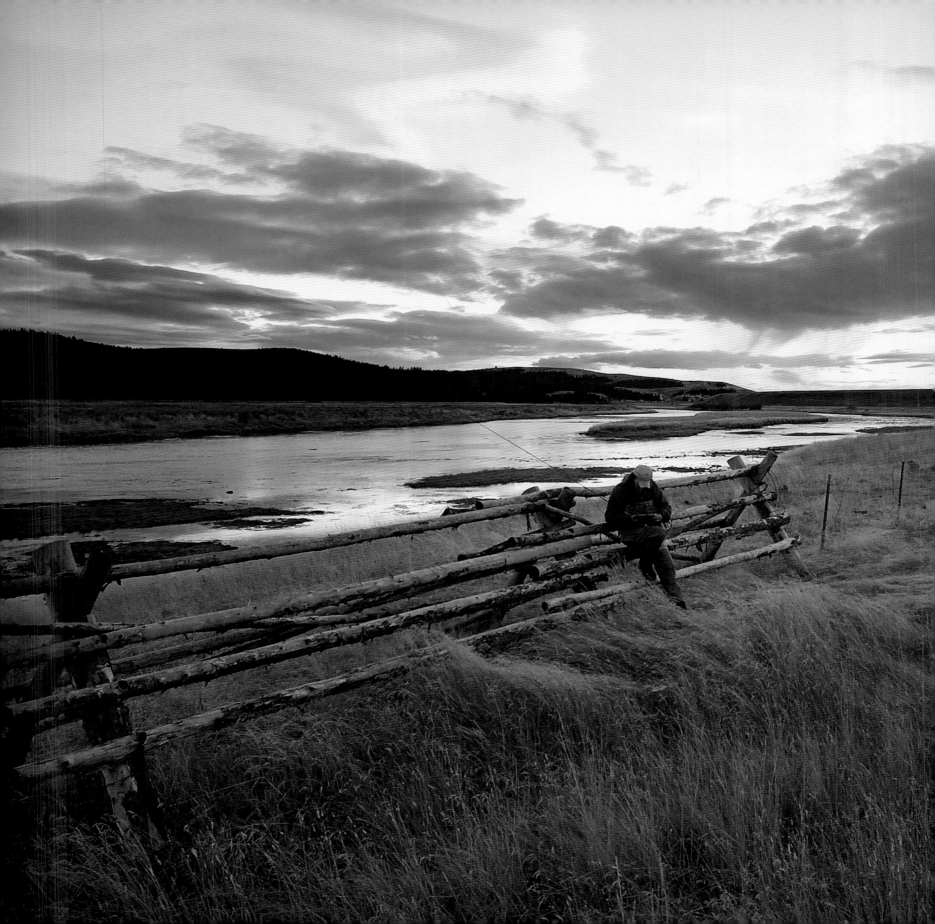

Craig Fellin Outfitters & Big Hole Lodge

WISE RIVER, MONTANA

Located in a remote valley near the Wise River
Founded in 1984

Most of us picture Montana as a place of vast distance, endless sky, distant mountain ranges, and wide, sweeping valleys cut with rivers. If there is a section of Montana that lives up to this vision, it is the Big Hole River Valley tucked next to the saddle of Idaho in the southwestern part of the state. What makes this valley even more enticing is that it's relatively undiscovered. Even though the Big Hole drainage encompasses 2,800 square miles, the population is only around 2,500 people. An agricultural valley often known as the valley of 10,000 haystacks, this region raises the most hay in Montana. The Big Hole River flows north from its origins in the Bitterroot Range, moving slowly through the rich bottomland with its isolated ranches and farms, then occa-

sionally plunging through canyons until it joins with the Jefferson after a circumnavigation of the lowlands around the Pioneer Mountains.

These are the home waters of Craig Fellin Outfitters and Big Hole Lodge. That this is a serious angler's destination is apparent for a number of reasons. While the lodge is beautiful, built of river rock and lodgepole pine, it is not ostentatious; the buildings fit its riverside location, tucked back against a cliff on the Wise River, just up from where it flows into the Big Hole. It's not big, handling at most 12 anglers who stay in well-appointed cabins looking out over the river and just steps from the home pool on the Wise. But it is the quality of the fishing and perhaps even more important, the quality of the guides, that bring fishermen back year after year.

OPPOSITE: *The sun sets over the Big Hole River.*

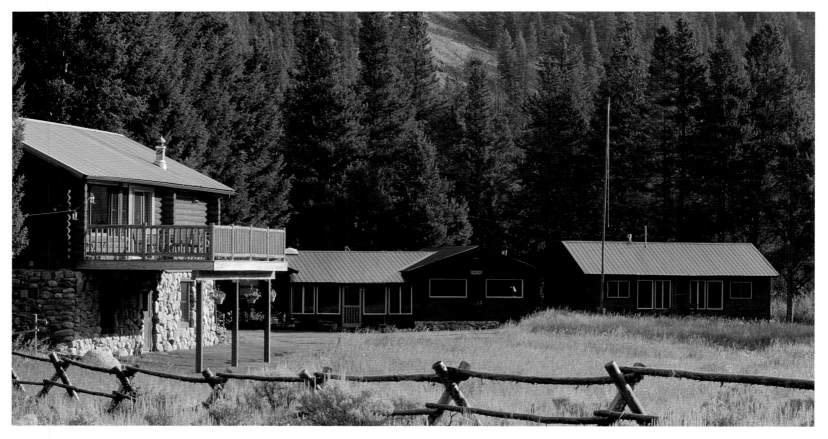

The guides total more than 100 years of guiding experience. They fish all over the world, but each year they return to the Big Hole to work, which says a great deal about the operation. These are experienced, patient guides who have the ability to show seasoned anglers the best the region has to offer and the patience to build confidence and create success for the novice.

The Big Hole is a dry-fly fisherman's river. Flowing through the wide and fertile valley, it is a classic pool and riffle river with multiple hatches and great numbers of brown, brook, cutthroat, and rainbow trout. In the upper stretches it's the last bastion of the fluvial Arctic grayling in the lower 48 states. There is more water here than can be fished in a single trip, from the Big Hole to the Beaverhead, tributaries, and private spring creeks that hold big trophies.

If there is a hallmark to Big Hole Lodge, it is continuity in the operation from year to year—from the guides to the chef, who has been with the lodge for more than 10 years. The loyalty of the staff is infectious and breeds the same loyalty in the clients, who return year after year, knowing they are going to experience pure, unfettered trout fishing, in an unspoiled region of the West, with the help of a staff that loves what they do. There is a subtle beauty in the straight-forward approach to fishing that resides here. While every necessary amenity is provided, the lodge reflects the remote valley where it sits: simple, quiet, and dedicated to the pursuit of great fishing.

ABOVE: *The lodge and cabins of Big Hole Lodge sit on the Wise River near its junction with the Big Hole River.*

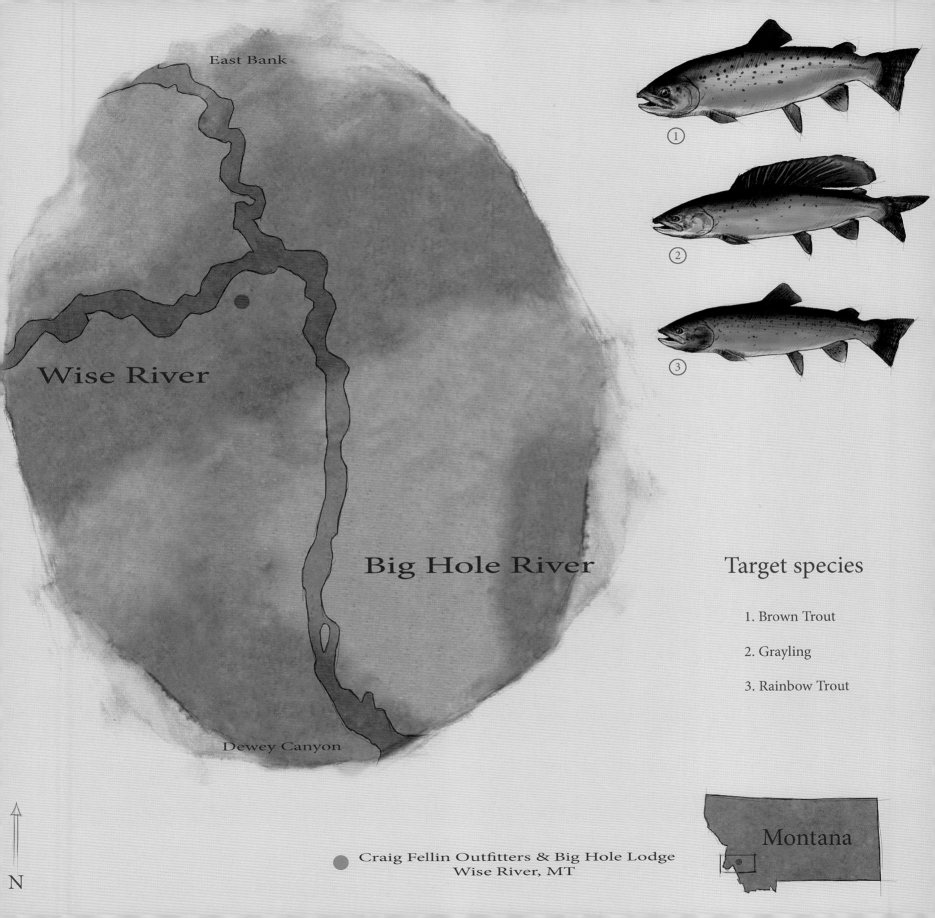

East Bank

Wise River

Big Hole River

Dewey Canyon

Target species

1. Brown Trout

2. Grayling

3. Rainbow Trout

Montana

Craig Fellin Outfitters & Big Hole Lodge
Wise River, MT

N

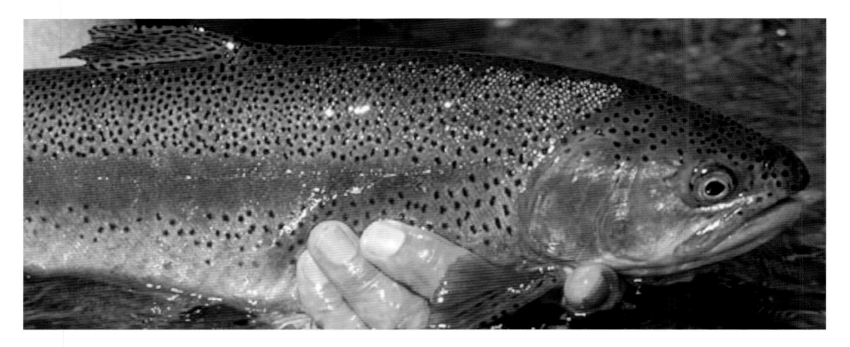

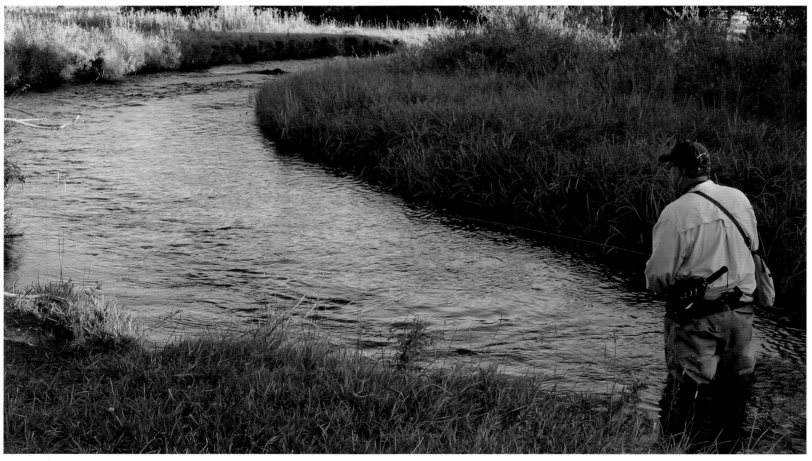

OPPOSITE, TOP: *Rainbows grow big on the Big Hole River due to the fertile river valley and the prolific hatches that offer the fish sustenance and the angler great fishing.* OPPOSITE, BOTTOM: *An angler works the seam on Horse Prairie Creek.* ABOVE: *The scenery surrounding the Big Hole River is ablaze in fall colors.*

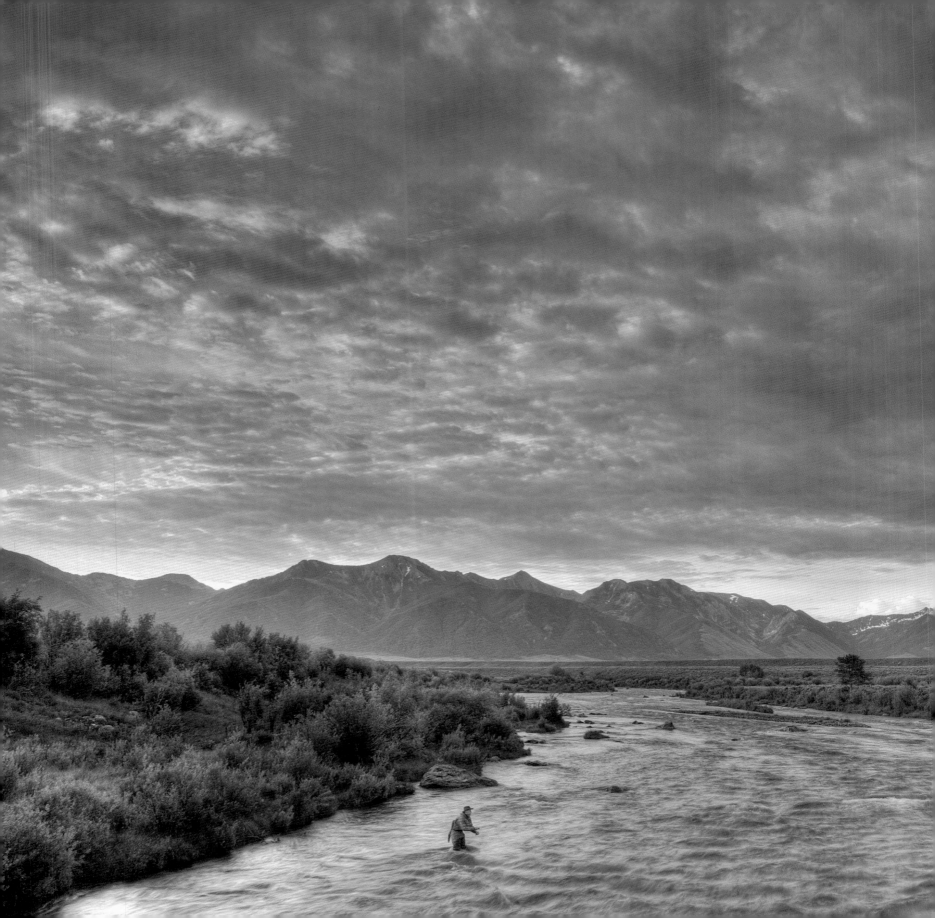

Firehole Ranch

WEST YELLOWSTONE, MONTANA

*Located on the shores of Hebgen Lake
Founded in 1947*

There are more than a few fishing lodges in this world that offer great fishing. Others focus on pampering guests, and the fishing is perhaps an afterthought. But a few iconic lodges manage to do both exceptionally well. Firehole Ranch resides at the pinnacle of this list. Not only is its trout fishing possibly the best there is, but its attention to detail in regard to its guests is as legendary as the original property, the Watkins Creek Ranch.

Located on the shores of Hebgen Lake, Firehole Ranch lies squarely in the middle of America's trout cathedral. Tucked in the southwest peninsula of Montana where it wraps around Wyoming's northwest corner and pushes down into Idaho's cradle, the ranch sits just outside the western gate of Yellowstone National Park on the outskirts of West Yellowstone, Montana. Within its reach are legendary rivers and streams that are the stage on which volumes of fly-fishing lore and literature are written—the Henry's Fork, the Yellowstone, the Gallatin, the Madison, the Firehole, the Gibbon, and the wonderfully remote rivers of the

LEFT: *The Madison River Valley.*

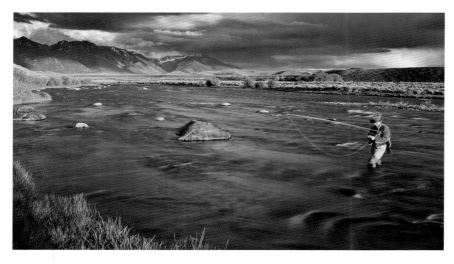
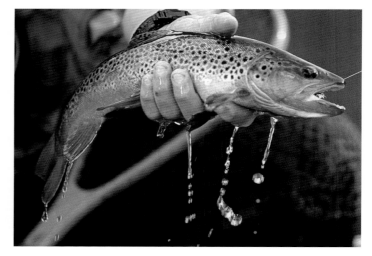

eastern park, the Lamar, Soda Butte Creek, and Slough Creek. The Lamar River Valley alone is one of the most magnificent valleys in the West and home to the Yellowstone wolves and great herds of bison. This list is the Mount Rushmore of trout rivers and Firehole Ranch sits at the base, offering its guests the most spectacular fly-fishing venue one could desire.

Though operated as a guest ranch since 1947, there was a danger that the 440-acre property would be sold off in small parcels until Lyndy Caine, a neighbor, bought the ranch in 1999 and ensured that it would remain a historic fishing lodge.

"This is an important calving area for the elk as it's the only low bank waterfront in the area. The sage meadow is perfect for the survival of young calves and offers protection from the bears as well," said Lyndy. "I'm third generation here and I bought it to save it for the elk, but also because it's an important historical area."

Listed on the National Registry of Historic Places, Firehole is also designated as one of the top 10 fly-fishing lodges in *The World's Great Luxury Fishing Resorts*. Consisting of the historic old log lodge and surrounding private guest cabins and old outbuildings, the ranch sits among the lodgepole pines overlooking the sage

meadow stretching down to the shores of Hebgen. Open only 15 weeks of the year, during the prime fishing season, the ranch caters to 20 guests per week, offering detail-oriented service that is legendary among lodge regulars. The ranch employs an experienced, professional staff of guides who are passionate about fly fishing in the Yellowstone area. The annual return rate of guests is extremely high. One of the reasons is the extraordinary cuisine of chefs Bruno and Kris Georgeton, who have maintained the ranch's culinary reputation for an astounding 20 years, given the tendency of chefs to move from one venue to another. This longstanding reputation with the guests and their trusted freedom of expression in what they create is the centerpiece of a remarkably focused attention to the guests' experience.

There are great fishing lodges out there, but very few have been doing this as long as Firehole, and doing it with the consistency of excellence that is the hallmark of its reputation. Lyndy Caine has taken one of the best, preserved it and the land around it, and ensured that it will remain one of the great fly-fishing lodges. For the trout angler with great expectations, Firehole Ranch is a destination that exceeds expectation.

TOP LEFT: *The Madison River is often called the "50-mile riffle" and is fishable for its entire length.* TOP RIGHT: *Madison brown trout, beautifully colored fish, offer anglers a great fight.* OPPOSITE, TOP: *Firehole Ranch faces the sage meadow on the shores of Hebgen Lake.*

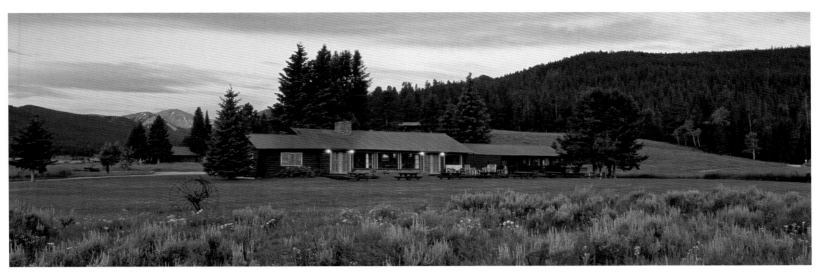

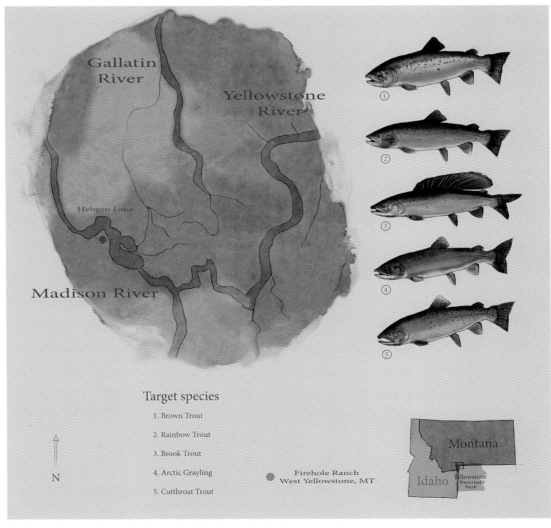

Gallatin River

Yellowstone River

Hebgen Lake

Madison River

Target species

1. Brown Trout

2. Rainbow Trout

3. Brook Trout

4. Arctic Grayling

5. Cutthroat Trout

Firehole Ranch
West Yellowstone, MT

N

Montana

Idaho

Yellowstone National Park

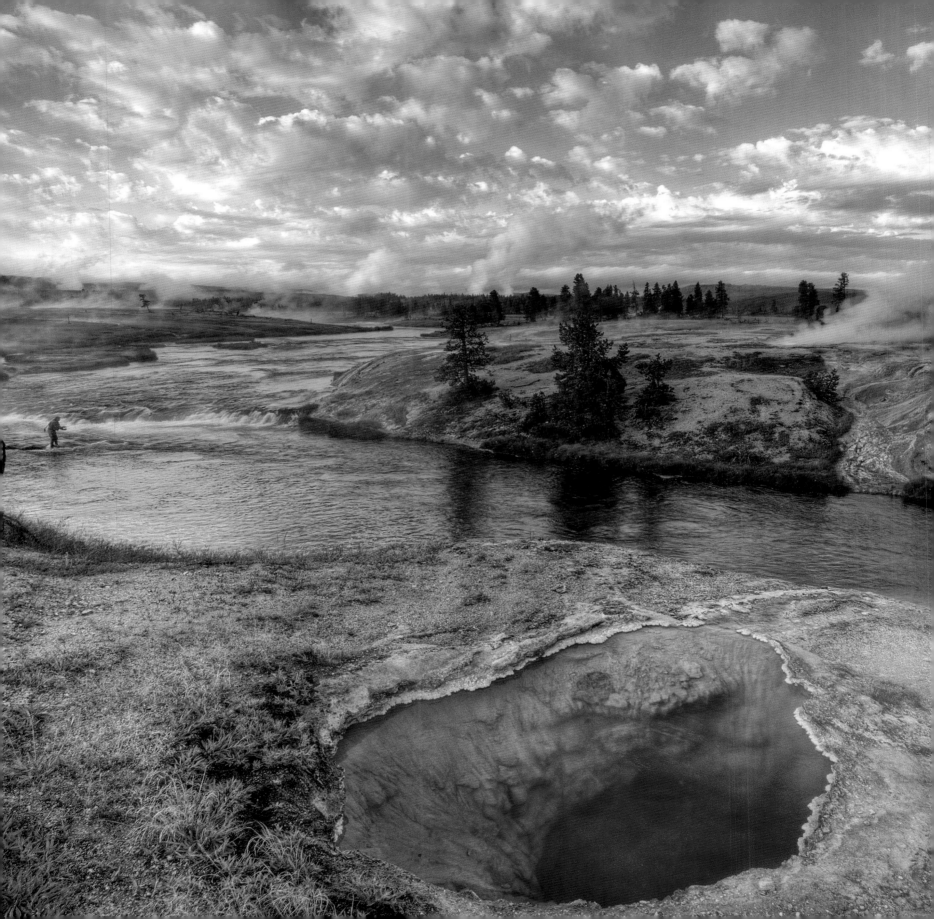

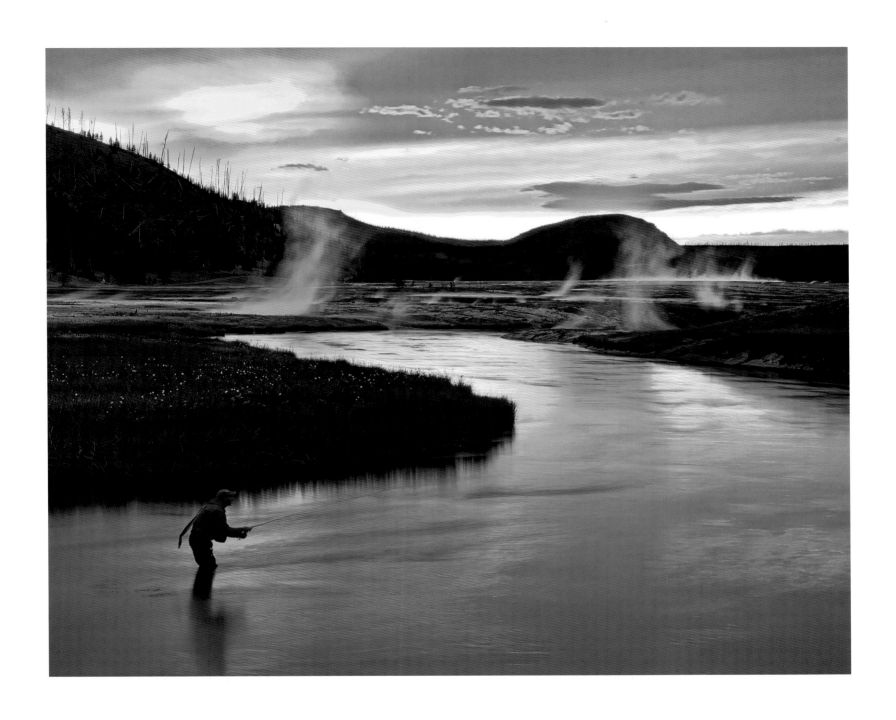

OPPOSITE: *Steam rises from the hot springs that surround the Firehole River in Yellowstone National Park.*
ABOVE: *As geysers shoot off in the background, an angler stalks the Firehole River at sunset.*

The Home Ranch

CLARK, COLORADO

Located in the Elk River Valley near Steamboat Springs
Founded in 1980

For those anglers with families or an inordinate love of good horses and the western lifestyle that surrounds them, the Home Ranch may very well be the answer to their dreams. Located in the northwest corner of Colorado in the Elk River Valley, the Home Ranch lies near Steamboat Springs on 4,000 acres of wilderness bordering the Routt National Forest in one of the last great alpine ranching valleys left in the country. The location is a picture book setting of western agricultural land, surrounded by high mountains and cut with tumbling freestone rivers.

Founded 30 years ago, the Home Ranch has developed a stellar reputation among western ranch enthusiasts for the quality of the lodging, the food, and most importantly, the experience. The main focus here is the riding and the relationship between the horse and the rider. The Home Ranch is about horses and people. It is dedicated to seeing that you have a wonderful time with—and on—your horse. The ranch has spent 25 years assembling a superb herd and it raises its own horses (as well as buying a select few to meet specific needs in its program). The ranch's riding program is suitable for everyone—employees are eager to share their love of horses with guests at every riding level from beginner to advanced. First-time riders, world-champion cowboys, Olympic medalists, and everyone in between have ridden trails at the Home Ranch. The wranglers and instructors specialize in helping beginners and

OPPOSITE: *The main entrance to the Home Ranch and its 4,000 acres near Steamboat Springs, Colorado, invites both anglers and their families to stay a while.*

advanced riders appreciate the qualities of their horses and enjoy challenging classes and cattle-working activities.

For the angler, the Home Ranch presents a great opportunity, for while most of the guests are out riding, there is some great western fishing right out the door and he or she might be the only angler around. The Home Ranch has almost three miles of the Elk River flowing through the property as well as a private pond sitting behind the lodge that is stocked with rainbow trout.

The Elk River is a classic rocky mountain freestone river that supports abundant populations of wild rainbow, brown, brook, and cutthroat trout. While the average trout is 10 to 16 inches in length, several rainbows are caught each year that reach 20 inches. Note that during spring runoff the river is almost unfish-

able. Depending on snowfall amounts, it usually begins to drop around the first of July and continues its descent throughout the rest of the summer. The best nymph fishing is usually in mid-July as the river begins to warm and descend: some of the largest trout are caught this time of year. The best dry-fly fishing is usually in August and September. The fall is a great time of year to hunt for trophy rainbows and browns with large streamer patterns.

Given the spectacular location, the quality of the lodging, and the fact that the Home Ranch is a Relais and Châteaux property and has been since 1987, you have the makings of a pretty spectacular place to spend a week or so. Imagine the amount of river you can cover from the back of a horse.

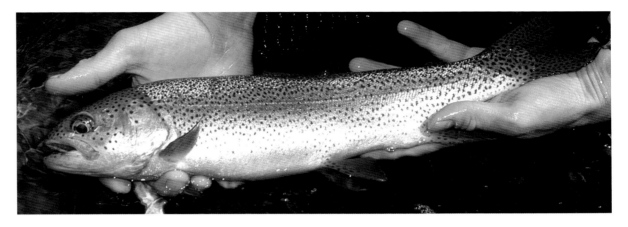

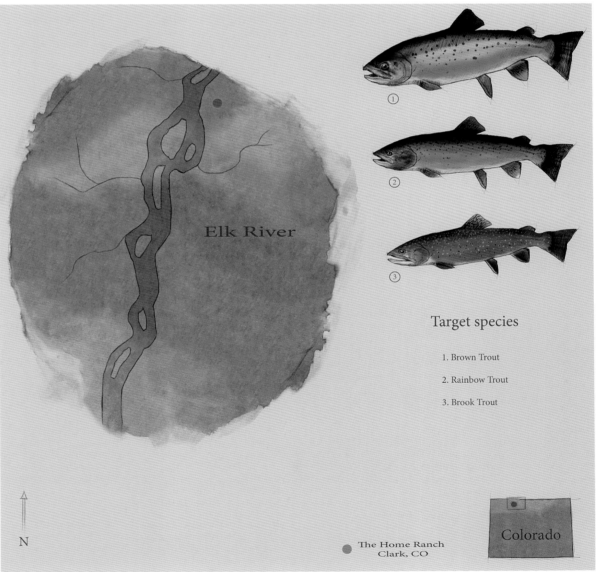

Elk River

Target species

1. Brown Trout

2. Rainbow Trout

3. Brook Trout

N

The Home Ranch
Clark, CO

Colorado

OPPOSITE: *The Elk River offers up another good fish.* TOP: *August is the prime time for dry-fly fishing for Elk River rainbows.*

Hubbard's Yellowstone Lodge

EMIGRANT, MONTANA

Located in a small valley near the Yellowstone River
Founded in 1976

If you could pick a place to put a fly-fishing lodge, there's probably not a better spot than where Hubbard's Yellowstone Lodge is located. Sitting just outside the northwestern corner of Yellowstone National Park, Hubbard's is located in a small, elevated valley traversed by Tom Miner Creek, which flows into the Yellowstone at the bottom of the valley. The lodge is surrounded on three sides by mountains and looks out over the Paradise Valley where the Yellowstone flows north toward Livingston, bordered on one side by the Absarokee Mountains and on the other by the Gallatin Range.

It is owned by "Big Jim" Hubbard, one of the deans of lodge owners in the American West. He came out as a young man to build a cattle business and over the years expanded his interests to include a first-rate fishing and hunting lodge that has been endorsed by Orvis for nearly two decades, has been named the Orvis-Endorsed Lodge of the Year twice, and maintains a reputation as consistently one of the best-run lodges in the West.

RIGHT: *Merrell Lake is the centerpiece of Hubbard's Yellowstone Lodge.*

Hubbard's Lodge sits facing Merrell Lake, a 90-acre impoundment full of trout for the pure pleasure of the lodge guests. Even after a day of hard fishing, guests can take a boat on the lake and leisurely cast to some pretty big trout. The main lodge itself is a massive log structure facing the lake. There are three other buildings, each with its own unique view of the ranch, the mountains, and the Yellowstone River flowing beneath them.

Fishing at Hubbard's is as good as it gets. In the park itself, anglers are treated to some of the best known trout waters on the Firehole, Gibbon, and Madison rivers; the magnificent Lamar and its beautiful surrounding valley, famous for the populations of Yellowstone wolves and home to some of the best late summer and fall hopper fishing available; Slough Creek and Soda Butte Creek, where big cutthroats are always willing to oblige anglers; and, of course, the mighty Yellowstone. Just up the valley toward Livingston are some of the best pure spring creeks and some of the most technically challenging trout fishing you can enjoy.

DePuy's, Armstrong's, Nelson's, Benhardt's, and Thompson's spring creeks are the ultimate in fly fishing. They are private fisheries that provide the optimum conditions for fly fishing for trout. The habitat supports huge numbers of fish, hatches are consistent, and the water is crystal clear.

While fishing is the focus there are other things here as well, including the chance to chase a few cows around on horseback or run the rapids of the Yellowstone in rafts. Hubbard's is a working cattle ranch as well as a fishing lodge, and for those who feel the urge to explore their inner cowpoke, there is always a horse to be had and a cow to be moved.

This is an American western fishing lodge, run by a family devoted to making it the best experience possible. It is considered one of the best and to prove it, Hubbard's actually teaches guides to be guides for other operations in its schools. Can there be a better place to find a good guide and a great place to fish? Probably not.

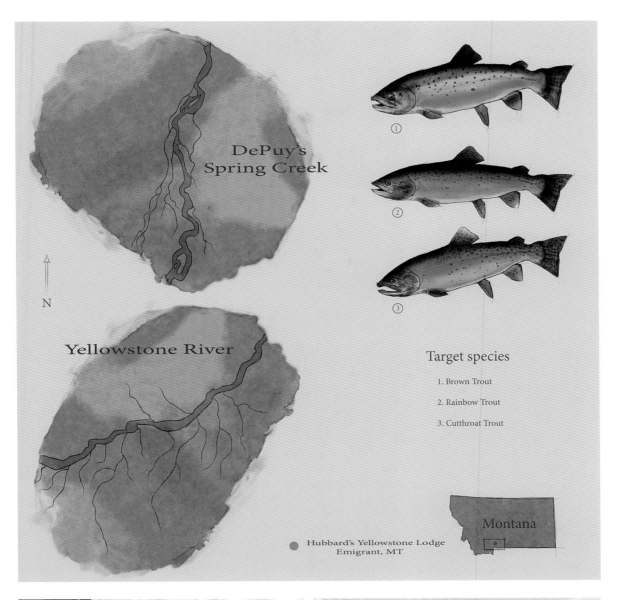

DePuy's
Spring Creek

Yellowstone River

N

Target species

1. Brown Trout

2. Rainbow Trout

3. Cutthroat Trout

Montana

● Hubbard's Yellowstone Lodge
Emigrant, MT

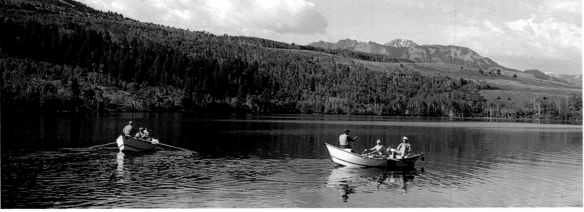

OPPOSITE: *Two anglers looking for brook trout survey the waters inside the canyon on the Upper Gardiner River, just below Sheepeater's Cliffs.* LEFT: *Anglers fish the stillwaters of Merrell Lake.*

The Lodge and Spa at Cordillera

EDWARDS, COLORADO

Located on a ridge overlooking the Vail Valley
Founded in 1987

If a resort's ambiance, service, and luxury amenities are as important as the fishing, the Lodge and Spa at Cordillera should be the perfect fit. It is ranked as the number one hotel for service, cuisine, and accommodations by *Condé Nast*, and has earned enough other awards to fill an entire web page—from best golfing to best skiing to awards from *Wine Spectator* for its cellar. In other words, this is not your everyday fishing lodge. In fact, fishing is not the primary activity here, but (and this is a pretty big but), they do have 1.5 miles of private water on Colorado's Eagle River, and that is a pretty exceptional river.

Located just a couple of hours from Denver, Cordillera is easy to access. It lies on a ridge overlooking the Vail Valley; from a distance the lodge looks like a huge French château. With 56 luxurious rooms from 450 to 700 square feet, nothing much has been spared in the way of luxury, from Anichini linens and feather down comforters to luxurious robes and bathrooms brimming with things to make you smell good. Most of the rooms have balconies and fireplaces as well.

If a few rounds of golf between hatches sounds good, Cordillera has four courses to satisfy even the most ardent duffer, designed by Jack Nicklaus, Tom Fazio, Dave Pelz, and Hale Irwin—a rather enviable quartet of designers. Needless to say the spa and the dining are equal to the rest of the property. Cordillera's two exceptional restaurants are the award-winning Mirador and Grouse on

OPPOSITE: *The Lodge and Spa at Cordillera lights up the winter Rockies.*

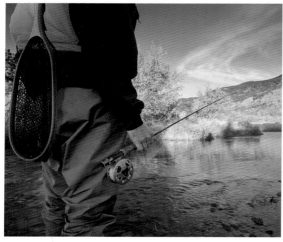

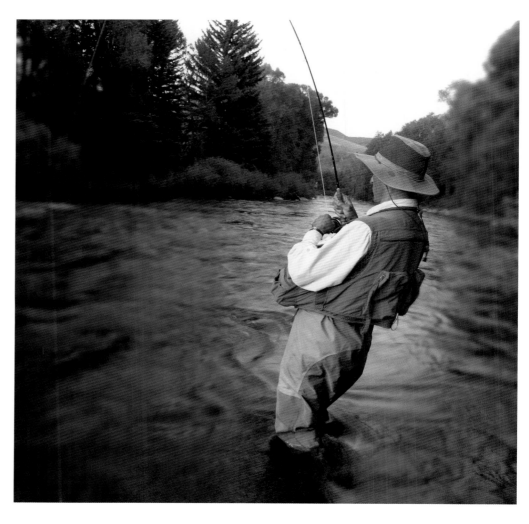

the Green, which offers an authentic Irish pub experience right down to the shepherd's pie.

While fishing is not the primary reason for the lodge's existence, the fishing is of a quality that will satisfy anyone who loves standing in a Rocky Mountain river and catching big trout. The beauty of this resort is that since it is a year-round resort with world-class Vail and Beaver Creek skiing in the winter, the angler can also fish year-round. The Eagle is a free-flowing river, there are no dams, and depending on the time of the year, the hatches can be prolific. Even in the winter the blue-winged olives, bless their hearts, will hatch if the weather is right, but during the spring and summer, the river

is full of insects and the trout can be aggressive eaters. There are browns and rainbows as well as the occasional cutthroat, and they run from 14 to 18 inches.

Cordillera offers more than one could ever hope to accomplish in a normal visit. The list of activities is huge, including hiking, golf, jeep rides, rodeos, sporting clays, biking, and even theater and the arts. You can hook it, hit it, shoot it, drive it, or ride it, and that's just in the summer. Come winter, this resort becomes one of the top rated ski resorts in the world, but once you're tired of skiing, you can still step into the river, tie on a couple of nymphs, and hook into some Rocky Mountain trout.

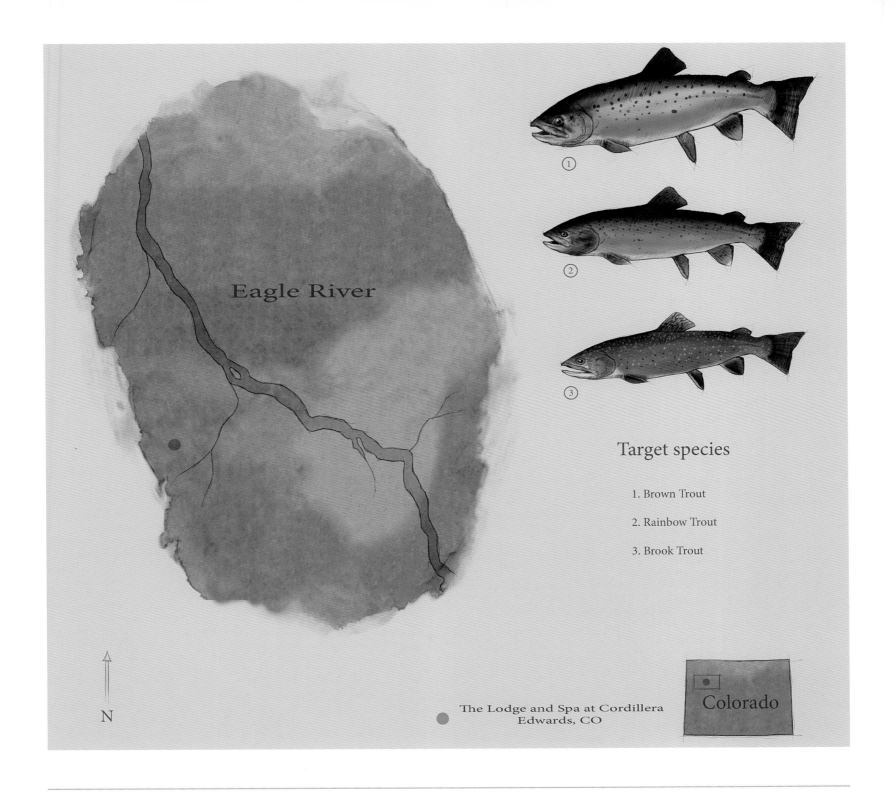

Eagle River

Target species

1. Brown Trout

2. Rainbow Trout

3. Brook Trout

N

The Lodge and Spa at Cordillera
Edwards, CO

Colorado

The Lodge at Palisades Creek

IRWIN, IDAHO

*Located at the confluence of Palisades Creek
and the South Fork of the Snake River
Founded in 1989*

For those who've heard the term "tailwater" and never quite understood its implications, it is a section of a river just below a dam. To the beginning trout angler it might seem adverse to the idea of wilderness to fish below a manmade dam, but the truth is, the flow of water from bottom-release dams can create perfect habitat conditions for trout in terms of consistent water temperature and flow, which is critical to their survival. Case in point, the Palisades Dam on the South Fork of the Snake River.

Just below the dam at the confluence of Palisades Creek and the South Fork lies the Lodge at Palisades Creek—and water that holds 7,000 fish per mile, including cutthroat, brown, and rainbow trout. For that reason, the South Fork of the Snake has gained a reputation as one of the most prolific rivers in the country. The

lodge's location in Idaho's southeast corner near the border of Wyoming is one of the most spectacular parts of the American West, with proximity to Yellowstone National Park and the Tetons, not to mention the proximity to the Henry's Fork, Teton River, Gray's River, Blackfoot River, and Palisades Creek, as if the South Fork wasn't sufficient. Conservatively speaking there are a few hundred thousand trout swimming in this lodge's home waters. The lodge has four sections of the South Fork, each with its own character. The fish average 15–17 inches, with 20-inch fish not uncommon.

Guests stay in individual log cabins with private drives and a central dining room. They may be log cabins, but there is nothing rustic about the amenities within. There is no television, no Internet, and no telephone in the cabins—rightfully so for a lodge

OPPOSITE: *Baldy Mountain, at the southern end of the Teton Range, overlooks the Snake River as it flows through Swan Valley.*

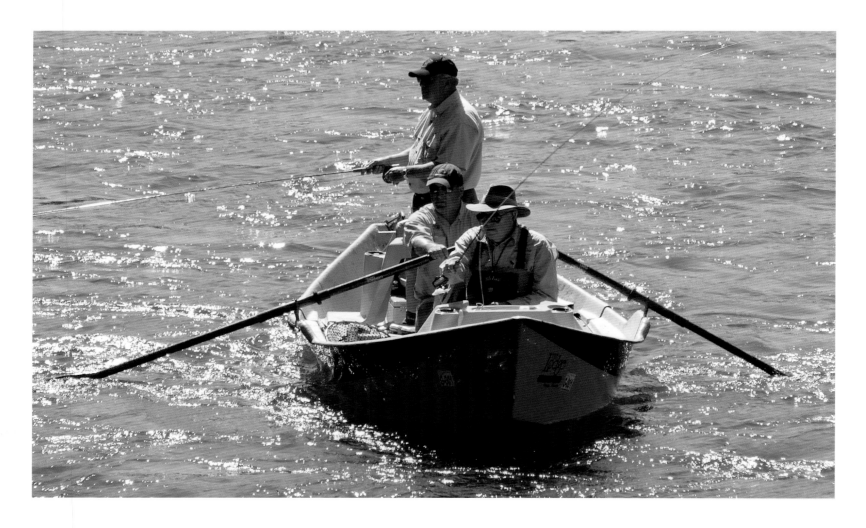

that wants to treat its guest to a true fishing lodge experience. There is a time to communicate with the world and standing in a river full of trout or sitting on the deck after a day of fishing and a spectacular meal is not it. The food is excellent, as it should be in a lodge of this caliber, with a professional staff using organic local ingredients and specializing in Western gourmet entrees of fish and steak, as well as breakfasts that every angler dreams of waking to.

The Lodge at Palisades Creek is managed by Stan Klassen, and that alone speaks volumes to the kind of service the guests here will receive. Stan has been a lodge manager for more than 20 years at some of the best fishing lodges in the country; the fact that he is here bespeaks the owner's desire to provide the best experience possible. His reputation in this industry is impeccable and from the moment a guest arrives until they leave, they have Stan's full attention.

There are not many places in this country where an angler will find more fish. Combined with food and service that is impeccable, guides that are experienced, and a location that is secluded and magnificent, the Lodge at Palisades Creek ranks at the top of any angler's list for a place where the priorities are in perfect order.

TOP: *Three anglers drift the South Fork of the Snake River.*
OPPOSITE, TOP: *A big, well-fed rainbow trout is the tailwater's reward.*

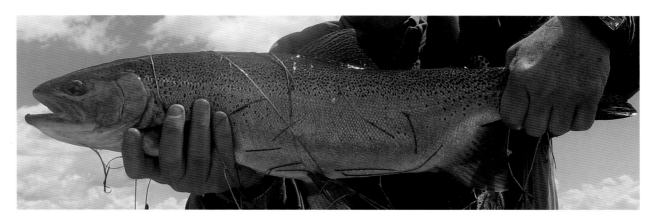

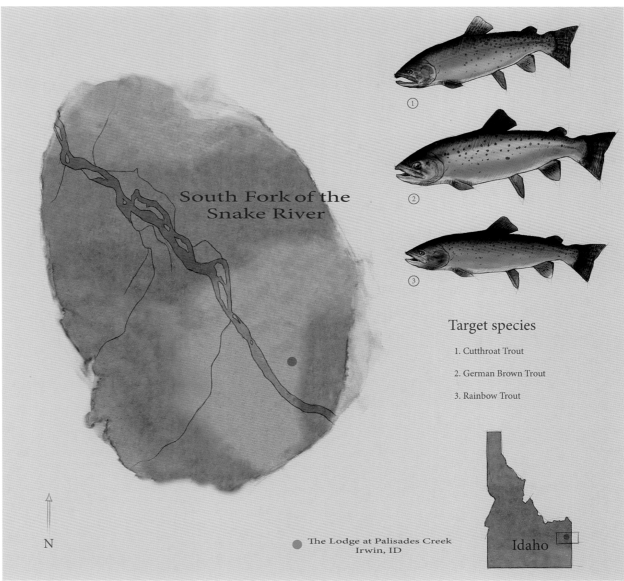

South Fork of the
Snake River

①

②

③

Target species

1. Cutthroat Trout

2. German Brown Trout

3. Rainbow Trout

N

The Lodge at Palisades Creek
Irwin, ID

Idaho

Lone Mountain Ranch

BIG SKY, MONTANA

*Located near the Gallatin River
Founded in 1926*

There have been a great many lodges built recently in the West, due to the increased interest in fly fishing over the past few years. Most of them are excellent. But there are a few lodges out there that offer more than just big beautiful log buildings, good fishing, and good food. There are those like Lone Mountain Ranch that offer history as well. While that might sound a bit academic for most lodge patrons, the fact is, it does add a significant cachet to the experience. There is history in these walls that can't be replicated or purchased, and the patina that comes with it is priceless.

Lone Mountain Ranch was placed on the National Register of Historic Places in December 2006. First homesteaded by Clarence Lytel in 1915 as a working cattle, horse, and hay ranch, it was sold in 1926 to a Chicago paper mill tycoon, J. Fred Butler. The Butlers built many of the existing buildings, sparing no cost in construction. Native lodgepole pine was used, and door hinges and locks were handmade. The late newscaster, Chet Huntley (along with Chrysler and several other large corporations), purchased Lone

RIGHT: *The Gallatin River flows north from Yellowstone to meet with the Jefferson and Madison rivers to form the Missouri River.*

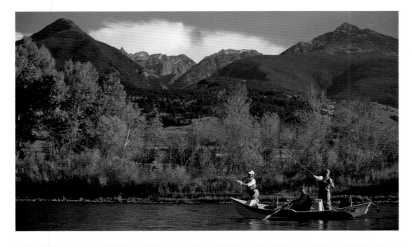

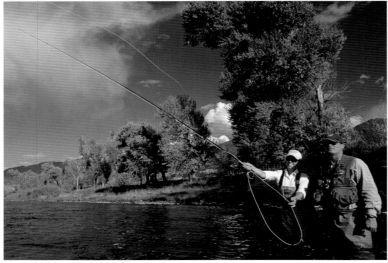

Mountain Ranch and much of what is now known as Big Sky Ski and Summer Resort and Meadow Village in the late 1960s to develop one of Montana's first destination alpine ski areas.

Aside from the beauty, the history, and the pure level of service that Lone Mountain offers, there is the location. Just a few miles from the Gallatin River, Lone Mountain Ranch sits at the northwest corner of Yellowstone National Park and has access to a litany of trout water that is as good as an angler could possibly ask. The Gallatin is actually a rather unsung river considering its proximity to the Madison, Firehole, Gibbon, Jefferson, Yellowstone, and other waters of that caliber. Running out of the park and heading north for 115 miles until it joins the Madison and the Jefferson to create the great Missouri River, the Gallatin is a big tumbling river which is closed for the most part to drift boats, but is accessible to waders, and is considered by some to be one of the top wading rivers in Montana.

Lone Mountain Ranch was the Orvis-Endorsed Lodge of the Year in 2002. Guides Gary Lewis and Brian Kimmel have both been awarded Orvis-Endorsed Guide of the Year. There is probably not a better staff of fishing guides in the country. Not only can it put an angler on hallowed waters, but Lone Mountain also has the Lee Metcalf Wilderness out the back door and access to some of the best alpine lake fishing above 8,500 feet in the lower 48 states. If the angler is willing to ride a horse for a few hours, the rewards of cutthroat, golden, rainbow trout, and Arctic grayling are there for the taking.

With history comes experience. With experience comes expertise. For the angler looking for a sure thing, Lone Mountain Ranch has a pedigree and a location with which it is difficult to argue.

TOP: *A group of guests drift the Yellowstone River.* MIDDLE: *Lone Mountain Ranch guides have twice been named Orvis-Endorsed Guides of the Year.* BOTTOM: *Anglers can relax and grab a bite to eat at Lone Mountain Ranch's dining lodge.*

Gallatin River

① ② ③

Target species

1. Brown Trout

2. Rainbow Trout

3. Cutthroat Trout

N

Lone Mountain Ranch
Big Sky, MT

Montana

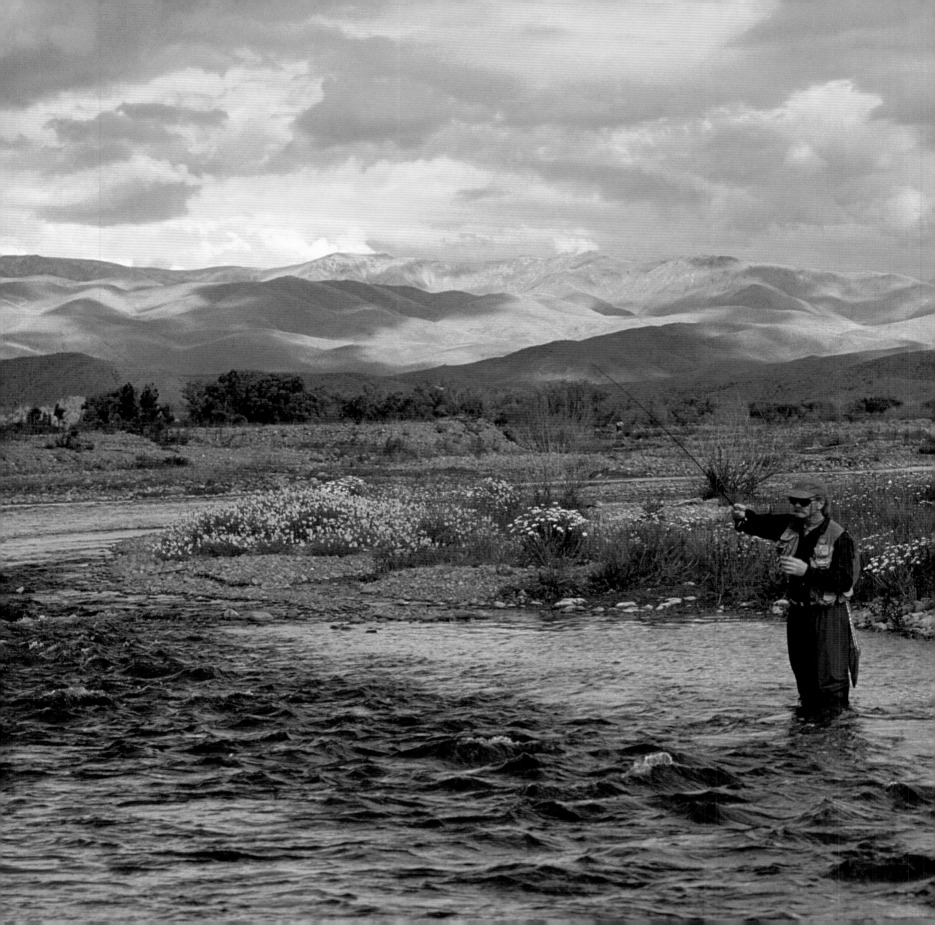

Madison Valley Ranch

ENNIS, MONTANA

Located between the Gravelly and Madison mountain ranges on the Madison River
Founded in 1993

There is a sign in Ennis, Montana, that says, "Welcome to Ennis. Population 840 People. 11,000,000 Trout." The veracity of these numbers may be a bit suspect, but the ratio is probably near the truth. Ennis is the largest town in the Madison River Valley, a spectacularly broad and flat valley between the Madison Range to the east, and the Gravelly Range to the west, with unencumbered views that are irrefutable proof that Montana's "Big Sky" moniker is not a marketing ploy.

Down the middle of this valley runs one of the most famous trout rivers in the world, the Madison. The Madison begins in Yellowstone, at the confluence of the Firehole and the Gibbon, runs through Hebgen Lake and Quake Lake, and then begins its famously consistent 50-mile run through the valley to Ennis Lake. This consistency of topography, elevation, and water flows from the base of Hebgen Dam gives the Madison its nickname, the "50-mile riffle," offering accessible and abundant fishing in fertile water with good hatches and strong populations of wild browns and rainbows (with a few Montana whitefish thrown in). The river's fame derives from the fact that it has 50 miles of everything an angler could want. The river is surrounded by fertile farm and ranch land, which helps the fertility of the river and the aquatic insect populations.

Three miles north of Ennis is Madison Valley Ranch, squarely located in the middle of the valley along the banks of the Madison's Channels section, where the river splits and rejoins in a

OPPOSITE: *An angler works a riffle on the Madison River near Ennis, Montana.*

series of braids that offer a remarkable volume of river acreage to fish. One could stay here for a while, and between the river, Jack Creek, and the private pond on the property, never set foot in a vehicle.

The lodge is a classic log structure built in the architectural style of the valley. The private entrances to each suite have covered porches so the anglers can end the day doing what they do best, sitting around and telling lies. No good angler would do less. The food is memorable, with a resident chef who's been on the

property for nine years; that kind of tenure speaks to success, as less-than-spectacular chefs at fishing lodges don't last long.

The views down the valley and the night sky are probably worth the trip alone, but with the opportunity to walk out the door and fish one of the greatest trout rivers in the world in one of the best parts of the river, this lodge is undoubtedly going to gain reputation and stature among anglers. If that isn't enough, the angler can drive for a few minutes and fish the Big Hole, Ruby, Beaverhead, Gallatin, or Yellowstone rivers.

ABOVE: *A blanket hatch inundates several anglers getting ready to float the Madison River.* OPPOSITE, TOP LEFT: *A Madison River brown holding in the current waits for something to come into its feeding lane.* OPPOSITE, TOP RIGHT: *The Channels Lodge building at Madison Valley Ranch sits right on the channel section of the Madison River.*

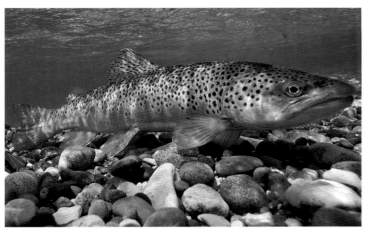

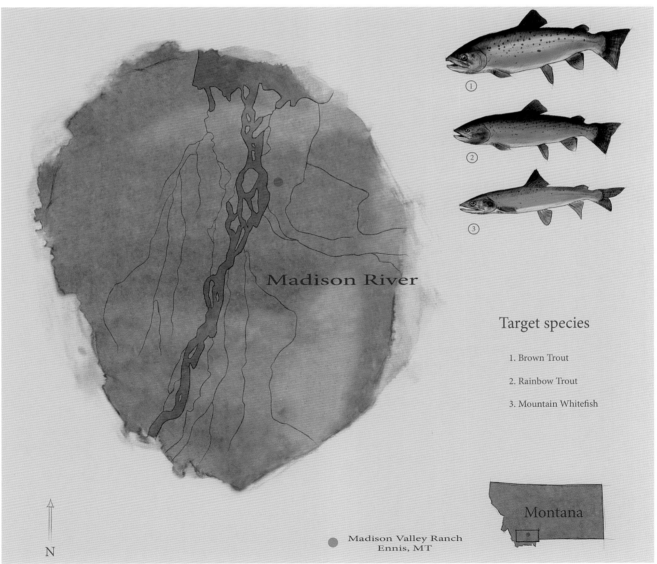

Madison River

Target species

1. Brown Trout

2. Rainbow Trout

3. Mountain Whitefish

Montana

Madison Valley Ranch
Ennis, MT

N

North Fork Ranch

SHAWNEE, COLORADO

*Located in Pike National Forest on the
North Fork of the South Platte River
Founded in 1985*

There is something to be said for proximity. While many fishing destinations pride themselves on being the most remote, furthest from the nearest road, or inaccessible except by dog sled or floatplane, there is something to be said for being very accessible. North Fork Ranch in Colorado is a perfect example. It is an easy hour's drive from the Denver airport, situated on the North Fork of the South Platte River in Colorado's Pike National Forest.

This would be difficult in most other regions of the country, but Denver is somewhat the exception. Lying at the base of the Rockies, it is a major metropolitan area, but it doesn't take long to find yourself in a pristine environment where the idea that a major city is just a short drive away is hard to comprehend. Such is the beauty of North Fork Ranch. No phones, no TV, no cell phone coverage—all the benefits of a remote lodge without the struggle of getting there.

For some people, particularly those with children, this is the perfect way to get into the wild in a reasonable manner and enjoy all the things the wilderness has to offer without the dreaded, "Are we there yet?" By the time they ask—you are there.

RIGHT: *North Fork Ranch is visible in the background as an angler bends his rod on the North Fork of the South Platte River.*

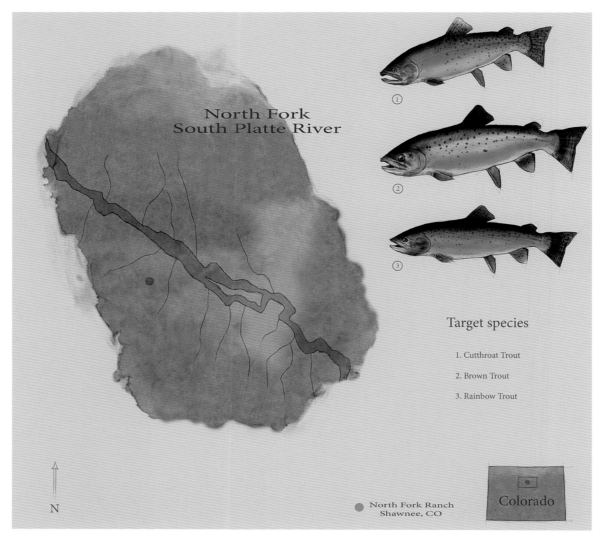

North Fork
South Plate River

Target species

1. Cutthroat Trout

2. Brown Trout

3. Rainbow Trout

North Fork Ranch
Shawnee, CO

Colorado

N

North Fork Ranch is a dude ranch in the finest sense of the word, offering families many different options, including whitewater rafting, horseback riding, hiking, and even special arrangements for the younger children, such as camping in a teepee and pony rides.

So where does this leave the angler? In great shape actually. For the dedicated angler who can't always get away to Alaska or Labrador and wants to accomplish both time with family and great fishing, there is perhaps no better option than North Fork. The ranch sits on the bank of some of the finest Colorado trophy trout water there is, in fact some of the favorite water of President Eisenhower. There are very big fish in this water. Wild rainbow, brown, cutthroat, and steel-

head up to (and over) five pounds are routine. The average fish is three pounds. It is reported that in the half-mile stretch of the ranch there are more than 1,500 pounds of fish waiting to be caught.

North Fork Ranch basically removes the compromise for anglers torn between passion and family. No longer is it necessary to settle for average fishing at a family resort, or disappoint the family by sticking them in a remote fish camp with nothing to do. At North Fork Ranch you can have the best of both within easy reach of a rental car. By the time most people are boarding their second flight, a North Fork family is already unpacked—the kids are off with the wranglers, the spouse is in the pool, and hopefully the angler is tied into a five-pound rainbow.

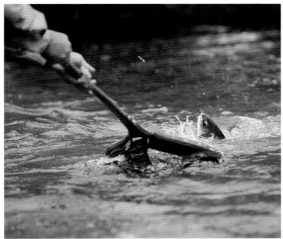

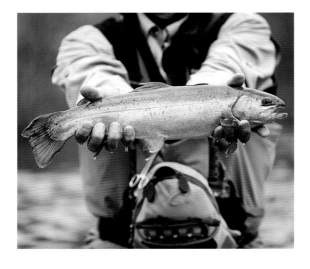

ABOVE: *Guests at North Fork Ranch can step out the front door and fish the North Fork of the South Platte River.* TOP LEFT: *An angler strips out line in preparation for the cast.* MIDDLE LEFT: *A guide reaches for the catch.* LEFT: *A beautiful North Fork cutthroat is the end result of the angler's efforts.*

PRO Outfitters and North Fork Crossing Lodge

OVANDO, MONTANA

Located in a secluded valley near the iconic Blackfoot River
Founded in 1997

The Blackfoot River in Montana is legendary, but much of the legend is recent. Before Norman Maclean chronicled his coming-of-age on the river, it was little known outside the state. After Robert Redford's film of the same name, *A River Runs Through It*, appeared in 1992, the Blackfoot became iconic for Montana and fly fishing became trendy. But not all was well with the river. Over the years, mining and poor farming and grazing practices had severely degraded the river. Due to the efforts of many people, including Paul Roos, one of the original owners of PRO Outfitters and North Fork Crossing Lodge, the Blackfoot River is once again one of the great trout rivers in Montana's western mountains.

In 1996, PRO Outfitters was the first recipient of the Orvis-Endorsed Outfitter of the Year award. In 1997, North Fork Crossing Lodge was created with the intention of creating a true Montana fishing experience where clients would be treated to all the creature comforts, but in a manner that would give them more of the outfitter's wilderness experience. Located in the secluded valley of the North Fork of the Blackfoot River, the lodge is spacious and lavishly equipped to meet the needs of the clients and their experience, but what sets it apart from other lodges is the cabins, for they are tents—big canvas outfitter tents. But make no mistake, they offer all the amenities of any lodge cabin and perhaps more due to their unique nature. Inside these tents are wooden floors, screened windows and doors, controlled heat, and perhaps best, large, custom-made oversized feather beds. Combine

OPPOSITE: *The tent cabins of North Fork Crossing Lodge sit right on the water's edge.*

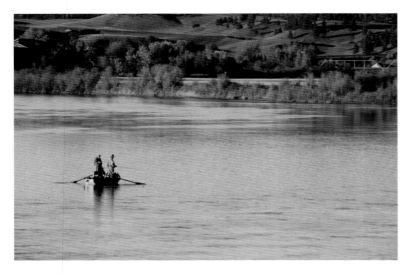

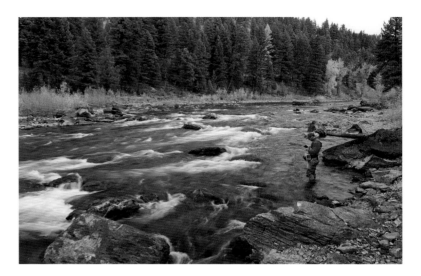

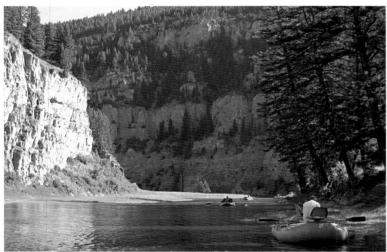

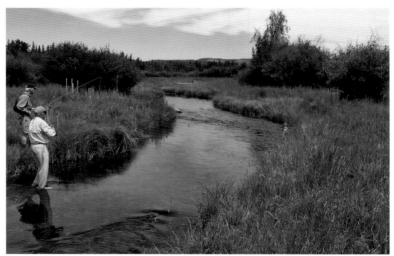

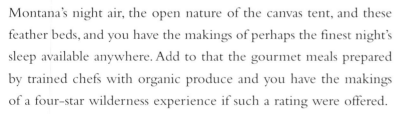

Montana's night air, the open nature of the canvas tent, and these feather beds, and you have the makings of perhaps the finest night's sleep available anywhere. Add to that the gourmet meals prepared by trained chefs with organic produce and you have the makings of a four-star wilderness experience if such a rating were offered.

For the angler, North Fork Crossing Lodge offers spectacular fishing in legendary waters for westslope cutthroat, bull trout, browns, and rainbows, whether it be in the four trout ponds on the property, private spring creeks, the Blackfoot, the Missouri, or on the incredible Smith River float trip where anglers spend five days and four nights drifting and fishing down one of the most prolific trout rivers in the country. This is a wilderness experience, yet it is so well orchestrated and planned that almost anyone can enjoy it. Over the years PRO Outfitters has perfected the art of making camping comfortable and the Smith is remarkably beautiful, full of lively whitewater and excellent fishing.

A trip with PRO Outfitters is ultimately about connecting— whether it's with Mother Nature, yourself, your family and friends, or the guides and staff. A visit to North Fork Crossing Lodge provides a unique and beautiful fishing destination, but also a chance to step back in time and connect with the Blackfoot River—a Montana trout legacy.

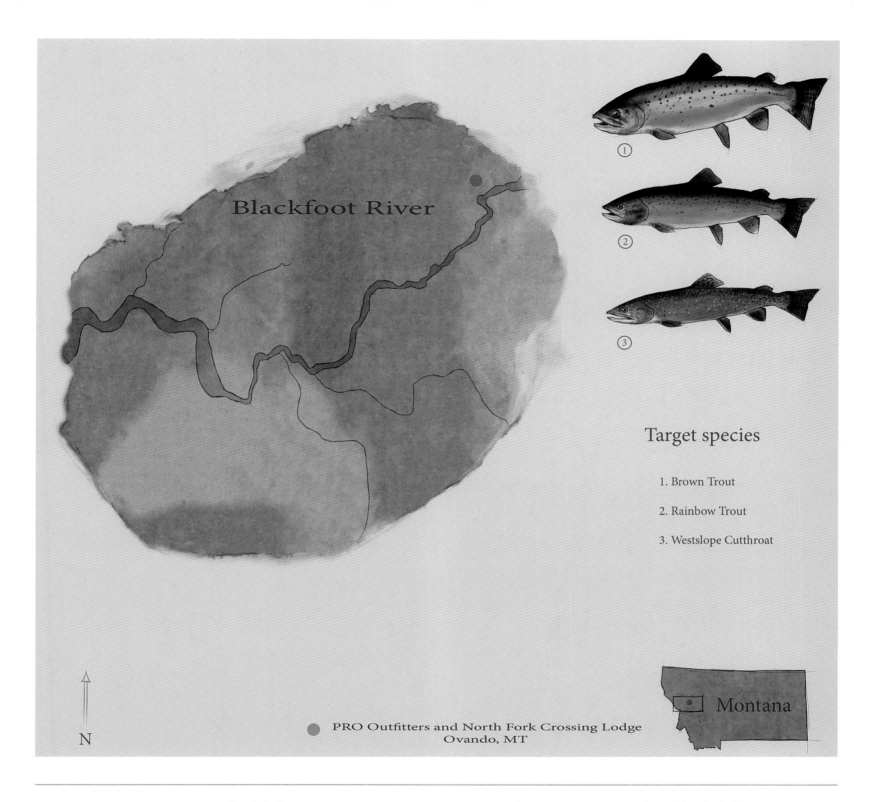

Blackfoot River

Target species

1. Brown Trout

2. Rainbow Trout

3. Westslope Cutthroat

N

Montana

PRO Outfitters and North Fork Crossing Lodge
Ovando, MT

OPPOSITE, TOP LEFT: *Two anglers drift the Missouri River.* OPPOSITE, TOP RIGHT: *An angler steps into Norman Maclean's beloved Blackfoot River.*
OPPOSITE, BOTTOM LEFT: *A guest takes a raft out to float the legendary Smith River.* OPPOSITE, BOTTOM RIGHT: *Two anglers work the backcountry creeks.*

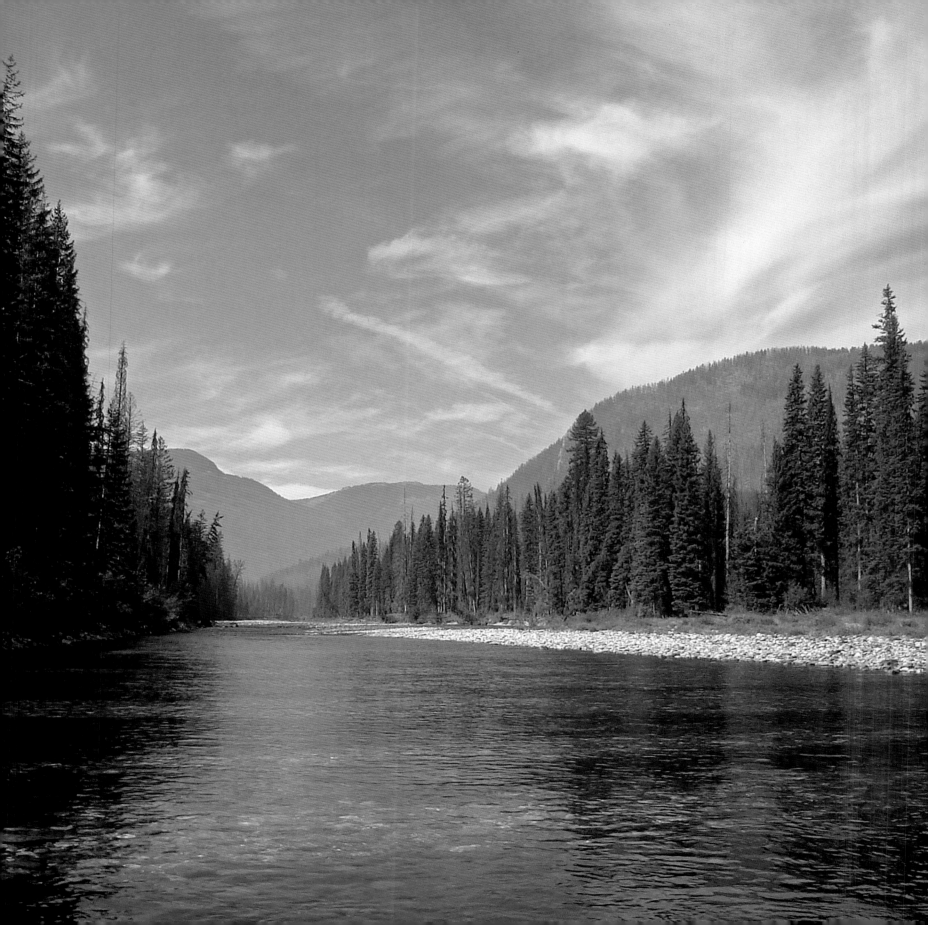

Spotted Bear Ranch

HUNGRY HORSE, MONTANA

Located in the remote woods between the Bob Marshall Wilderness and Glacier National Park
Founded in 1939

There is remote and then there is remote. In the lower 48 states there is not a place that can claim to be more remote than Spotted Bear Ranch, which is located between the 1.5-million-acre Bob Marshall Wilderness complex to the south and Glacier National Park to the north. Look at a map of western Montana where it juts over Idaho and there is a massive blank area of uninhabited wilderness, with no roads, no towns, and nothing to indicate whether this is the 21st century or the 18th. It sits astride the Great Divide and is one of the most pristine wilderness areas left in North America.

Flowing out of that wilderness is the South Fork of the Flathead, which is protected by the National Wild and Scenic Rivers Act, and the Spotted Bear rivers, two secluded, pure, and beautiful rivers, simply due to their inaccessibility by 21st-century human traffic. Situated at the confluence is Spotted Bear Ranch. You can get there, but you have to want to get there. Flowing out of the pristine wilderness, these rivers are home to the native westslope cutthroat trout and bull trout, both rare and fascinating fish. The cutthroat are wonderfully aggressive fish in the 10- to 20-inch range and will attack dry flies with abandon, not unlike the small brook trout of the East. Their window of opportunity is small up here and the lack of major hatches in these cold, clear rivers make them aggressive opportunists.

The South Fork of the Flathead River is one of only three

OPPOSITE: *Guests of Spotted Bear Ranch can fish the upper stretch of the South Fork of the Flathead River inside the Bob Marshall Wilderness.*

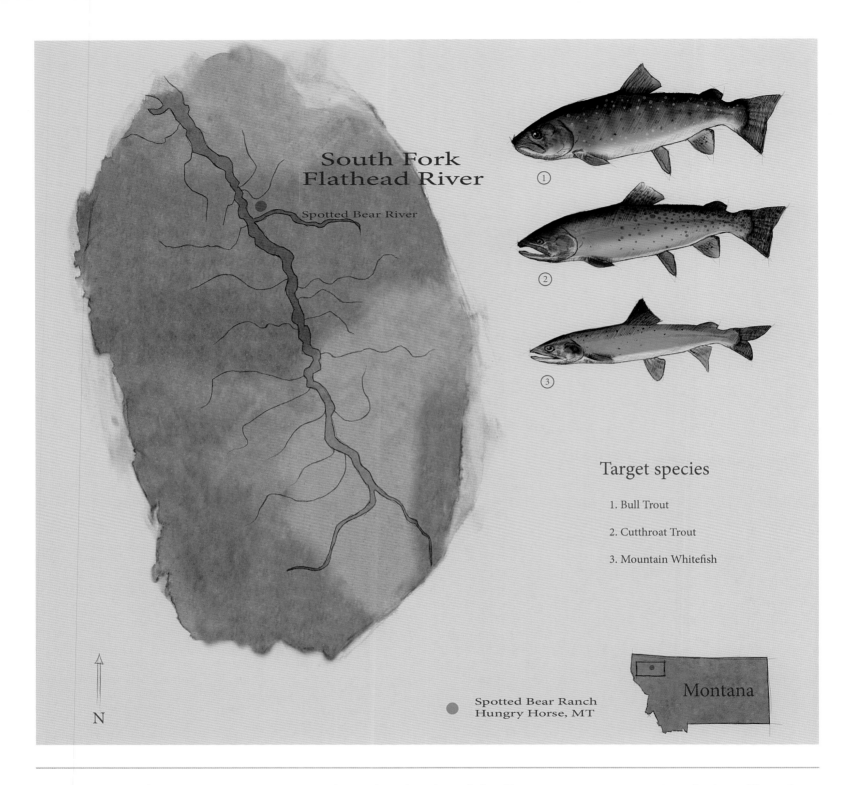

South Fork Flathead River

Spotted Bear River

Target species

1. Bull Trout

2. Cutthroat Trout

3. Mountain Whitefish

Spotted Bear Ranch
Hungry Horse, MT

Montana

N

OPPOSITE, LEFT: *Lodge guest Grant Detro casts into Big Salmon Lake in the Bob Marshall Wilderness.* OPPOSITE, TOP RIGHT: *An angler shows off his catch, a Native Westslope cutthroat trout.* OPPOSITE, BOTTOM RIGHT: *The "White River" cabin, like all of the guest cabins at Spotted Bear Ranch, is named after a tributary of the South Fork of the Flathead River.*

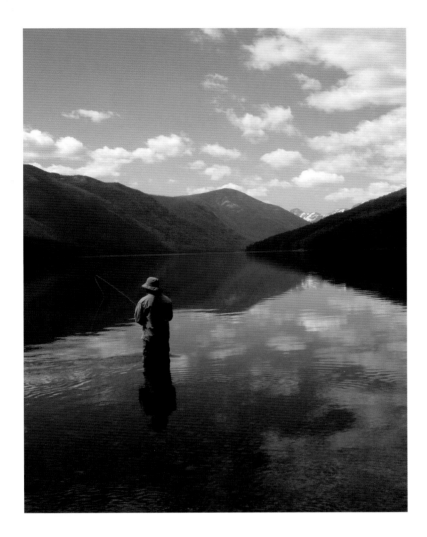

waters where anglers are permitted to fish for bull trout in Montana and these gigantic trout are a spectacular challenge. This is fishing like it was 200 years ago and Spotted Bear Ranch has built its reputation on bringing anglers to this rare opportunity.

Once there, anglers have the opportunity for a lodge-based fishing experience or, if they are a bit more adventuresome, they can go further into the wilderness for overnight trips to remote sections of the river that rarely anyone sees. A three-time winner of the Orvis-Endorsed Expedition of the Year, Spotted Bear Ranch specializes in these kinds of trips.

For the lodge guest, the accommodations are simple, but simple does not mean average. The things that count, the chef-prepared food, the comfort of the down bed, the warmth of the fire, and of course the location, are anything but average. There is maid service even in the middle of nowhere.

For those who want something more, there is a six-day trip far into the wilderness, two days on horseback going up the South Fork of the Flathead and fishing over what is essentially virgin water. The third day is spent in camp and then the next three days are spent floating and fishing back down to the lodge.

On a planet where the wilderness is disappearing faster than we like to admit and where some "wilderness trips" are a compromise at best, it's nice to know that there still exist places on this earth that we have preserved, places where you can stand in a stream and legitimately say, "This is what it must have been like 200 years ago."

Spotted Horse Ranch

JACKSON HOLE, WYOMING

Located on the banks of the Hoback River
Founded in 1961

One of the things about the West, the Rockies in particular, is the abundance of great and legendary trout rivers such as the Madison, the Yellowstone, the Henry's Fork, and the Big Horn. While these rivers form a who's who, if you will, of destinations for trout anglers the world over, what is often overlooked are the hundreds of rivers with less of a worldwide reputation, but with fishing that is as good if not better, and certainly less pressured than these legends. While these famous rivers deserve their reputations, there are other rivers that the locals and dedicated anglers looking for great trout water diligently search out.

Spotted Horse Ranch sits right on the bank of one of these lesser-known rivers, the Hoback, which originates in the Gros Ventre Range and runs northwest until it meets the Snake River at Hoback Junction. A free-flowing western freestone stream, it is filled with the native fine spotted Snake River cutthroat. While not overly big, ranging from 8 to 13 inches, they are great fighters and the true native species of the area. These golden colored trout with fine black spots are beautiful and are only found in local waters.

RIGHT: *The Grand Tetons overlook the Snake River.*

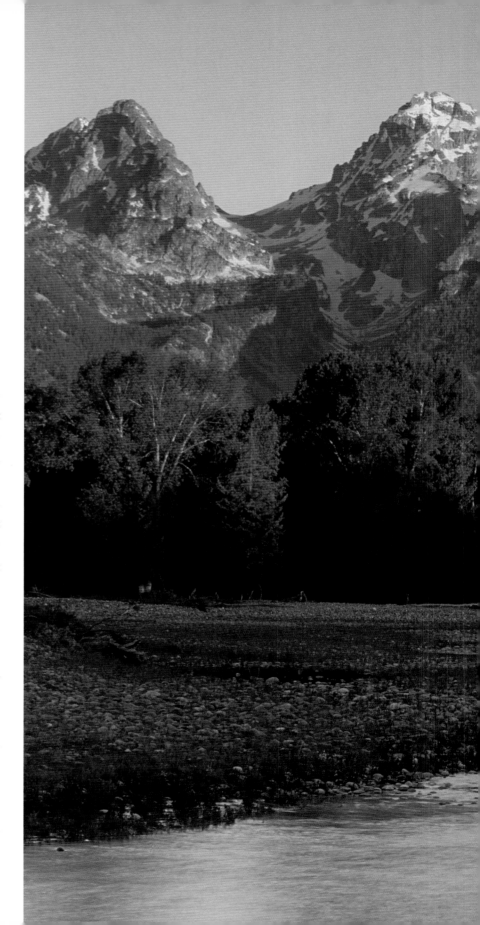

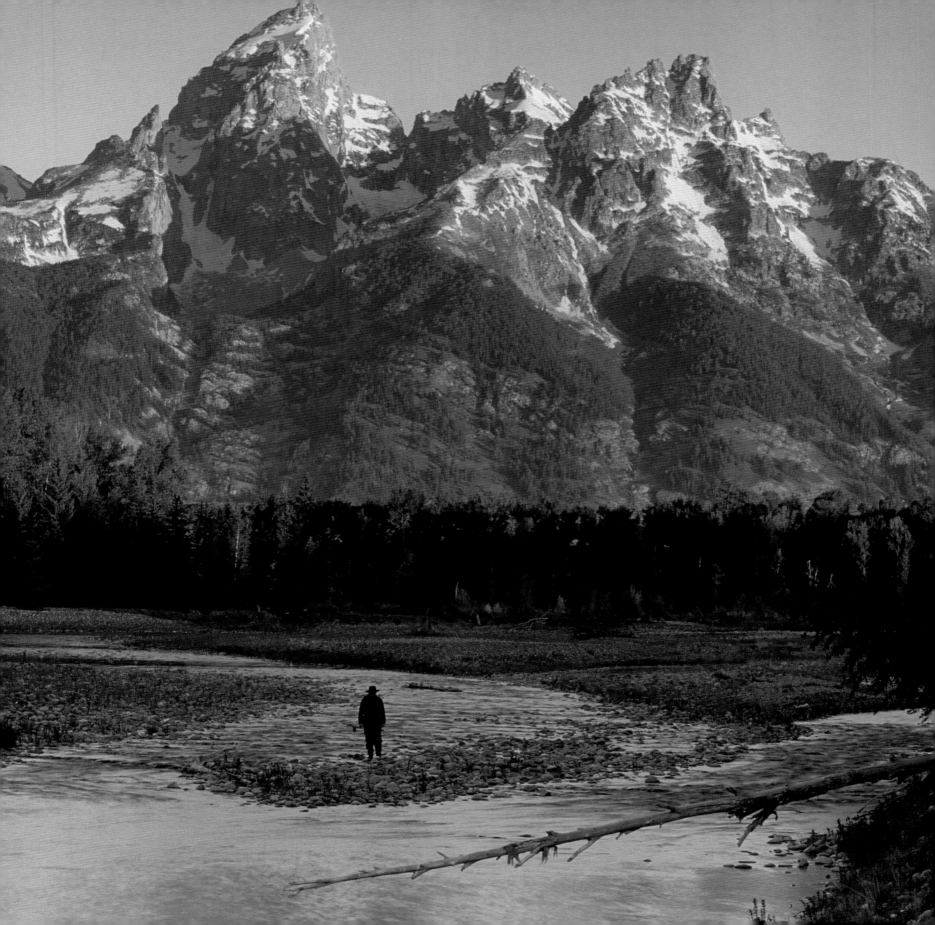

Spotted Horse Ranch offers much more than most lodges do, with bigger and more famous rivers very accessible to drift boat fishing and unspoiled tributaries available for overnight back-country fishing. The Upper Green is well-known to serious anglers as one of the best fly-fishing rivers in the West. Brown, rainbow, and cutthroat populate the river and the hatches are profuse at certain times of the year, giving anglers a big fish opportunity. The Snake is the biggest of the rivers, easily accessible by driftboat, and is the primary drainage for the habitat of the Snake River cutthroat.

A tributary of the Hoback, Willow Creek gives anglers a back-country option for fishing the pure strain of Snake River cutthroats in their natural habitat of fast-flowing, wilderness water. Access is by horseback and the angler can spend a night or nights at the Hunter Camp some 14 miles back in the Bridger-Teton National Forest.

The ranch itself is located right on the banks of the Hoback, in a valley that has been a farm and ranching valley for years. About 16 miles south of Jackson Hole, the ranch sits at the gateway to Grand Teton National Park, Yellowstone National Park, and millions of acres of national forest. Traditional log cabins line the river with front porches overlooking the Hoback. Anglers can step right into the river, fish the private trout pond, take a trail ride, or just sit on the porch and watch the water. Spotted Horse is a simple ranch, an unpretentious retreat situated in one of the most magnificent parts of North America. For those who value great fishing, the little ranch tucked away in this valley is a hidden gem, not unlike the river that runs by it.

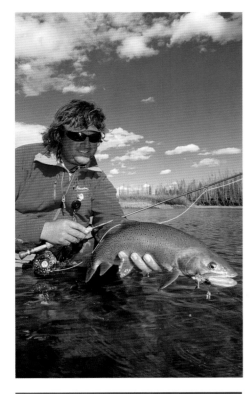

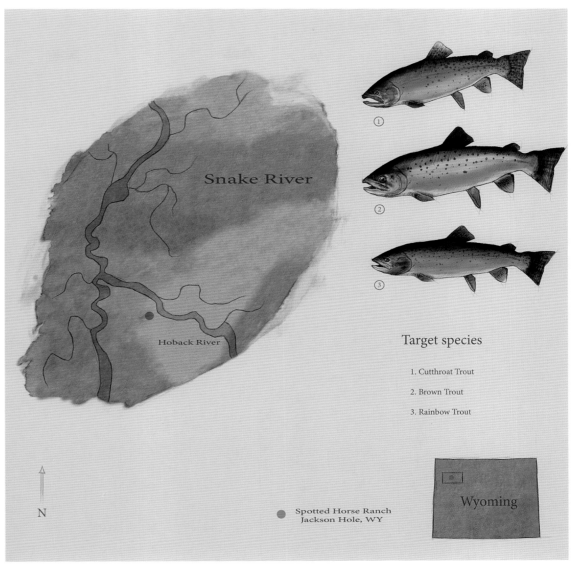

Snake River

Hoback River

① Cutthroat Trout

Target species

1. Cutthroat Trout

2. Brown Trout

3. Rainbow Trout

N

● Spotted Horse Ranch
Jackson Hole, WY

Wyoming

OPPOSITE, LEFT: *Guests are welcomed to the Spotted Horse Ranch by the beautiful main gate.*
OPPOSITE, RIGHT: *A close-up reveals the colors of a Yellowstone cutthroat.* TOP LEFT: *This angler admires the beauty of this magnificent spotted Snake River cutthroat.* LEFT: *Guests at Spotted Horse Ranch can fish from the porch in one of these fishing chairs, or step off the porch and into the Hoback River.*

Three Rivers Ranch

WARM RIVER, IDAHO

*Located near several western rivers, including the
Henry's Fork and the South Fork of the Snake
Founded in 1974*

While fly fishing has, over the past few years, become somewhat trendy, that's not a bad thing; it exposes more people to the sport. Some will truly love it and pursue it for the rest of their lives while others will move to newer trends. Many lodges offer fly fishing as part of their curriculum, if you will, and they generally do it well, but it is not their focus. This is where Three Rivers Ranch in Warm River, Idaho, rises to the surface as one of the truly great, pure, authentic, legendary, and whatever other adjective you might choose, fly-fishing lodges. Not only has it been offering fly fishing longer than most, it is, for all intents and purposes, all the lodge does. And as any guest will tell you, Three Rivers Ranch does it extraordinarily well. While the lodge is happy to arrange other activities, coming here to do something other than fish borders on heresy.

Lonnie Allen has owned the property since 1987, but it has been in her family since her grandparents homesteaded the ranch. There is great history here, but it is under Lonnie's care that Three Rivers Ranch developed into one of the best pure

RIGHT: *Gene Gwaltney, a lodge guest, wet wades the South Fork of the Snake River at Table Rock.*

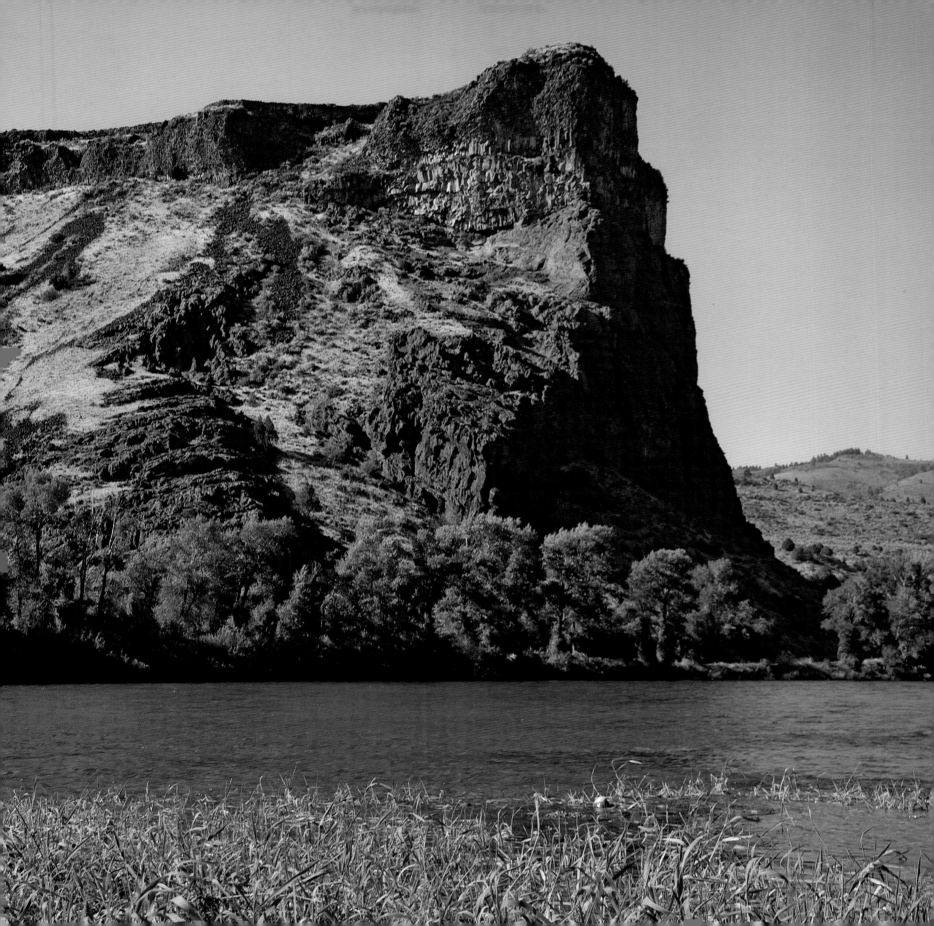

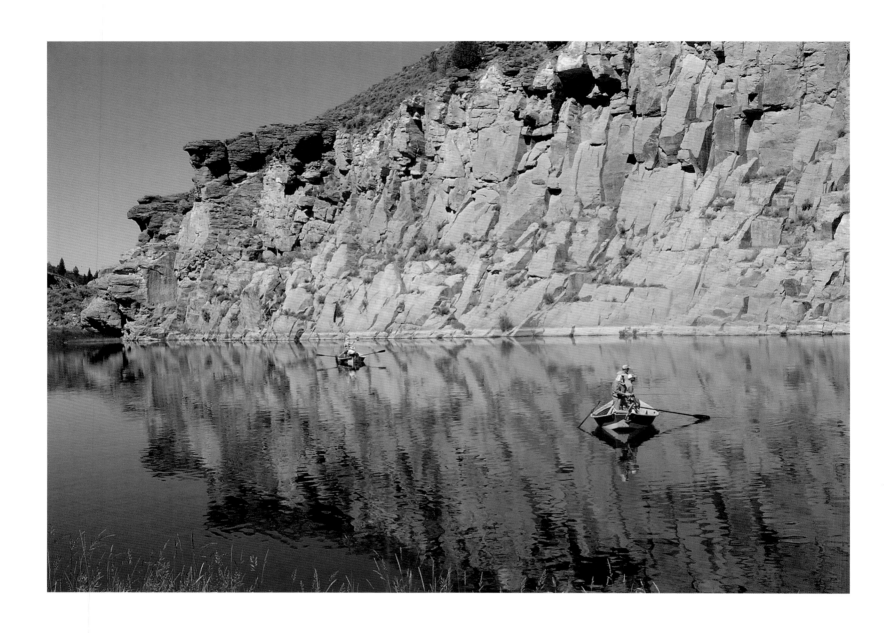

ABOVE: *Drift boats work the deep waters of the Teton River.*

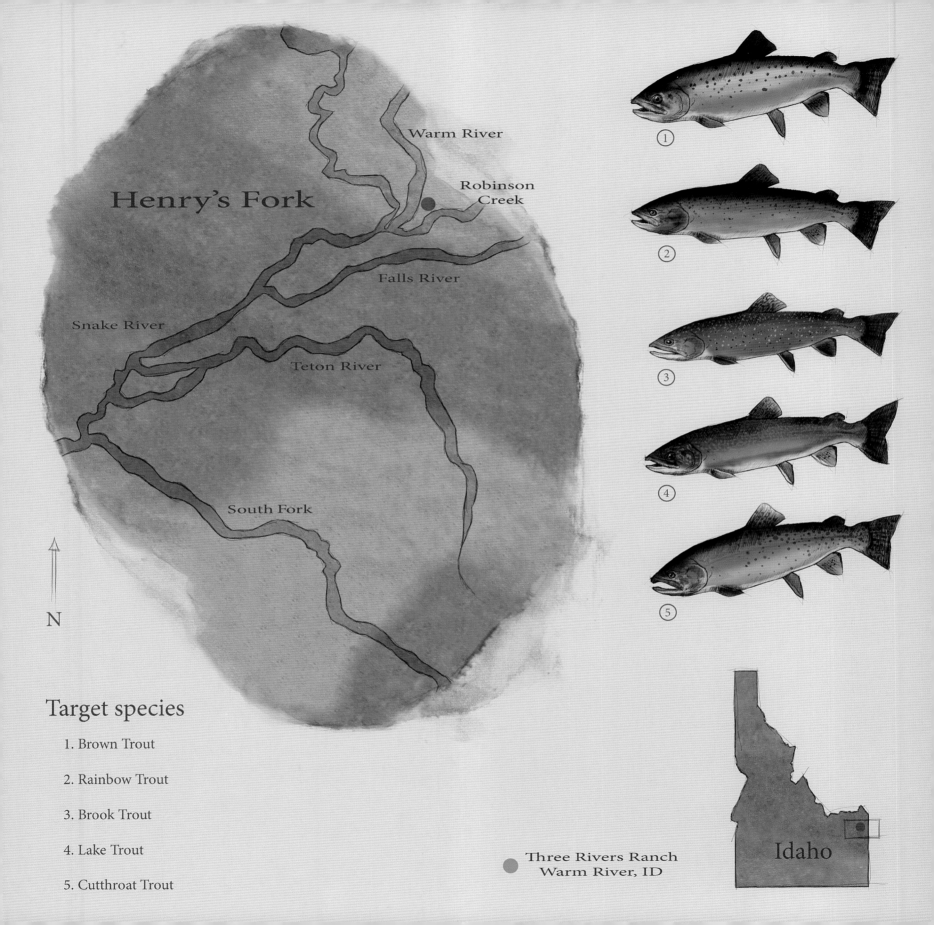

Henry's Fork

Warm River

Robinson
Creek

Falls River

Snake River

Teton River

South Fork

N

Target species

1. Brown Trout

2. Rainbow Trout

3. Brook Trout

4. Lake Trout

5. Cutthroat Trout

① ② ③ ④ ⑤

Three Rivers Ranch
Warm River, ID

Idaho

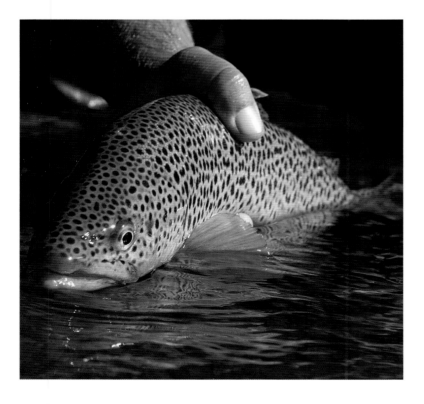

TOP LEFT: *The cabins at Three Rivers Ranch have welcomed trout anglers for years and have the great patina to show for it.* ABOVE: *A lodge guest drifts the South Fork of the Snake River.* LEFT: *A beautiful, magnificently colored brown trout is lifted from the water.* OPPOSITE: *Nick Minor, a Three Rivers Ranch guide, puts his anglers in position on the South Fork of the Snake River.*

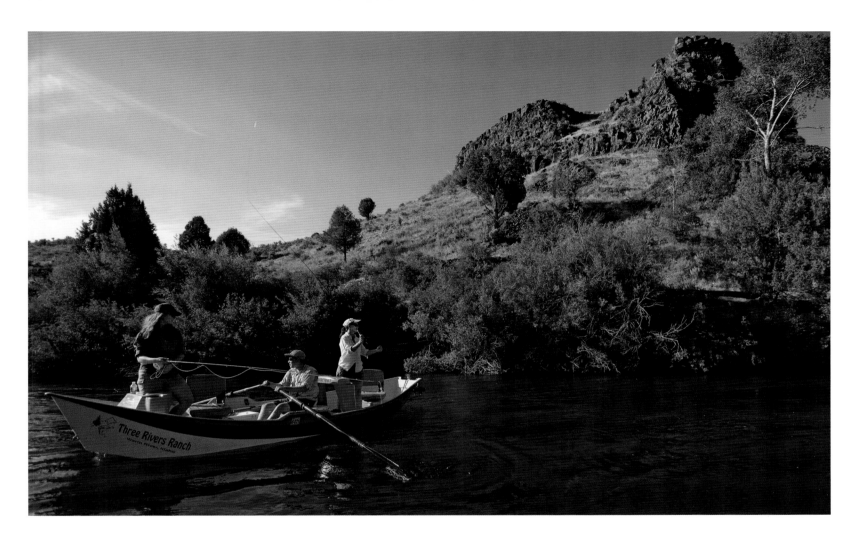

fly-fishing resorts in the world. The other reason for its success is Doug Gibson, who is Lonnie's head guide and has been with her since the beginning. He is the epitome of the legendary cowboy fishing guide who has spent his life on these rivers: among western fishing guides there are few his equal. Both the lodge and Doug have received the Lodge and Guide of the Year awards from Orvis as testament to their skill and love of what they do.

Their location certainly doesn't hurt them either. They are licensed to guide on more than 200 miles of the most impressive trout water in the United States, including the Henry's Fork, the South Fork of the Snake, the Madison, the Teton, and the rivers and streams of Yellowstone National Park. What sets them apart from the others that ply these rivers is the length of time they've been

doing this and the pure and simple approach they take to treating their guests.

The lodge looks like a western fishing lodge should look, for that's all it's ever been. The cabins are built for fishermen. You may not find a Jacuzzi and heated robes, but you will find rod racks on the porch and a clean and very comfortable place to sleep. Most of all, you will find a staff that has one desire only, to help you enjoy your fishing trip. While that may sound simple enough, there is an art to it, and Lonnie and Doug have perfected that art for decades.

Andrew Harper's *Hideaway Report* lists Three Rivers Ranch as one of the 10 best classic fishing lodges in North America. The word "classic" perfectly fits here. There is no better way to describe Three Rivers Ranch in the world of fly-fishing destinations.

Triple Creek Ranch

DARBY, MONTANA

Located among towering pines on the side of Trapper Mountain
Founded in 1986

There are certain images that the words "fishing lodge" conjure in one's mind: rustic accommodations, simple and hearty food, and perhaps even rustic hosts. Anglers generally go to a lodge for the fishing; the accommodations are secondary and "rustic" is simply part of the charm. Although many fishing lodges are upscale enough to accommodate the tastes of today's more urbane anglers, it might be hard to convince someone that a fishing lodge was rated the No. 1 Hotel in the United States, and the No. 4 Hotel Worldwide in 2009 by *Travel and Leisure*. But Triple Creek Ranch in Darby, Montana, was the recipient of these honors and many more.

A Relais and Châteaux property, this remarkable ranch is situated in some of the most beautiful country Montana has to offer. Located on the state's western border, situated high on the side of Trapper Mountain, Triple Creek Ranch is an uncompromising blend of the finest accommodations the world has to offer (in this case unexaggerated) in a wilderness setting from which its guests can venture forth and experience everything from fly fishing to hiking to scenic helicopter rides to cattle drives. But it is when the sun sets that Triple Creek shines brightest, for its dining and wine cellar are as good as one will find anywhere in the world—and they have the awards to prove it, including repeat wins of the *Wine Spectator* Award of Excellence.

The lodge itself is a magnificent log structure set on 600 acres

OPPOSITE: *The magnificent entrance to Triple Creek Ranch welcomes guests to the facility that* Travel and Leisure *rated the No. 1 Hotel in the United States.*

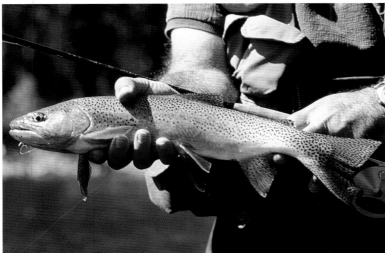

high above the valley. The guests stay in 23 individual log cabins, but these log cabins have little in common with Abe Lincoln's domicile, other than that they are made of logs. Imagine every possible amenity one could desire and incomparable service that rivals the best hotels in the world and "log cabin" takes on an entirely different persona.

Within the lodge is the award-winning wine cellar, a beautiful glass-encased room finished with South American mahogany racks and housing more than 3,000 bottles from house wines to mature Bordeaux and classic vintages, all stored at an ideal temperature of 55 degrees. The expansive wine list appeals to a variety of tastes, and features more than 200 international wines and champagnes, representing every major growing region in the world, with a focus on California and the Pacific Northwest. Combined with culinary offerings ranging from traditional French dishes to innovative southwestern, West Indian, Central American, and other international blendings, dining at the ranch is a remarkable experience.

Triple Creek Ranch guests fish the Bitterroot, a freestone river with its headwaters at the upper end of the Bitterroot Valley, just west of the Continental Divide. It is about 100 miles long, including the east and west forks, and offers blue-ribbon fishing for trout—rainbow, brown, and the beautiful westslope cutthroat. There have not been any fish stocked in the Bitterroot since the 1940s and all fish caught are wild. That alone is worth the price of admission. The Bitterroot River provides the best opportunity to catch brown trout longer than 22 inches on a dry fly, and is famous for very heavy aquatic insect hatches. For anglers on a mission, the Bitterroot is the place to fish for big trout on dries during the spring skwala hatch.

Perhaps the fact that after a day on the river one can get a massage in front of a fireplace, have a haute cuisine dinner delivered to the cabin with an extraordinary Bordeaux, and finish the evening in a private hot tub overlooking the Rockies is some indication that this is a fishing lodge that defies perception.

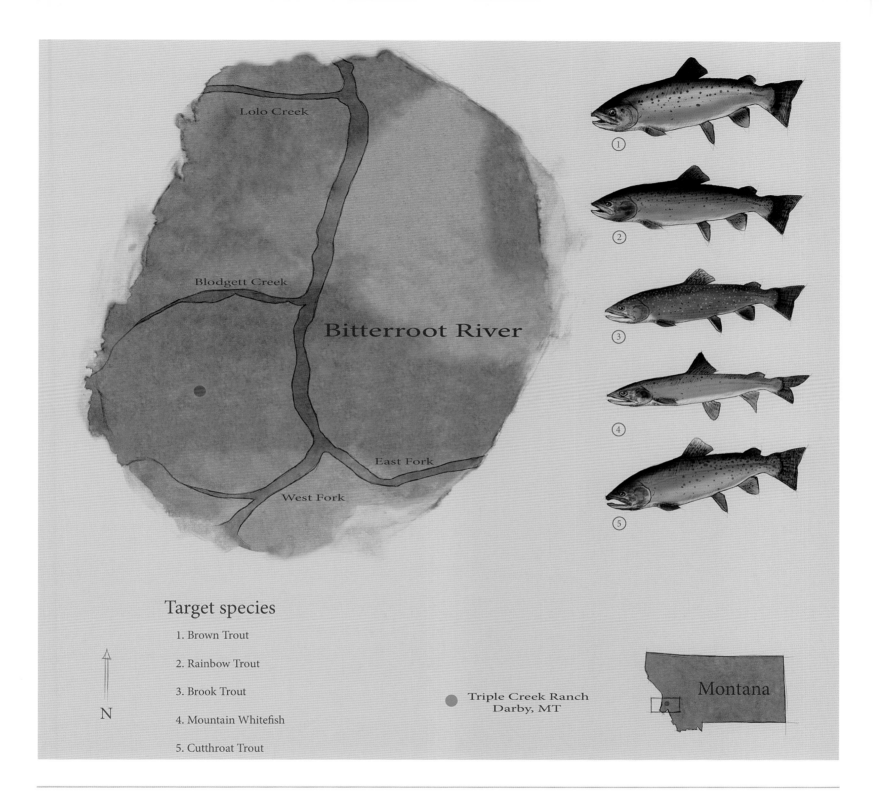

Lolo Creek

Blodgett Creek

Bitterroot River

East Fork

West Fork

① ② ③ ④ ⑤

Target species

1. Brown Trout

2. Rainbow Trout

3. Brook Trout

4. Mountain Whitefish

5. Cutthroat Trout

N

● Triple Creek Ranch
Darby, MT

Montana

OPPOSITE, TOP: *The interior of one of Triple Creek Ranch's cabins looks out on a beautiful scenic view of the area.* OPPOSITE, MIDDLE: *An angler holds a Bitterroot rainbow trout.* OPPOSITE, BOTTOM: *A lodge guest wet wades the Bitterroot River.*

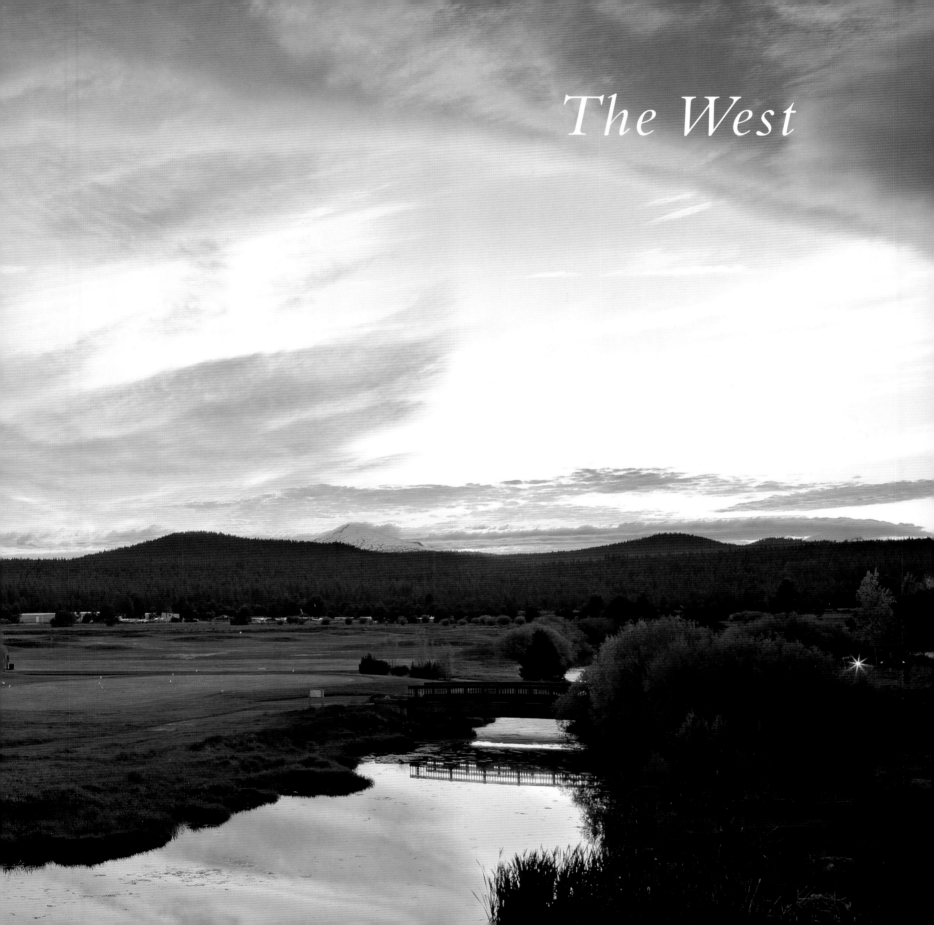

The West

Cow Creek Ranch

PECOS, NEW MEXICO

*Located in a secluded valley surrounded
by the Sangre de Cristo Mountains
Founded in 1934*

About an hour and 15 minutes from Santa Fe lies the historic Cow Creek Ranch, where waters teeming with trophy trout await the avid angler. Nestled in a lush, secluded mountain valley, the ranch has served as a tranquil retreat for fishermen and their families for nearly 80 years.

Cow Creek Ranch really is a ranch. It may call itself a fishing lodge and it certainly has the fishing as validation, but this is a southwestern, high country ranch with the views and the architecture to prove it. All the buildings on the ranch were built from pine and aspen harvested from the property itself. The historic lodge, with its open-beamed ceilings and two fireplaces, offers a warm and inviting place to begin and end the day—a place that reminds guests every moment of where they are and how lucky they are to be there. The other thing they will find is a staff that enjoys working there. One of the secret ingredients of a great lodge (besides the fishing and the great food) is a great staff. Although the fishing and other activities at the ranch are the big

PAGES 180–181: *The sun sets over Sun River and the snowy peak of Mount Bachelor.* RIGHT: *Cow Creek Ranch, surrounded by the Sangre de Cristo Mountains, reflects in the waters of Cow Creek.*

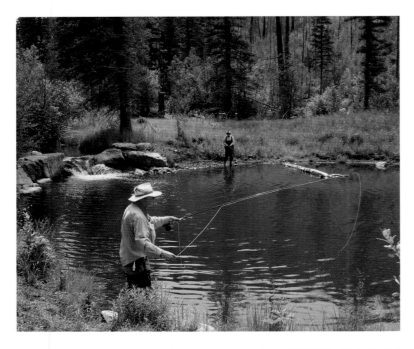

draw, guests return to Cow Creek Ranch year after year to enjoy warm southwestern hospitality and reconnect with friends.

The charming rooms are comfortable and romantic, each with a fireplace and private bath. All the rooms are connected to the lodge and open onto a large porch surrounding a courtyard, which overlooks the stream. At most there are 20 guests at Cow Creek Ranch at a time. For families who like to do more than fishing, there is horseback riding, wilderness hiking, spa treatments, sporting clays for shooters, archery, and special activities for children.

What makes this ranch such a gem is the proximity, quality, and diversity of the fishing. Everything is here on the ranch: no need to go anywhere else. The centerpiece of this is the 4.5-mile stretch of Cow Creek, which has never been open to the public and has been carefully nurtured to provide anglers with unpressured fishing for some very big fish. It's not a big stream by any means, but it is riffle and pool, riffle and pool, the perfect trout water for the fly angler. To make it even better, the river is divided into private stations, not unlike the private beats in the British Isles, and the angler is allowed to choose his private beat for the day and won't see another angler in his water. The fish average 16–20 inches, but there are also some much larger fish available. Last year's record was 31.5 inches.

If that isn't enough, or if guests are more interested in stillwater, there are seven high mountain lakes on the property, full of rainbows, browns, cutthroat, and brook trout. Being sequestered in a remote valley with this kind of fishing is about as good as it gets for the fly fisherman.

TOP: *A lodge guest fishes one of the private beats on Cow Creek.*
ABOVE: *A Cow Creek brown is caught in the riffle-and-pool section that has never been open to the public.*

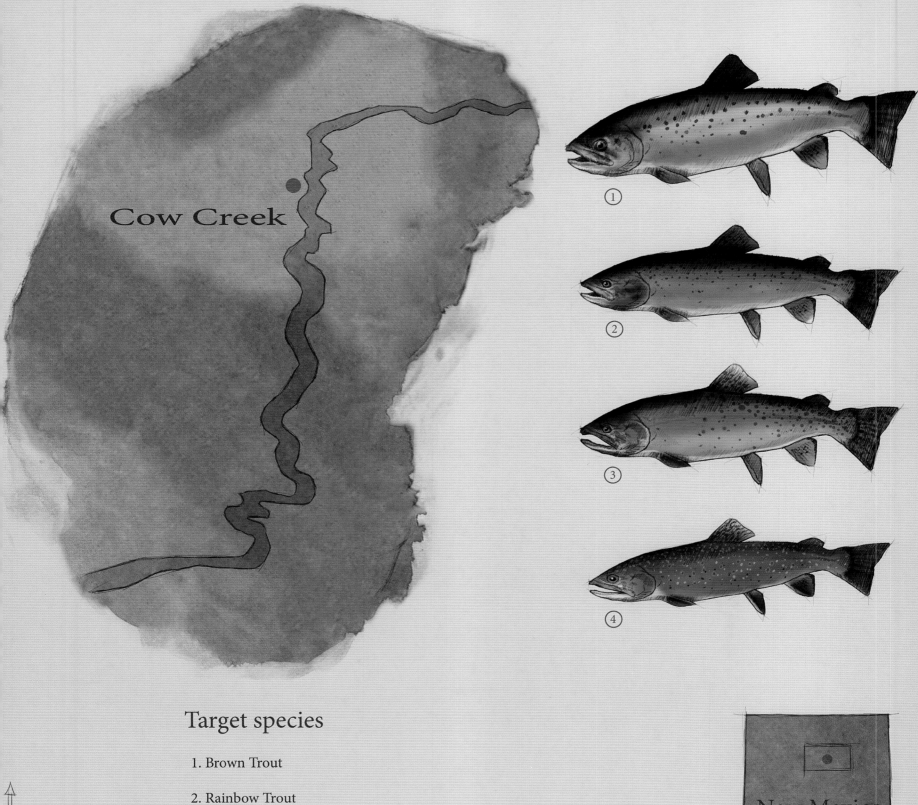

Cow Creek

Target species

1. Brown Trout

2. Rainbow Trout

3. Rio Grande Cutthroat

4. Brook Trout

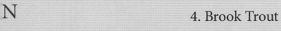

● Cow Creek Ranch
Pecos, NM

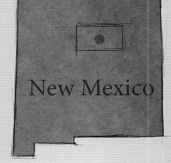

New Mexico

N

Falcon's Ledge

ALTAMONT, UTAH

*Located near the Uinta Mountains
in the largest wilderness area in Utah
Founded in 1992*

While Colorado, Wyoming, and Montana get much of the fly-fishing press, there are other states that quietly harbor some of the most magnificent country and spectacular trout fishing available. You don't hear about them as much, but true anglers, those who know, understand these places exist. One of them is northeastern Utah.

Located in this region are the Uintas Mountains, most of which are contained within Ashley National Forest, established in 1908 by President Theodore Roosevelt. The High Uintas Wilderness, established by Congress in 1984, includes 460,000 acres and is the largest wilderness area in Utah.

There are well over 1,000 natural lakes in the Uintas and more than 500 of them support populations of game fish. There are also more than 400 miles of streams. Elevations range from 8,000 feet in the lower canyons to 13,528 feet atop Kings Peak—the highest point in Utah. This is Falcon's Ledge's backyard.

Falcon's Ledge wasn't built in an architectural style that one

RIGHT: *A group of lodge guests cast in the famous Falcon's Ledge stillwaters.*

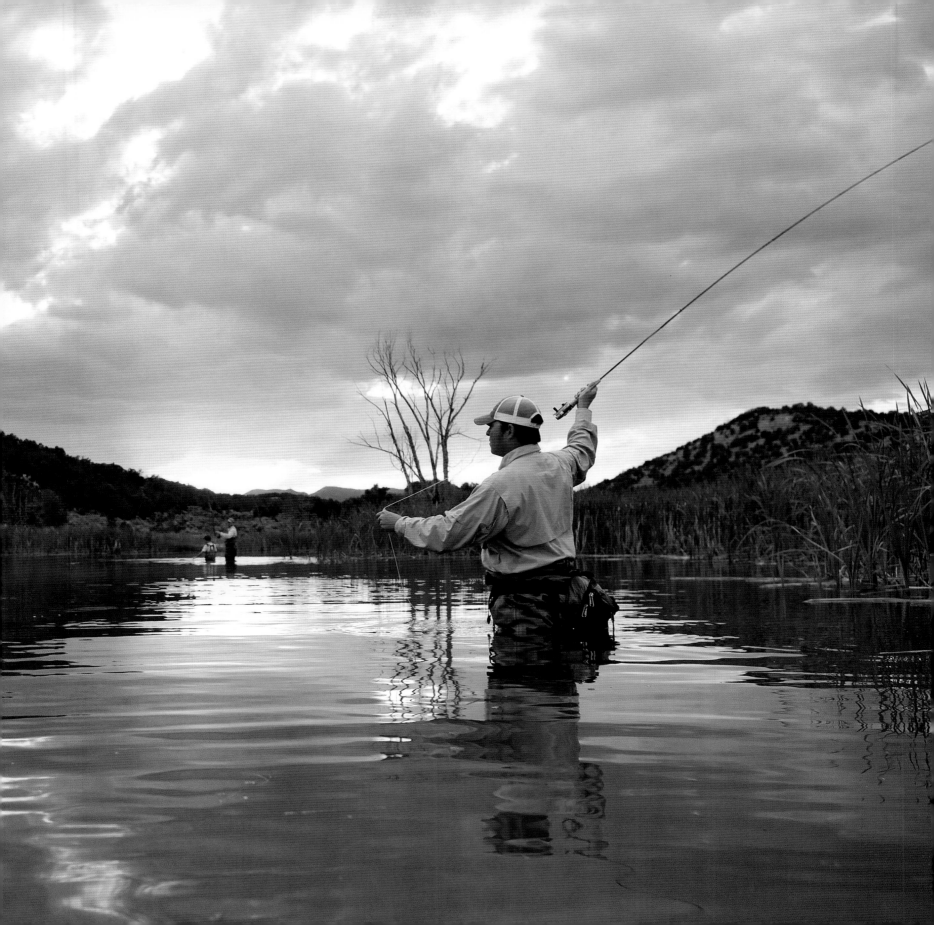

would generally expect in a western fishing lodge. Although it's a very modern structure, it blends interestingly with the topography of the valley in which it sits, and in some ways has the look of southwestern Pueblo architecture.

The lodge is set in a secluded private canyon surrounded by trout-filled waters. Passing through the entrance into Stillwater Canyon, you are immediately struck by the red rock cliffs and spires that shelter the birds of prey that give Falcon's Ledge its name. The setting is absolutely private, with no visible signs of civilization; it was designed specifically to be the ultimate retreat for anglers and bird hunters. Falcon's Ledge has been endorsed by Orvis almost since its inception and was the Orvis-Endorsed Lodge of the Year in 2001. It is one of the most distinctive lodges that you will find in the West, with more than 15,000 square feet of interesting and comfortable architecture, and secluded surroundings that are spectacular.

Fishing on waters such as the Strawberry, Lake Fork, and Duchesne rivers and Rock Creek, as well as numerous stillwater fisheries, the opportunity to catch big trout (particularly on the technically advanced Strawberry River) is significant. The stillwaters are the great secret, though. The eight stillwaters of this fly-fisherman's paradise are perfect habitats for trout to forage and grow. They hold an abundant population of brown, rainbow, tiger, and brook trout as well as the acrobatic Donaldson steelhead. The stillwaters hold many trophy-size fish; the largest fish to date was recorded at 32 inches, with the average fish in the 18- to 20-inch range. Each stillwater has its own secrets and idiosyncrasies that provide endless challenges and variety.

Finally there is the Green River. This legendary river offers up some of the best trout fishing there is. Pounding the banks with terrestrials at the right time of year can result in days that will live forever in anglers' dreams. If you're looking for something a little different, with fishing that is as good as it gets and a massive wilderness for a backyard, then Falcon's Ledge is as distinctive as its architecture.

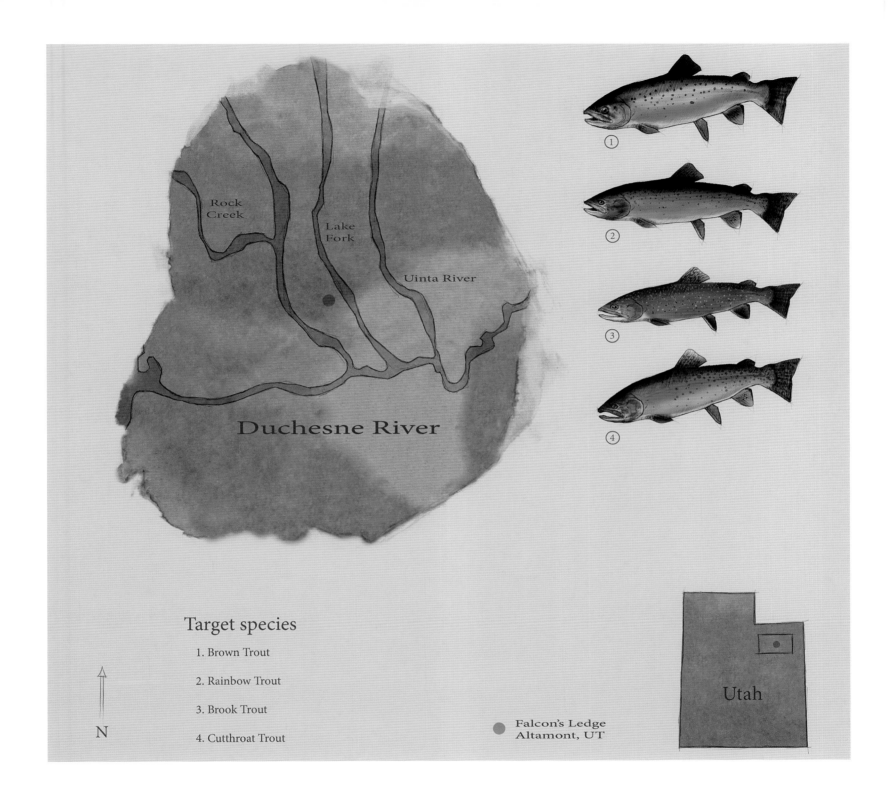

Rock
Creek

Lake
Fork

Uinta River

Duchesne River

Target species

1. Brown Trout

2. Rainbow Trout

3. Brook Trout

N

4. Cutthroat Trout

● Falcon's Ledge
Altamont, UT

Utah

OPPOSITE: *Falcon's Ledge, with its unique southwestern architecture, resembles a modern-day pueblo.*

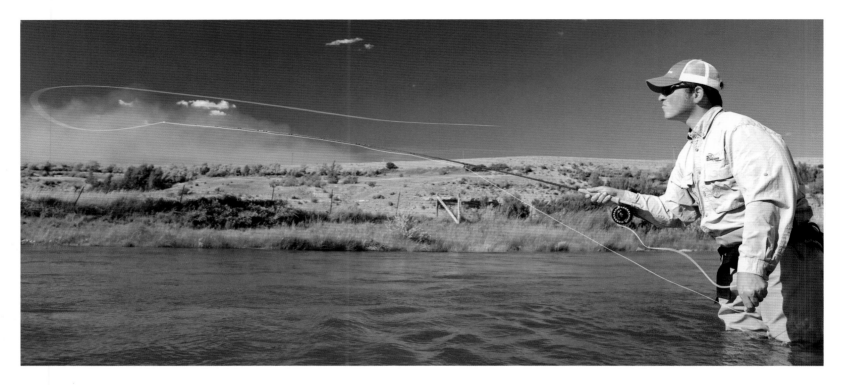

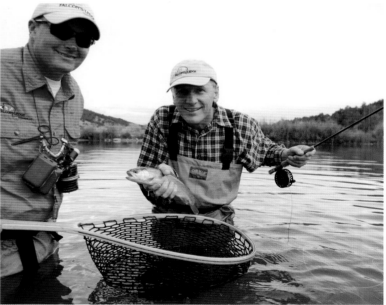

TOP: *Lodge Manager Spencer Higa throws a tight loop on the Strawberry River.*
BOTTOM LEFT: *These hook-jawed Utah browns are very aggressive and put up great fights.* BOTTOM RIGHT: *A happy Falcon's Ledge angler shows off his stillwater prize.*
OPPOSITE: *An angler works upstream on the Strawberry River.*

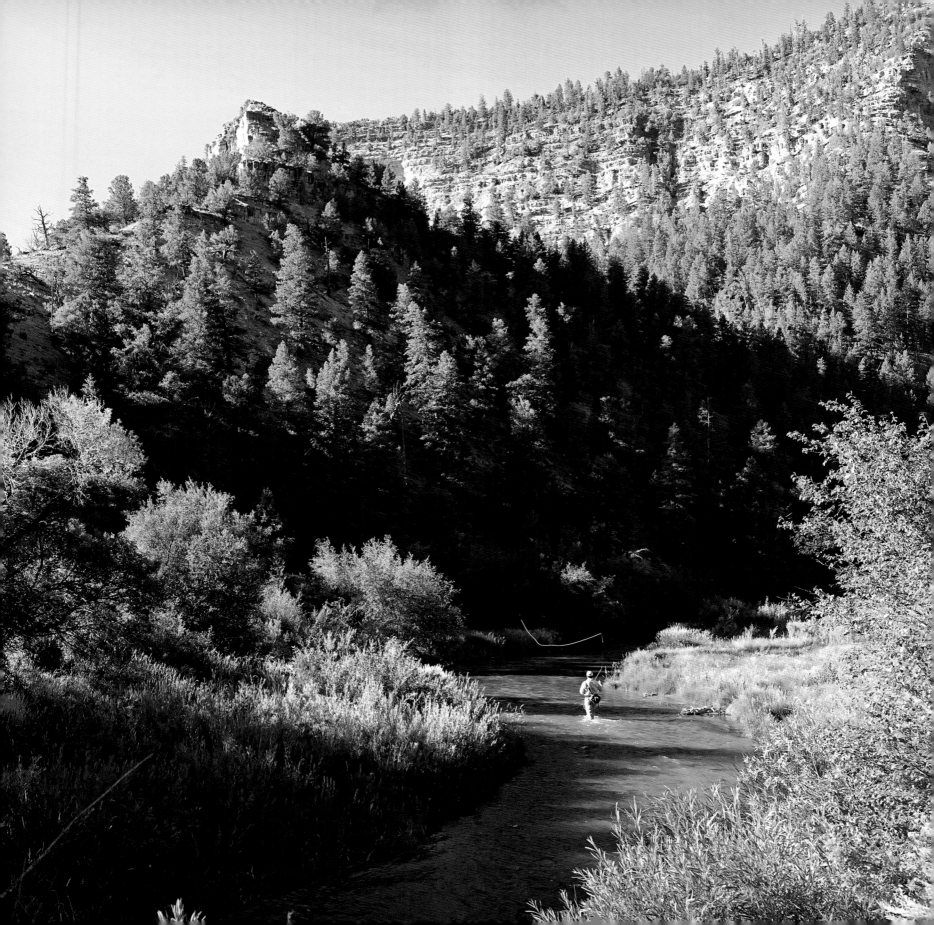

Morrison's Rogue River Lodge

MERLIN, OREGON

Located on the Rogue River, one of the wildest
waterways in North America
Founded in 1945

Tumbling out of Crater Lake in the Cascades and running 215 miles southwest to Gold Beach on the coast of Oregon is the Rogue River, one of the wildest and most beautiful waterways North America has to offer. One of the eight original rivers in the Wild and Scenic Rivers Act of 1968—which was enacted by Congress to protect these waters from development—the Rogue is now one of 166 protected rivers, comprising more than 11,000 miles of river in 38 states.

That the Rogue is one of the original protected rivers is a testament to its natural beauty, but anglers love it for another reason as well. Its exit into the Pacific Ocean is the entrance for three of the most sought after anadromous species of fish on the angler's target list: steelhead, coho or silver salmon, and chinook or king salmon, all of which move up into the Rogue to spawn during the fall season. Between the stunning beauty of this rugged free-running river and the angling opportunities available, the Rogue is one of the primary autumn destinations for anglers from all over the world.

RIGHT: *A Morrison's guide takes a guest out in a drift boat to fish in front of the lodge.*

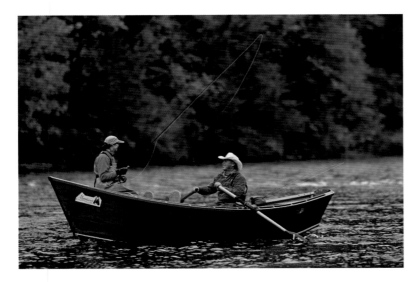

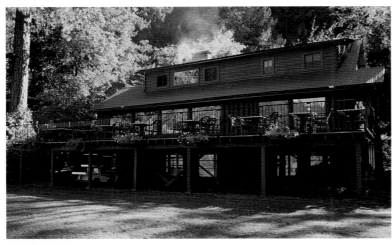

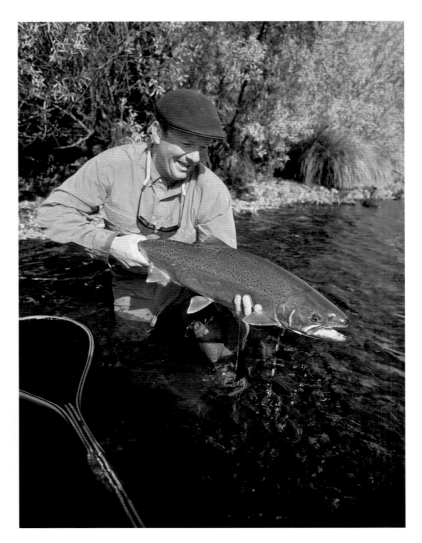

Located just west of Grant's Pass, Oregon, is one of the older and more famous fishing lodges on the river, Morrison's Rogue River Lodge. Built in 1945 by lumberman and fishing guide Lloyd Morrison, the lodge was purchased by the Hanten family in 1964 and has been in the family since; it's now being run by the third generation in its 44th year under the same ownership. In this rewarding but difficult business, where many lodges pass ownership on a fairly regular basis, this continuity of stewardship says volumes about the lodge and its dedication to guests' experience.

While the spring can offer "springers"—spring runs of king salmon—fall is when the action really begins with steelhead and kings coming in late August and September, and then silver salmon showing up later and continuing into November. All three of these species are heart-stopping on a fly rod, with kings running 35–45 pounds and steelhead putting up their signature back-alley fight. Fishing here is an adrenaline junkie angler's delight.

One of the techniques for fly fishing steelhead and salmon, which is fast gaining in popularity, is Spey casting, the use of a much longer rod and a technique that allows greater coverage of the river. Originating in the British Isles on the great salmon rivers of Scotland, Spey casting is not only an efficient way of covering the water, but is also one of the most beautiful and graceful techniques in presenting a fly. Morrison's has intro-

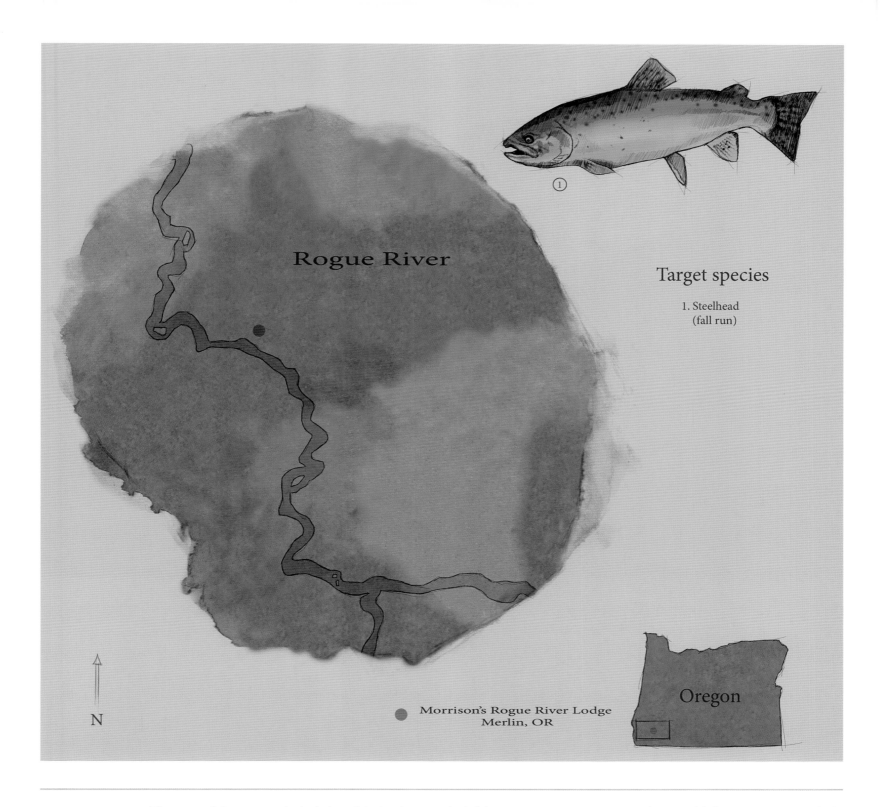

Rogue River

Target species

1. Steelhead
(fall run)

N

Oregon

● Morrison's Rogue River Lodge
Merlin, OR

OPPOSITE, TOP LEFT: *The waters of Oregon were the birthplace of the Mackenzie-style drift boats.* OPPOSITE, BOTTOM LEFT: *The original lodge at Morrison's was built by lumberman Lloyd Morrison.* OPPOSITE, RIGHT: *This beautiful steelhead is the reason anglers have been coming to this river for decades.*

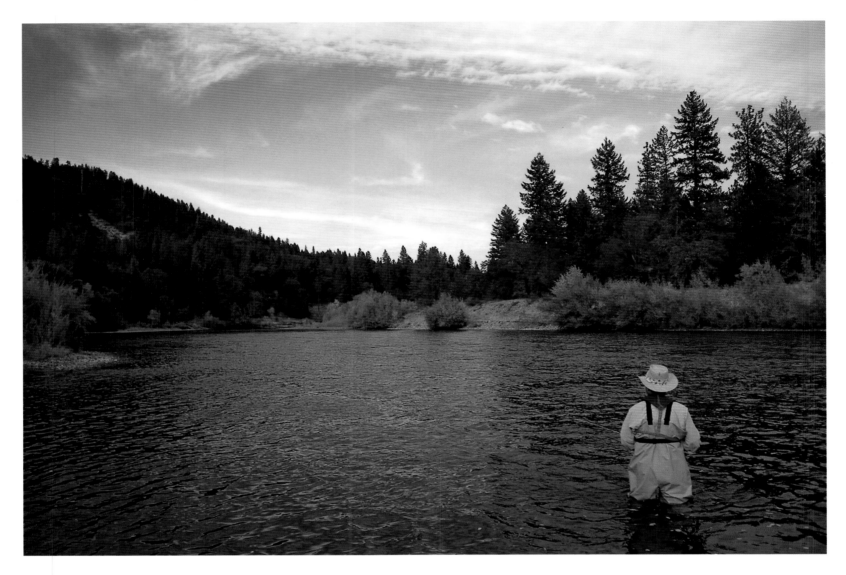

duced this form of casting recently and offers experienced anglers the opportunity to learn and fish this technique with expert guides and instructors.

The lodge itself was built by Lloyd Morrison out of handpicked bird's eye pine. Over the years the lodge has added nine cabins built on stilts that face the river, offering the guests a serene way to end the day after dining on award-winning cuisine, which has twice been featured in *Bon Appetit*.

Zane Grey loved the Rogue, as did Clark Gable. It is at once one of the nation's natural treasures and a fishing destination that offers the chance to hook into very big fish in very big country. Not a bad combination.

TOP: *An angler contemplates the beautiful Rogue River.*
OPPOSITE: *A lodge guest is Spey casting for steelhead in the big water.*

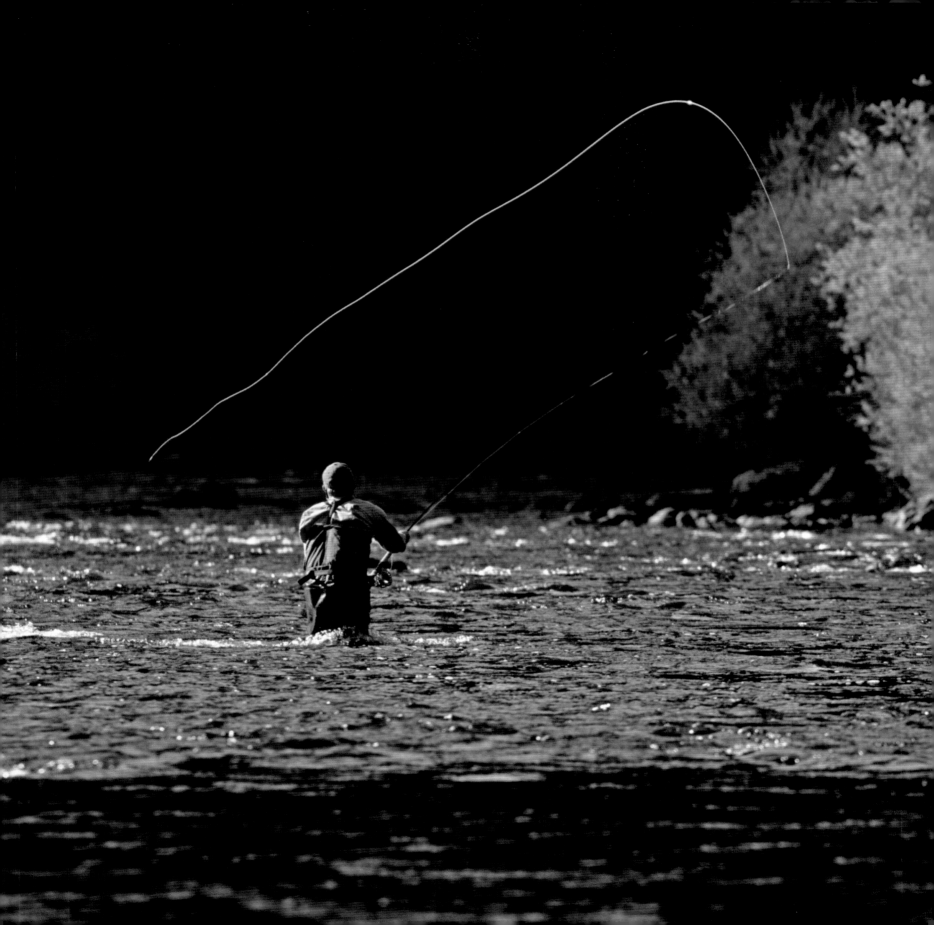

Oasis Springs

PAYNES CREEK, CALIFORNIA

*Located on Battle Creek
in the shadow of Mount Lassen
Founded in 1991*

There is something to be said for simplicity. There is focus. There is the ability to do one thing and do it well. While there are fishing lodges out there that offer vast amounts of water to fish, volumes of accommodations, and myriad other activities, Oasis Springs simply offers a beautiful lodge on an extraordinary stream. It has created a fishing paradise on 4,000 secluded acres, accessible only by one road in the shadow of Mount Lassen, a volcanic peak in the Mount Shasta region of northern California.

Some anglers would be reluctant to rely on one stream for their fishing vacation, but Battle Creek is not an ordinary stream, nor is it subject to the pressure and depredations of other anglers. Oasis Springs owns six miles of this remarkable stream that emanates from springs in the mountains and, combined with the snowmelt from the nearby volcanic peaks, creates a waterway of enviable purity. Add to that the topography or riffles and pools and you have what could be considered a near perfect place to fish for trout, steelhead, and Pacific salmon.

RIGHT: *An angler casts into the clear waters of Battle Creek.*

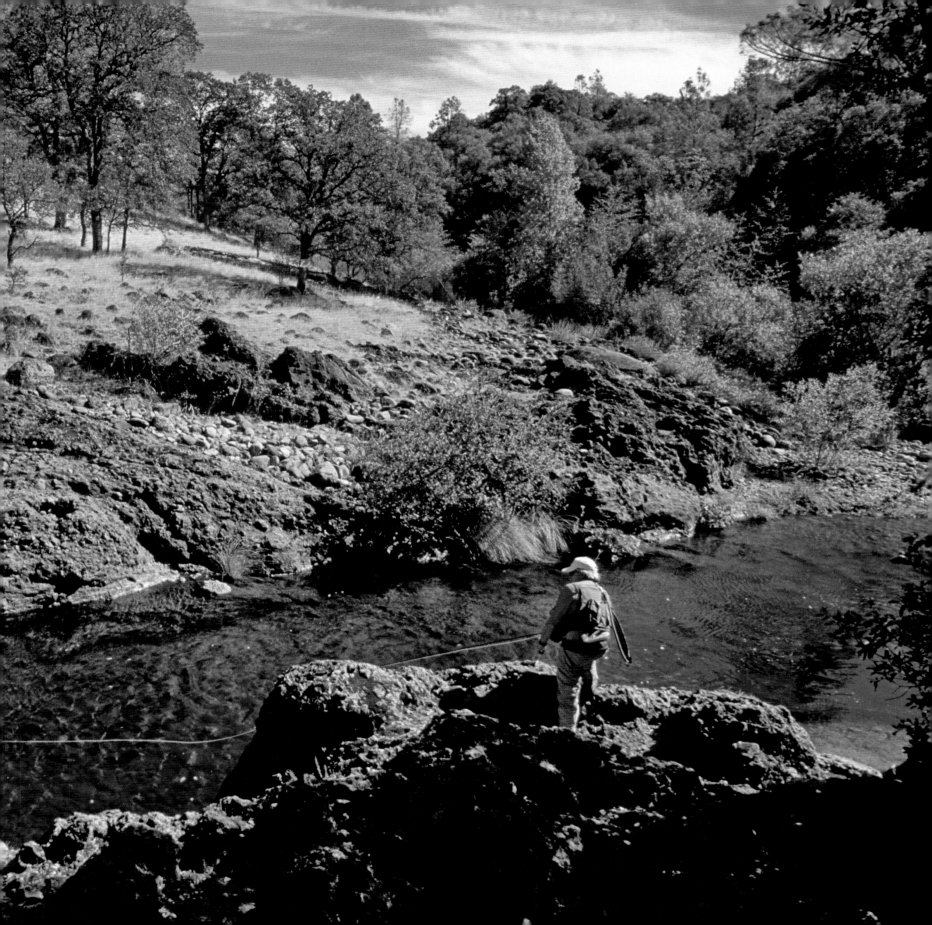

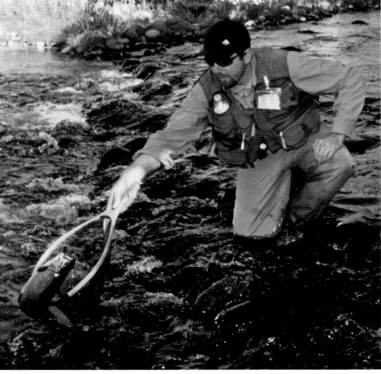

Within the confines of Oasis Springs water there are 15 pools beginning with the home pool in front of the lodge and ranging through more challenging pools with names like Ishi's Pool, Lonesome Trout, The Aquarium, Honey Hole, and Outlaw's Camp. What this means for the angler is a tremendous variety of water within the confines of a single ranch. No long trips, no wasted hours, the elimination of the stress of trying to get it all in before the stay is over. The idea of having the perfect trout stream a few steps away and the option of fishing unpressured pools full of salmonids for six miles is an angler's dream. It would take a very long stay indeed to tire of this kind of water. The lodge's catch-and-release policy ensures that the resource will be preserved intact and unchanged since the volcanoes formed it some 10,000 years ago.

The lodge was built in 1991 with a focus on the ecological preservation of the wilderness in which it resides. The 12,000-square-foot lodge sits on the banks of the stream and houses up to 22 guests. Perhaps the best feature of the lodge is the huge front porch, which faces the river. After a day's fishing, there is nothing better than a huge front porch on which to laugh and lie. The accommodations are plush, but not ostentatious, and if there is someone in the party who doesn't want to fish, there is the ability to hike for miles in some of the most beautiful country in the United States.

Oasis Springs is in fact an oasis. In an angler's world where the best fishing is often overfished, where the choices are too many, where human degradation is often visible, Oasis Springs offers simple perfection in its lodge, its hospitality, its food, and most certainly in the stream that runs before it.

TOP: *An angler searches for a stonefly nymph.* LEFT: *A wild Battle Creek trout comes to hand somewhere along the six miles of private water.*

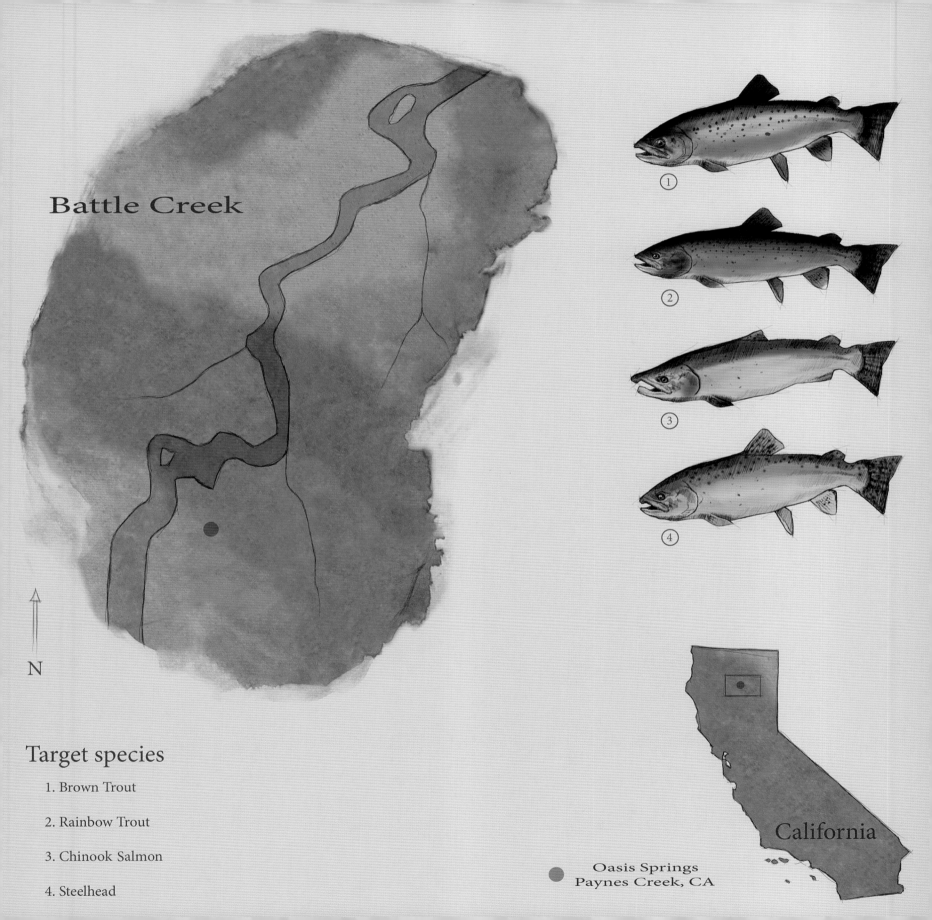

Battle Creek

Target species

1. Brown Trout

2. Rainbow Trout

3. Chinook Salmon

4. Steelhead

N

① Oasis Springs
Paynes Creek, CA

California

Sunriver Resort

SUNRIVER, OREGON

*Located on the Deschutes River
near the Cascade Mountains
Founded in 1968*

If one were asked to describe the geography of Oregon, perhaps the easiest analogy would be the human body. Oregon has a spine running up the middle of the state made up of the Cascades, a volcanic mountain range that cuts the state into two distinctly different climates: a wet, heavily forested western slope and the high desert of the eastern slope. Running parallel along the east side of the Cascade spine is a major artery, the Deschutes River, which is the lifeblood of the eastern high desert (to extend the analogy further), and one of the most revered fly-fishing rivers in North America.

The Deschutes rises in southern central Oregon and flows north picking up water from the Cascade Range and the eastern high desert region until it flows into the Columbia River, carving magnificent desert canyons up to 2,000 feet deep. In the river are the native redband rainbow, unique to this area, and the cultish anadromous rainbow or steelhead, which draws anglers from around the world who will go anywhere to pursue this big, hard-fighting species.

RIGHT: *This beautiful, all-purpose resort sits right on the Sun River.*

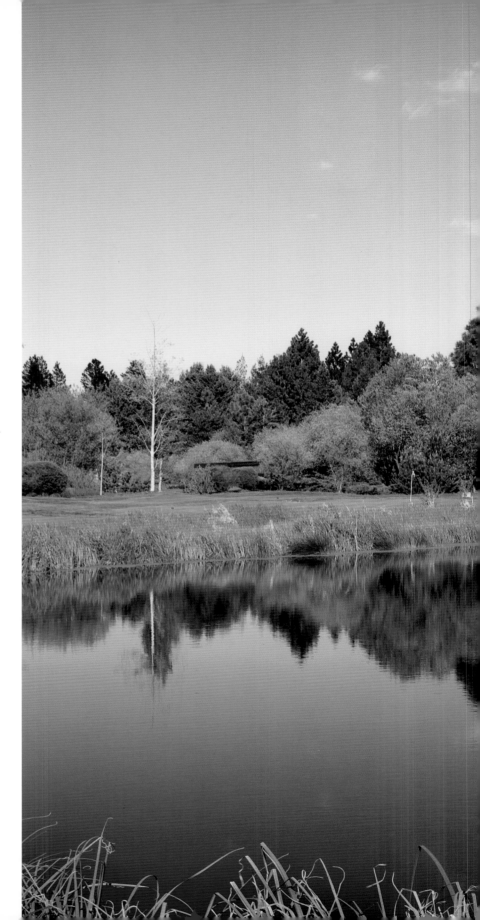

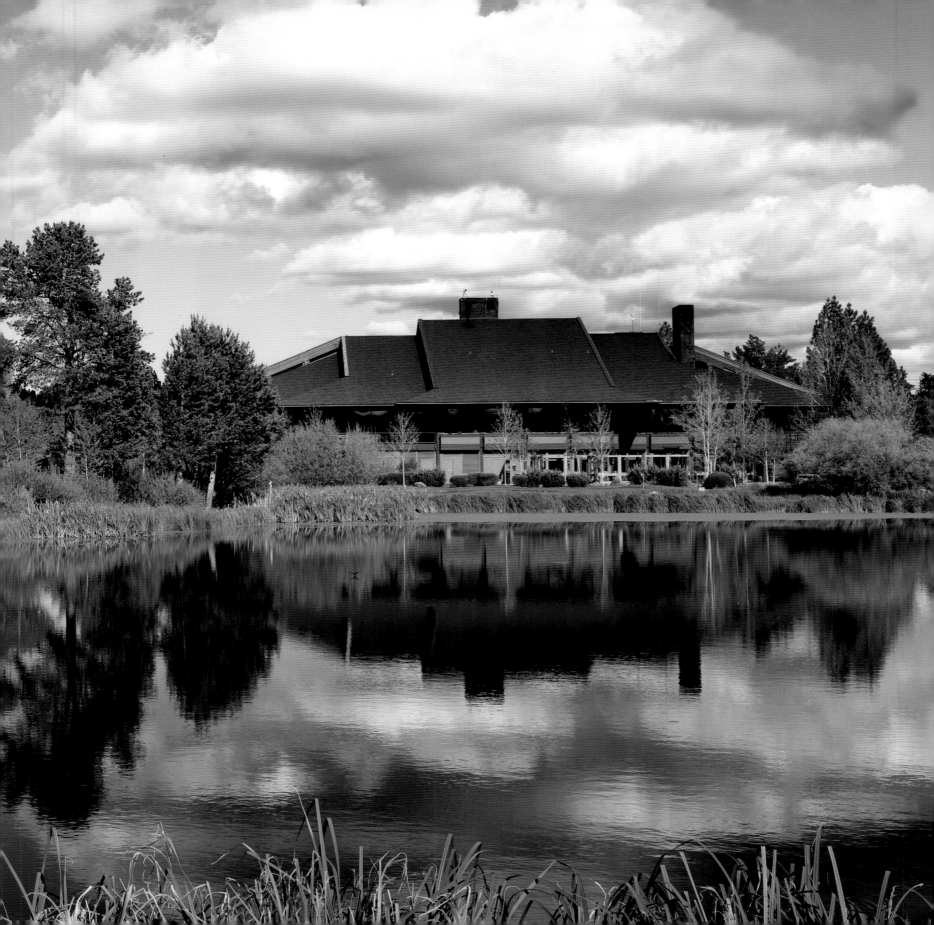

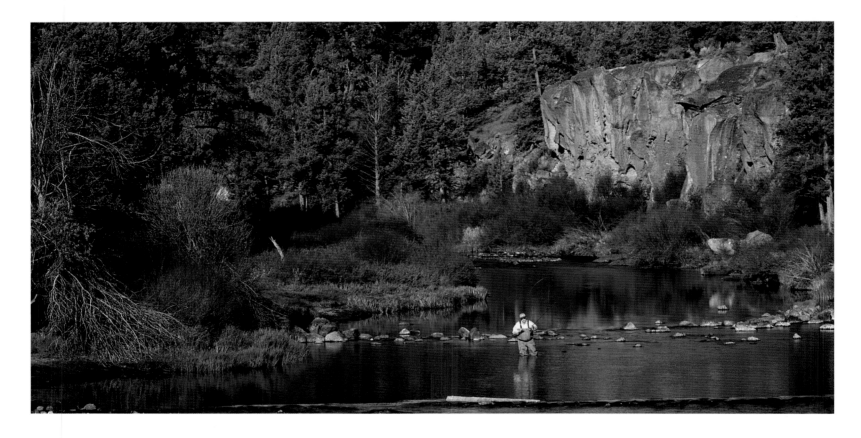

Sunriver Resort is a destination resort, which simply means it has something for everyone. It has more than 500 varied accommodations—from hotel rooms to private six-bedroom homes and everything in between. It offers four golf courses, a marina, stables, skiing in the winter at Mount Bachelor, spas, and great cuisine. Built in the magnificent northwest architectural style of massive log and stone structures, this is indeed an imposing resort.

But there is a difference here. Many destination resorts that offer fishing offer good fishing to be sure, but Sunriver offers anglers a superb experience. The Deschutes in all its legendary glory forms the western boundary of the resort, and the fishing is handled by one of the premier outfitters in the Northwest, Cascade Guides and Outfitters. They have access to more than 100 lakes and 400 miles of river within an hour of the resort, and offer half-day and full-day trips to almost all the rivers and lakes of central Oregon.

For the passionate angler, this is a blessing in some respects, for they are afforded the opportunity to satisfy the whims of their family with the resort's attractions, while at the same time pursuing an uncompromising fishery of legendary proportions. The Deschutes speaks for itself with its June salmon fly hatch where trout are keyed in on these huge stoneflies. It is arguably the best dry-fly fishing in the Northwest. Caddis and mayflies show up in mid- to late summer and then in August come the steelhead. The Fall River is a giant spring creek rising and running 10 miles before it dumps into the Deschutes, and its rainbows reach 20 inches. The Crooked River is a tailwater buried in a gorge, offering pools and riffles and year-round fishing for redband rainbows.

While Sunriver Resort is more than a fishing lodge, its location in this remarkable drainage and the emphasis given to this resource sets it apart from many big resorts. This is a place where the best of both worlds reside without compromise: spectacular amenities and fishing that is as good as North America has to offer.

OPPOSITE: *A lodge guest fishes for redband rainbows on the Crooked River, one of the great tributaries of the Deschutes River.* BELOW: *The Fall River winds its way toward the Deschutes.*

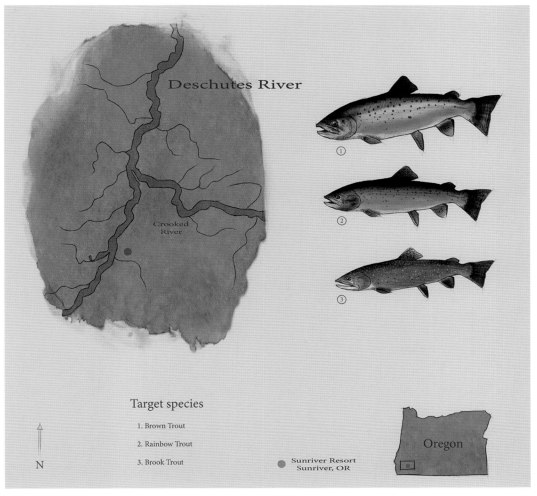

Deschutes River

Crooked River

Target species

1. Brown Trout

2. Rainbow Trout

3. Brook Trout

● Sunriver Resort
Sunriver, OR

Oregon

N

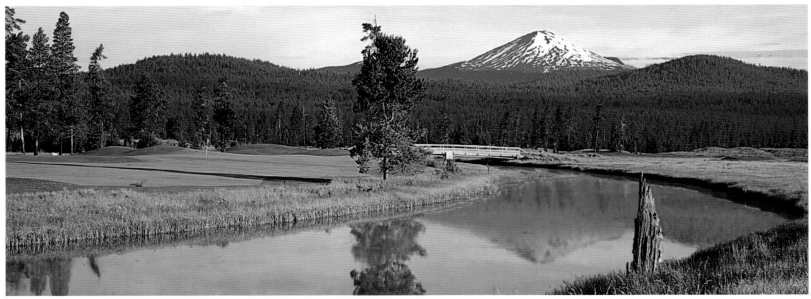

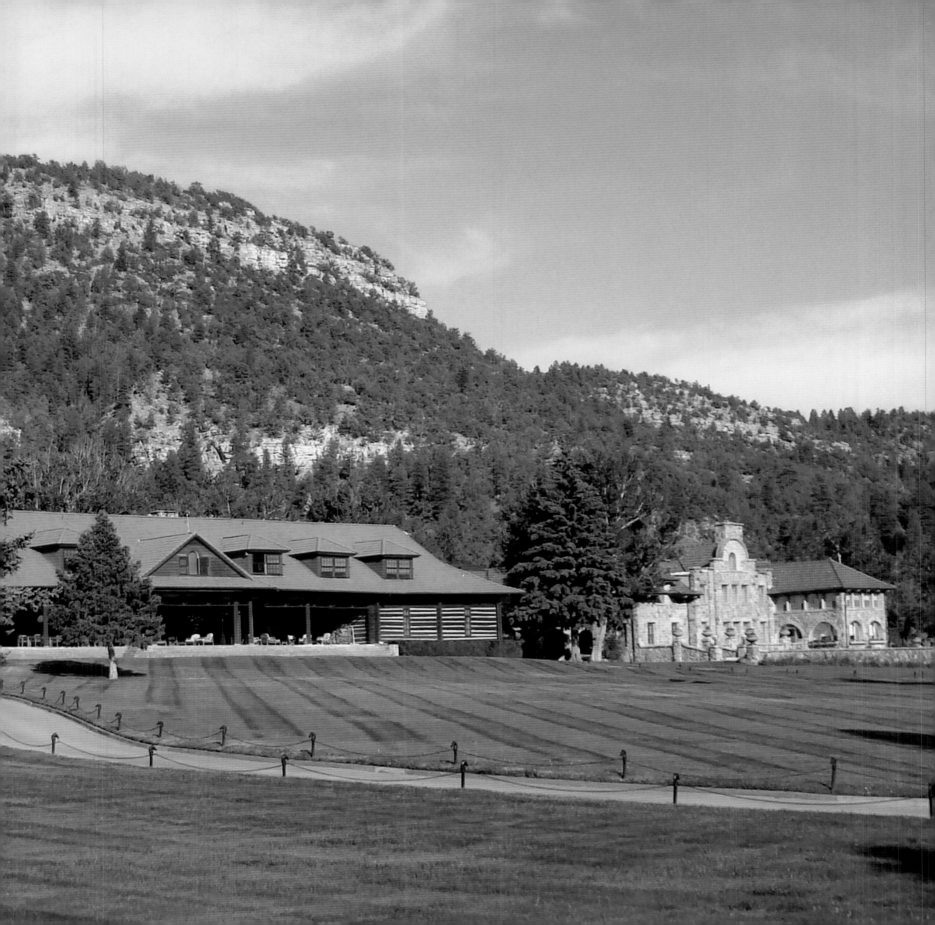

Vermejo Park Ranch

RATON, NEW MEXICO

Located on 588,000 acres of wilderness near the Sangre de Cristo Mountains
Founded in 1841

Vermejo Park Ranch is the largest landholding of the largest landholder in the world, Ted Turner. The ranch encompasses more than 588,000 acres of wilderness in the northern New Mexico portion of the Sangre de Cristo Range. Running southeast from Colorado into northern New Mexico is the southernmost range of the Rockies, the Sangre de Cristo (Spanish for "the blood of Christ") Mountains. They got their name from the blood red color of the mountains at sunrise and sunset, particularly when the peaks are covered in snow. It is a magnificent range of mountains with many "fourteeners"—peaks higher than 14,000 feet—that offers some of the most spectacular wilderness still left in the lower 48 states.

Vermejo Park Ranch is the heart of the famous two-million-acre Maxwell Land Grant created in 1841 and named after Lucien Maxwell, a fur trader colleague of Kit Carson. Over the years various owners acquired and managed the property, including a group of businessmen in the 1920s who turned it into a private club with members including Douglas Fairbanks and Mary Pickford, as well as business and political titans Harvey Firestone and Herbert Hoover. Today it is owned by Ted Turner, who is committed to returning the ranch to its ecological origins through a variety of ambitious projects.

One of the projects is the reintroduction of the prairie dog, the black-footed ferret, the American bison, and sustainable wolf populations. There are now thriving populations of black bear, coyotes,

OPPOSITE: *The lodge at Vermejo Park Ranch used to be a favorite haunt of actors Mary Pickford and Douglas Fairbanks, Jr.*

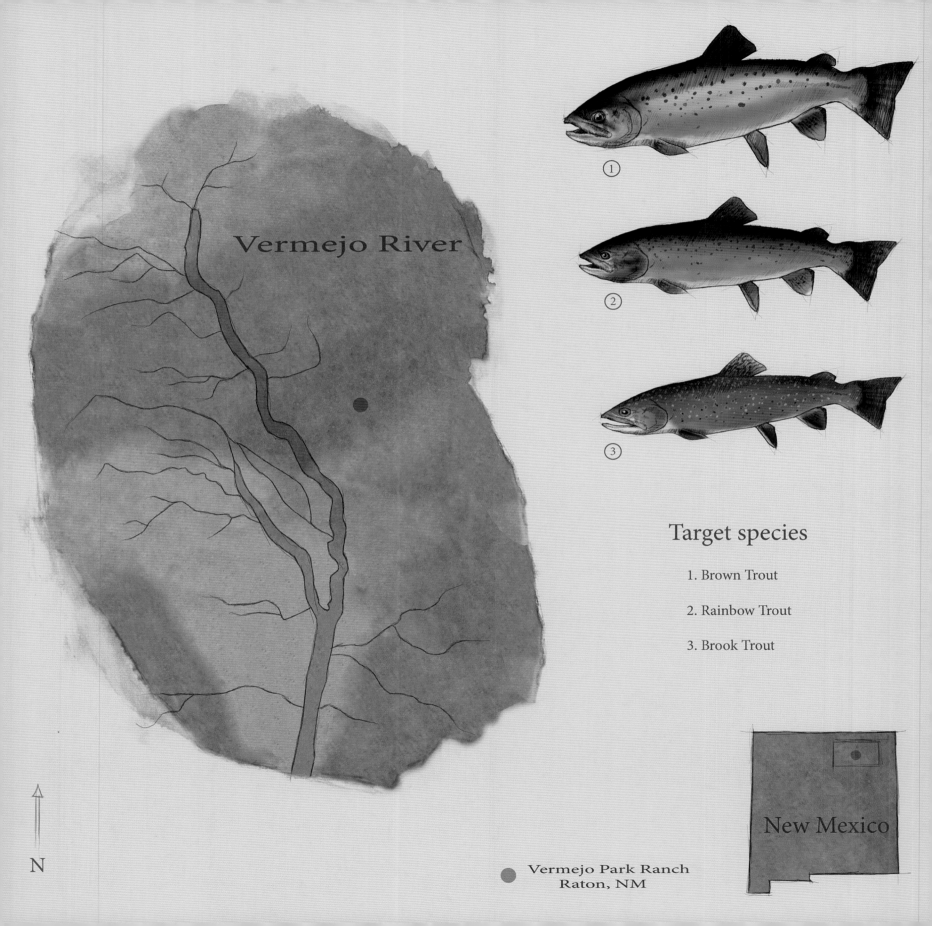

Vermejo River

Target species

1. Brown Trout

2. Rainbow Trout

3. Brook Trout

New Mexico

N

Vermejo Park Ranch
Raton, NM

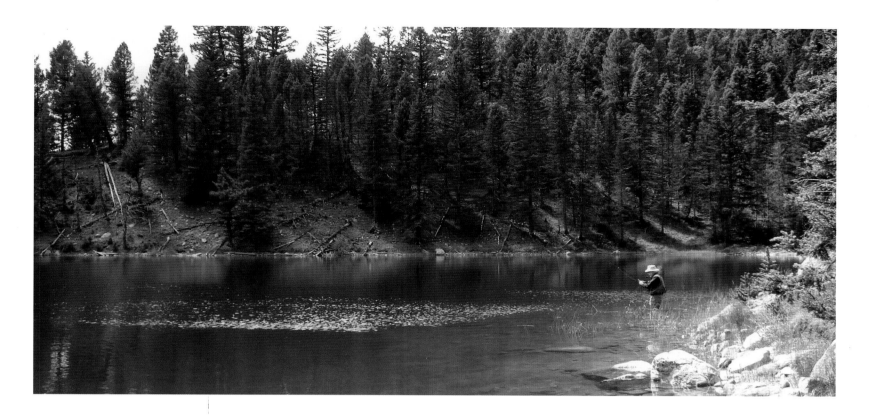

and even mountain lions. Vermejo is home to one of the last bastions of the Rio Grande cutthroat trout, and their habitat is actively being expanded and protected. More than 60 percent of the land on the ranch is Ponderosa pine forest; through the use of select cutting and controlled burning of more than 20,000 acres a year, Vermejo is returning this ecosystem to a state not seen since the arrival of the first Europeans.

In returning this ranch to its original ecological state, the hunting and fishing is returning to its original state as well. There are 21 lakes and more than 30 miles of pristine streams offering anglers the opportunity to fish the lakes for big browns and rainbows and pursue native brook trout and Rio Grande cutthroat in their natural environment. Hunters can pursue elk, pronghorn antelope, mule deer, turkey, and even bison. Given the vastness of the ranch, there are distinct ecosystems from the alpine tundra of the west side to the high prairie grasslands on the east side of the range.

Very rarely can a single landholding this large be found. Even rarer is a commitment from the owner to spend the resources necessary to bring it back to its original state and offer it to the discerning sportsman. This is an astonishing opportunity to experience the great southwest as it was long before the incursion of European settlers. It is one of those rare places where one doesn't have to wonder what it was like before we came.

TOP: *An angler fishes on the Upper 7 Lakes at Vermejo Park Ranch.*

Canada

Camp Bonaventure

BONAVENTURE, QUEBEC

Located in the heart of the Gaspe Peninsula on the Bonaventure River
Founded in 1993

One can argue about the virtues of various game fish around the world—the hardest fighting, the most difficult to catch, the best eating—but there is little argument that the king of all game fish in terms of history, literature, and tradition is the Atlantic salmon. Add to that the fact that it ranks at or near the top of the first three categories as well.

Historically there is no fish that is as revered as the Atlantic salmon. The amount of literature devoted to the pursuit of this one fish is extraordinary and the history of the sport of fly fishing is centered around the development of the techniques used over the years to catch this fish. It is the patriarch from which the family tree of fly fishing emanated.

There are legendary rivers where this fish returns to spawn, rivers that are familiar to even those who don't fish for salmon, simply because of the ubiquitous nature of their presence in fly-fishing literature: the Grand Cascapedia, Petit Cascapedia, Miramichi, Bonaventure, and Restigouche, to name a few. These names resonate with tradition unlike any other rivers and the camps on these rivers are piscatorial hallowed ground.

Camp Bonaventure lies on the Bonaventure River, which is called Wagamet (clear water) by the local Mic-Mac aboriginals, and flows for 76 miles down from the Chic Choc Mountains found deep in the heart of Gaspe Peninsula's interior before emptying into the Baie des Chaleurs. Atlantic salmon and sea trout travel a

PAGES 210–211: *The lower Dean River is one of the best places for steelhead in Canada.* OPPOSITE: *A lodge guest fishes the Bonaventure River.*

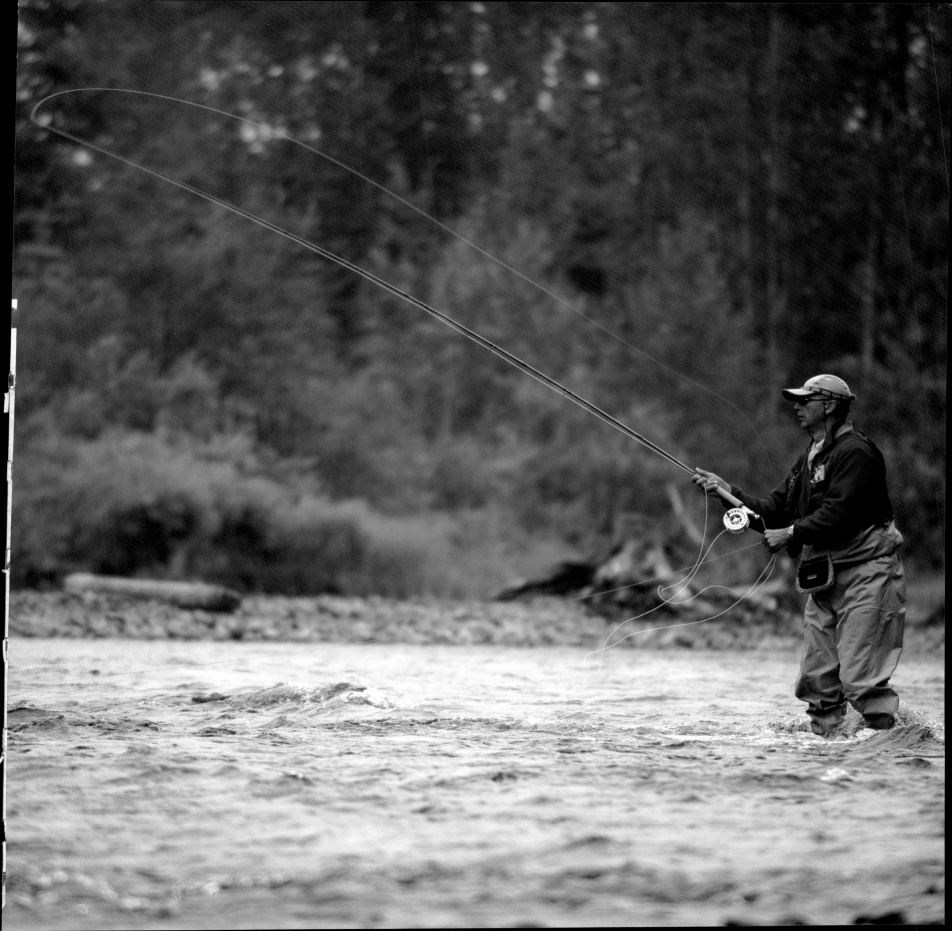

great distance up the main river, and there are 103 named pools, and almost as many unnamed runs and little holding areas scattered throughout the area.

A truly spectacular river, the Bonaventure is one of the clearest rivers in the world: anglers are treated to sight fishing for big Atlantic salmon up to 30–40 pounds. Perhaps what makes it most remarkable is that the Bonaventure fishes well on dry flies. Watching a big Atlantic leave its lie and attack a dry fly on the surface is something that no angler can ever forget.

The Bonaventure has one of the biggest runs of salmon of all the Gaspe rivers, with between 2,000 and 3,000 returning annually. With an almost ever-changing pool structure, the "Bonnie" offers the angler almost every type of fishing situation possible. Depending on water levels and sectors, the river can be waded, but to truly see and appreciate the river, a canoe is a must. Watching

one of the native guides pole a canoe down the river in the traditional fashion is a treat unto itself.

For anglers fishing Camp Bonaventure there is access to both the Cascapedias: the Little Cascapedia known particularly for its run of big sea-run brook trout and the Big Cascapedia for the often enormous size of its individual salmon.

When the day is over, anglers return to one of the most well-appointed salmon lodges on any river. Sitting in a birch grove on the banks of the Bonaventure are the main lodge and guest house, both built in a rustic elegance that pays homage to the tradition of the great salmon camps. It is designed to be exactly what a salmon camp should be. A visitor to Camp Bonaventure is offered not only the opportunity to fish for the king of game fish, but also to take his or her place in the tradition that is Atlantic salmon fishing.

TOP: *The Bonaventure River in Quebec is one of the clearest rivers in the world.* OPPOSITE, TOP: *This classic poled guide canoe seems to float in midair on the waters of the Bonaventure River.* OPPOSITE, BOTTOM LEFT: *The most storied and revered game fish of all is the Atlantic salmon.*
OPPOSITE, BOTTOM RIGHT: *The inviting and comfortable main lodge interior at Camp Bonaventure is where the tales and lies are told.*

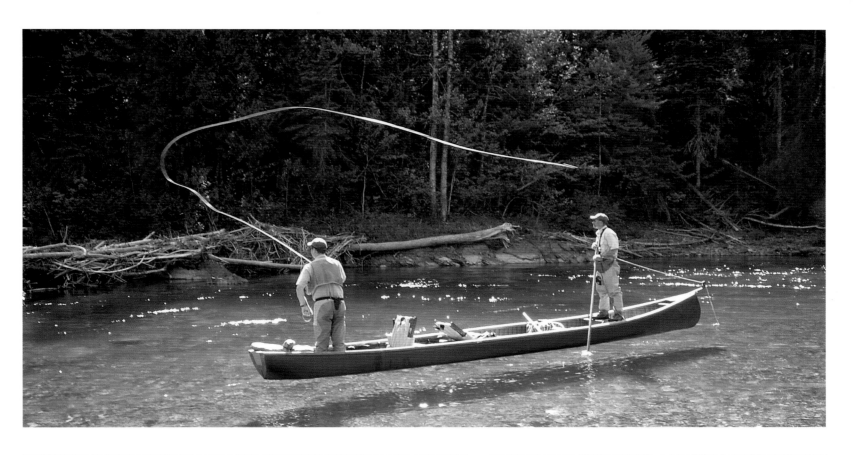

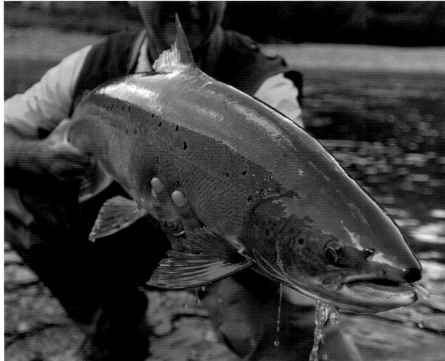

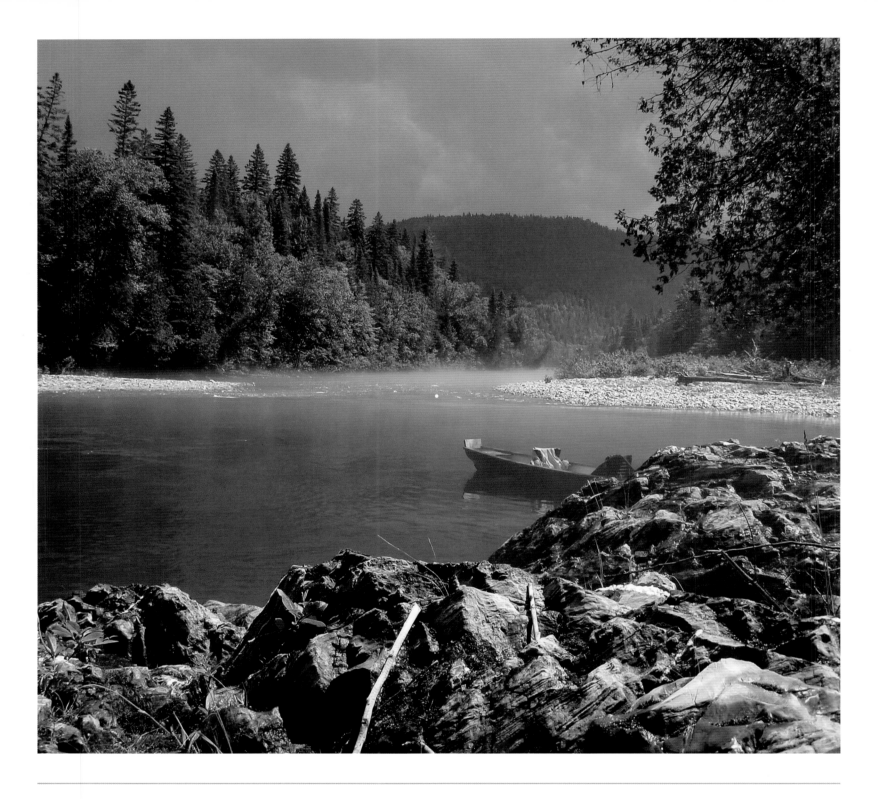

ABOVE: *A guide canoe rests near the shore of a pool.* OPPOSITE, TOP: *The strength and beauty of the Atlantic salmon can never be overstated, as shown by this magnificent specimen.* OPPOSITE, BOTTOM RIGHT: *An angler hooks up on the "Bonnie."*

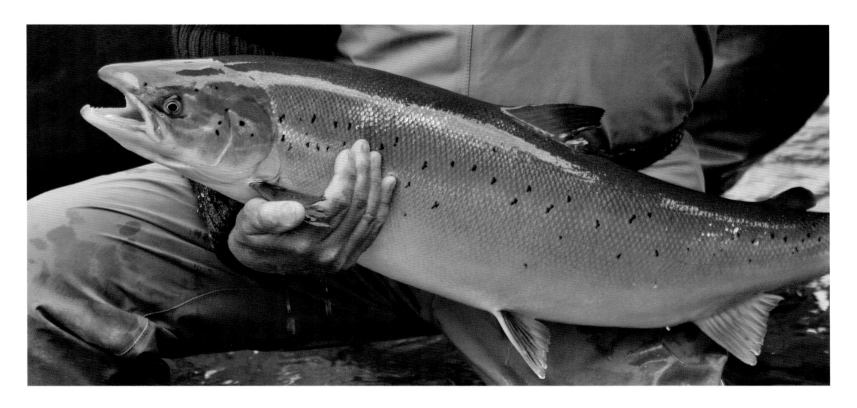

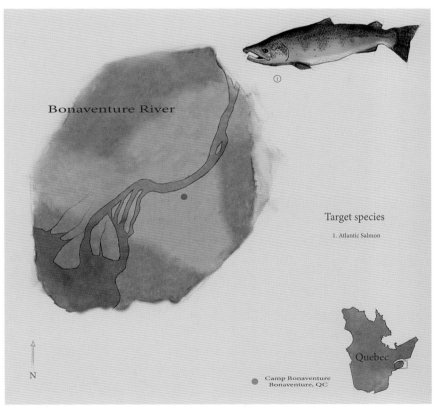

Bonaventure River

Target species

1. Atlantic Salmon

N

Quebec

Camp Bonaventure
Bonaventure, QC

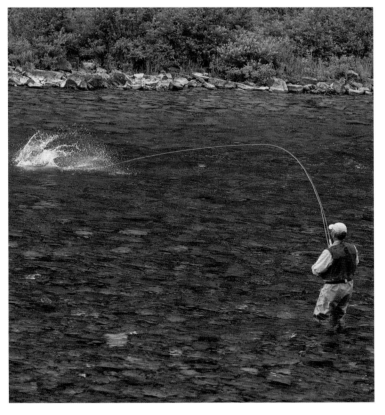

Fairmont Kenauk at Le Château Montebello

MONTEBELLO, QUEBEC

Located on a private wilderness reserve near the Outaouais River
Founded in 1930

If there is one dream that every outdoorsman has, it is to have his own cabin, tucked somewhere on a lake full of fish, surrounded by wilderness. The ultimate dream is that the lake has no other cabins or people on it. It is his own private kingdom to which he wakes only to the call of the loons.

Not many outdoorsmen will achieve this dream, but it can be a reality in one of the largest and most beautiful private wilderness reserves in North America. Fairmont Kenauk at Le Château Montebello was formerly known as "Reserve de la Petite Nation," a 100-square-mile, 65,000-acre protected wilderness domain originally granted by the King of France in 1674 to Quebec's first bishop, Monseigneur Laval. Located near the Outaouais River west of Papineau Lake, halfway between Ottawa and Montreal, Fair-

mont Kenauk is associated with Fairmont Le Château Montebello, a historic luxury resort with a legendary red cedar log building that has welcomed guests from around the world since 1930.

Fairmont Kenauk is one of North America's largest and longest-established private fish and game reserves, boasting more than 70 lakes within its borders. The reserve employs its own biologists to ensure preservation of the spectacular resources, and naturalists are available for guided exploration of the property.

The Seigniory Club, as it was known at the turn of the 20th century, was a favorite refuge of heads of state, royalty, and celebrities seeking privacy. The gates of the preserve open to a road that leads to the 13 four-star chalets, eight of which are located on their own lake and are the only structures there. Each chalet comes

OPPOSITE: *One of the wilderness cabins at Fairmont Kenauk overlooks a small stream.*

equipped with propane lights, stove, furnace, and hot water tank. All cabins are off the electrical grid so solar panels power the high-efficiency refrigerator and water pump. Ten cabins have a spacious screened porch. Each cabin also has its own unique location attributes, like nearby waterfalls or superb views. All have been recently renovated and accorded four-star chalet ratings. While there is no cellular phone coverage at Fairmont Kenauk and the only black-berries grow on bushes, two-way radios in each cabin provide communication with the entrance gate.

For the angler, this is heaven. Each of the chalets is equipped with its own boats and each morning there is nothing better to do than paddle out on the still and quiet lake alone and fish. These lakes support a remarkable array of game fish including rainbow, brook, lake, and brown trout, largemouth and smallmouth bass, and northern pike. There is no one on the lake except the visiting angler, and the pressure on these fish is minimal. Not only are the lakes full of fish, but the many rivers and streams that run through the property are flush with trout as well and the opportunities are close to overwhelming.

The word "kenauk" comes from "mukekenauk," the word for turtle in the language of the original Algonquin inhabitants of the land. The symbol of Fairmont Kenauk is the turtle and perhaps rightly so, for coming to this wilderness retreat with the elimination of any outside stimulation is the ultimate way to slow down.

TOP: *Many of the wilderness lakes on the "Reserve de la Petite Nation" have a single cabin and the guest has his own private domain.*

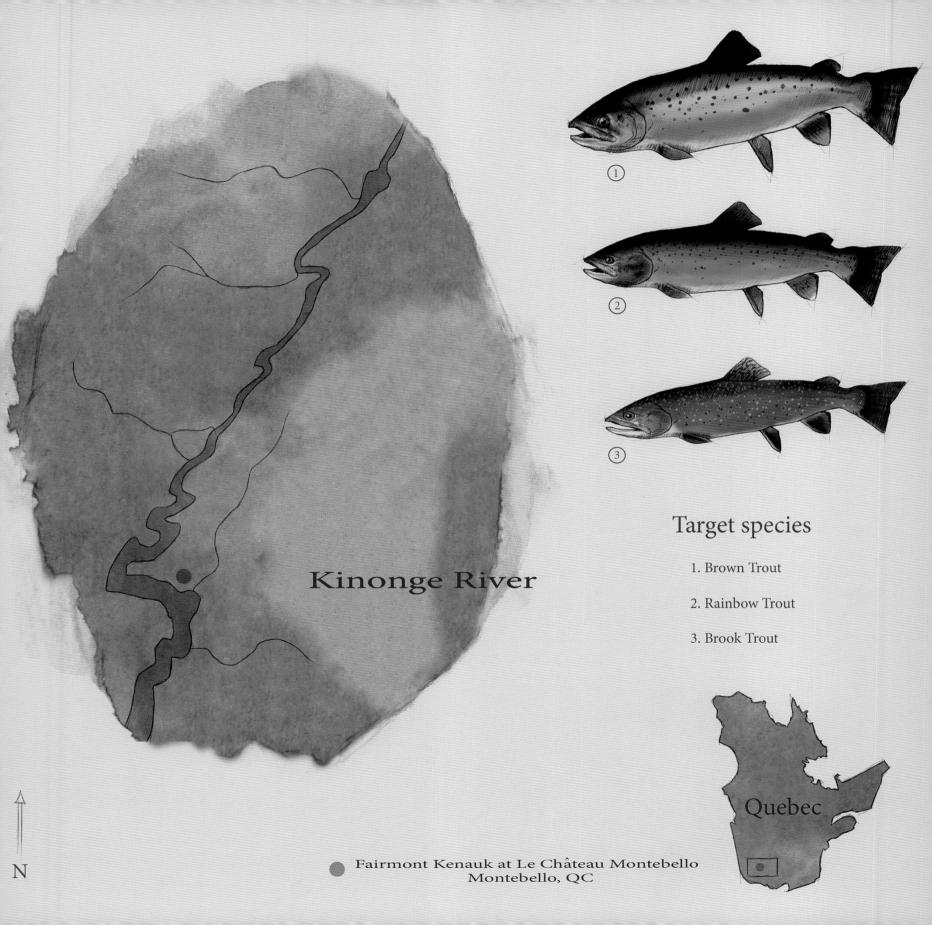

Kinonge River

Target species

1. Brown Trout

2. Rainbow Trout

3. Brook Trout

Quebec

Fairmont Kenauk at Le Château Montebello
Montebello, QC

N

Minette Bay Lodge

KITIMAT, BRITISH COLUMBIA

*Located between coastal mountains and forested
wilderness on the shores of the Douglas Channel
Founded in 1999*

Mention the words "fishing lodge" and "British Columbia" together and the first thought is perhaps that of a massive log structure and all the rustic surroundings that accompany it. Minette Bay Lodge is anything but. While the scenery is certainly rustic and the fishing is without equal, the lodge itself is a remarkably beautiful manor house, built and appointed in the finest tradition of the English countryside with all the attendant pleasures of a library, sitting rooms, verandahs, and even a large lawn for croquet. If the guests never venture outside to see what surrounds the lodge, they might think they were somewhere in Hampshire. The rooms are full of antiques and all have large feather beds that offer a splendid respite after a long day in the northwestern outdoors.

Don't let the extraordinary décor and feel of England fool you. You are squarely in the middle of one of the greatest salmon and steelhead fisheries in the world, with access to waters such as the Kildala, Giltoyees, Kemano, and Foch rivers, and other remote rivers that rarely see an angler's footprints. That seemingly benign lawn for croquet doubles as a landing pad for the helicopters that give anglers the ability to set down on waters seldom fished by others simply because of inaccessibility. A day of heli-fishing, as it's called, begins with leaving the lodge after breakfast, flying to remote pools in these rivers, and moving from remote pool to remote pool—all the while hooking into trophy-size fish.

In the spring the chinook is targeted on the Skeena and Kalum rivers, home to the largest chinook in the world. These monsters

OPPOSITE: *This aerial view shows the blue waters of the Giltoyees River in British Columbia.*

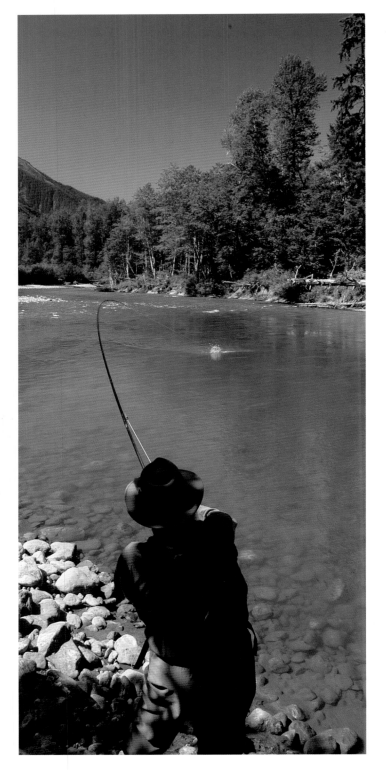

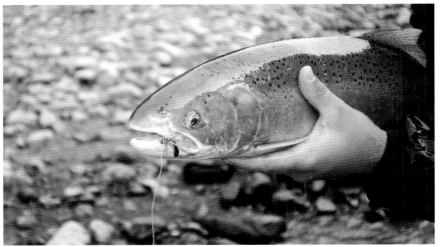

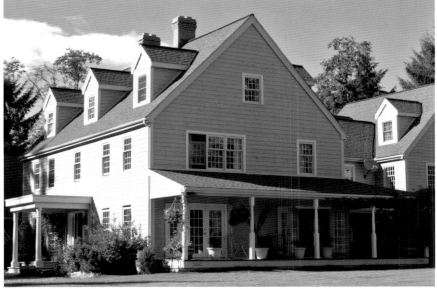

LEFT: *A steelhead hammers a fly on the Kildala River in British Columbia.* TOP: *The steelhead is the sea-run cousin of the rainbow trout and is just as angry, if not more so, when hooked.* ABOVE: *The main building of Minette Bay Lodge is an English-style manor house.*

Hecate Strait

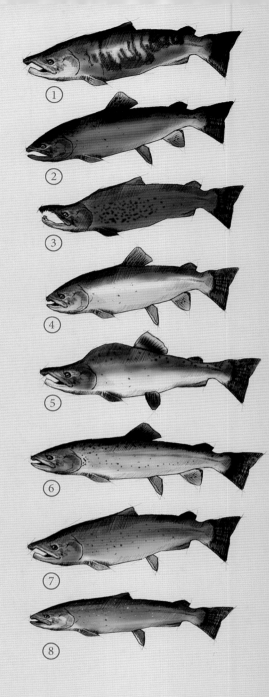

Target species

1. Chum Salmon

2. Cutthroat Trout

3. Sockeye Salmon

4. Steelhead

5. Pink Salmon

6. Rainbow Trout

7. Coho Salmon

8. Dolly Varden

N

British Columbia

 Minette Bay Lodge
Kitimat, BC

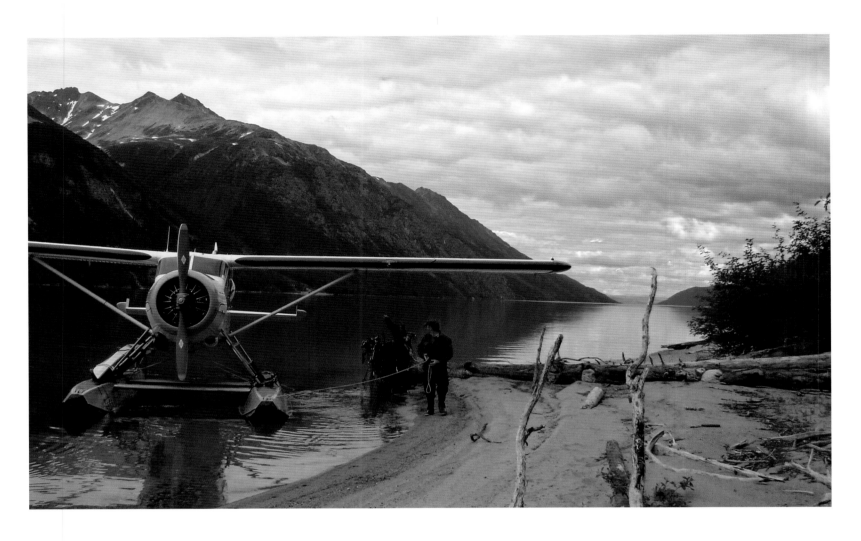

average 30 pounds, and fish more than 50 pounds are common. The largest sport-caught chinook was brought to shore here, weighing a fraction under 100 pounds.

The spring and summer brings steelhead and its hallmark fighting capability that drives anglers to extremes to catch this legendary fish. Perhaps no other fish in the world boasts quite the cult following as the steelhead. Runs of 60,000 or more are common in these rivers.

Minette Bay offers more: fishing these rivers from drift boats, kayaking the estuarial waters of the bay, running the rivers in search of grizzly bears feeding on salmon, heli-hiking to places most will never see. This lodge experience is second to none. The proprietors found one of the most beautiful places in the world, situated in the middle of perhaps the best anadromous species fishing available, and built a lodge of incongruous elegance in the middle of it. Then they created a way to transport their guests to places of spectacular beauty, hidden from the rest of the world by the very nature of their remoteness and inaccessibility. For the angler in search of steelhead dreams or the naturalist in search of the last best places, Minette Bay Lodge is difficult to pass up.

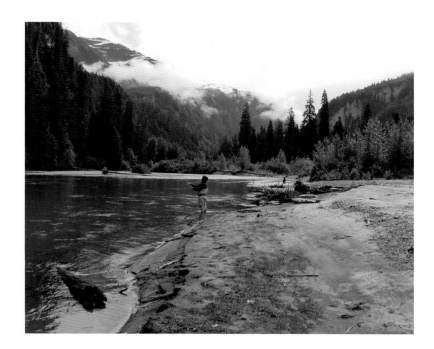

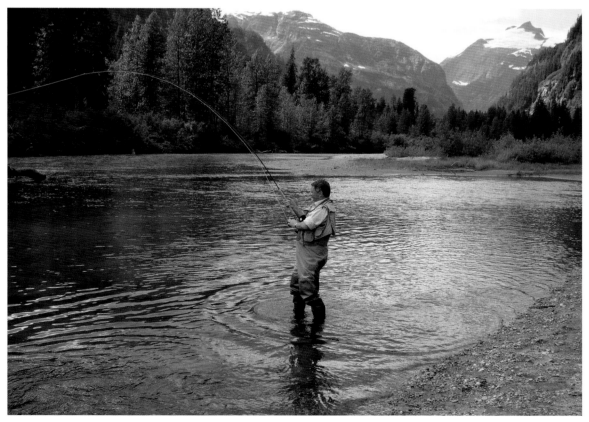

OPPOSITE: *A pilot brings his Beaver ashore in one of British Columbia's fjords.*
TOP LEFT: *A lodge guest fishes the gravel bars of the Giltoyees River.*
TOP RIGHT: *Two anglers pick their way across the river in search of salmon.*
RIGHT: *A bent rod is not an unusual sight on the rivers of British Columbia.*

Moose Lake Lodge

ANAHIM LAKE, BRITISH COLUMBIA

*Located deep in the heart of the
British Columbian wilderness
Founded in 1969*

British Columbia is one of the most ruggedly beautiful regions of North America, if not the world, ruggedly being the operative word here. From the Pacific Coast the mountain ranges rise in succession, cut and drained by an extraordinary system of lakes and rivers. This environment creates a diverse ecosystem teeming with wildlife and, due to the magnificent but difficult nature of the topography, still somewhat inaccessible to most men's efforts. For that reason it remains mostly wilderness and shares its heart only to those willing to live by its rules. John and Mary Lou Blackwell are just such a couple.

In 1969, John took Mary Lou and their two small sons and homesteaded a piece of land on the shores of Moose Lake, deep in the heart of the British Columbian wilderness. Their land was 70 miles by trail from the nearest town of Anahim Lake, a tiny outpost 200 miles by poor dirt road from Williams Lake. To survive here was a big enough task, but to build a lodge business from nothing was a seemingly insurmountable job. Mail and supplies

RIGHT: *The floatplanes at Moose Lake Lodge fly out to remote, rarely fished areas to drop off anglers.*

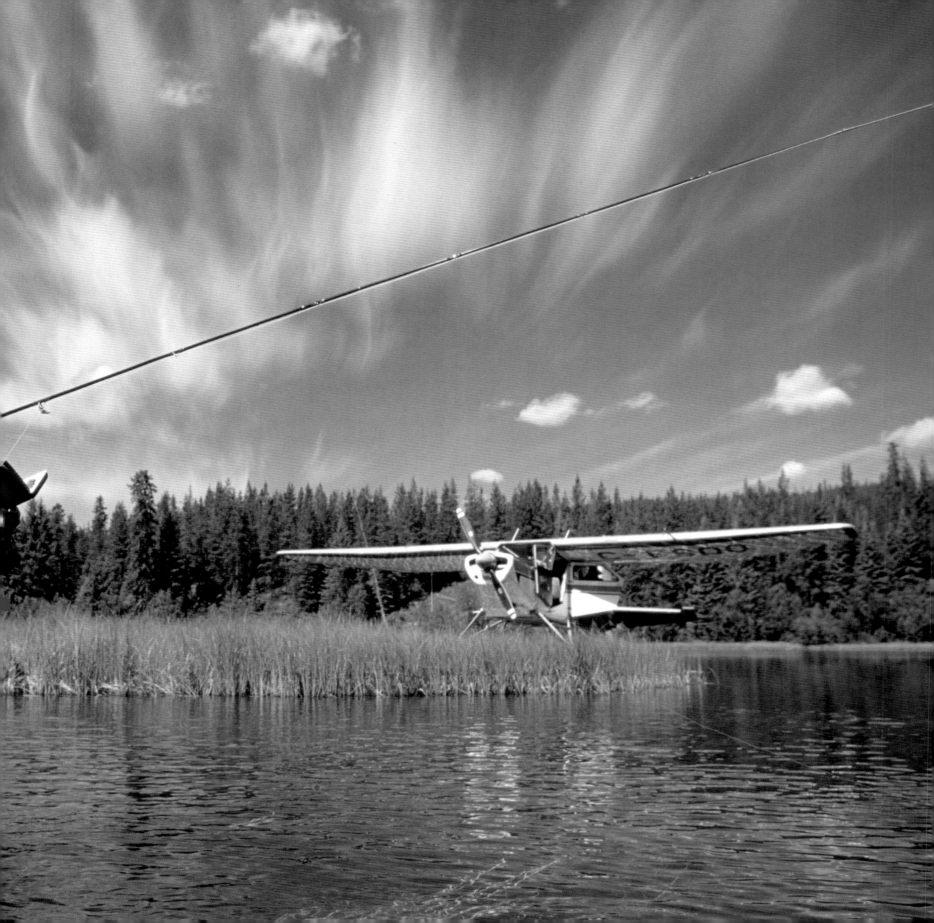

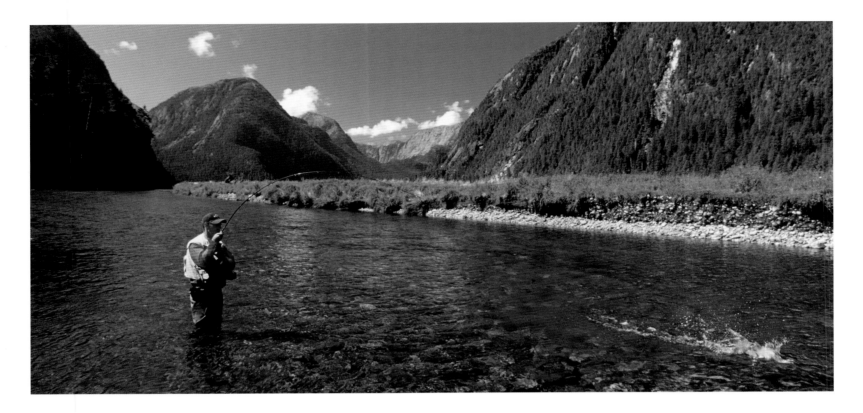

only reached Anahim once a week if the roads were passable, and then John had to bring them the next 70 miles by horse-drawn wagon or tractor. The trip took six days if all went well.

During the first seven years, they built the lodge, the guest cabins, and an airstrip and Moose Lake Lodge began to take shape. The result of their efforts is an astonishingly remote fishing and hunting lodge, situated in the middle of some of the most unspoiled wilderness left on this earth. A wilderness shredded by brawny rivers full of rainbows, char, the five species of Pacific salmon, and the legendary steelhead of the Dean River. Steelhead have a cult following of anglers who will suffer pretty much any hardship to fish for them, particularly in those hallowed rivers where the steelies are huge and brutally strong. They are natural fighters and the best of them put up a leaping and thrashing resistance that will suck the breath from you like immersion in the icy water in which you stand. The Dean is one of those sacred rivers,

surrounded by some of the most spectacular scenery North America has to offer.

Guests of Moose Lake Lodge all come by plane as the wilderness area around the lodge is now prohibited to motor vehicles. Guests have the option to fish different water daily, flying out to remote areas of the Blackwater, Upper Dean, Entiako, Iltasyuko, and Fawnie rivers. For those not satisfied with the remote nature of the lodge, there are outpost camps tucked away in the endless river canyons and lakes where an angler can disappear for a while and converse only with himself.

To find anything more beautiful or more remote, one would have to take on the wilderness alone. The Blackwells have already done this for their guests, carving out a haven where the wilderness lies at their feet, but with a warm bed and an abundance of good food, offering ordinary people a chance to see what most sportsmen will never see.

OPPOSITE: *An angler enjoys a sunny day as he makes a catch in the Kynoch Inlet in the Great Bear Rain Forest of British Columbia. The Kitimat Range of the Coast Mountains is in the background.* BELOW: *The coho salmon female (left) and male (right) shown here are indicative of the big silver runs that come up these rivers in the late summer and early fall.*

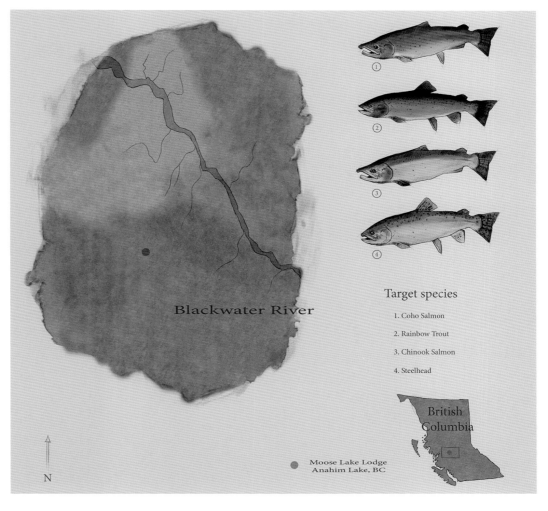

Blackwater River

Target species

1. Coho Salmon

2. Rainbow Trout

3. Chinook Salmon

4. Steelhead

British Columbia

Moose Lake Lodge
Anahim Lake, BC

N

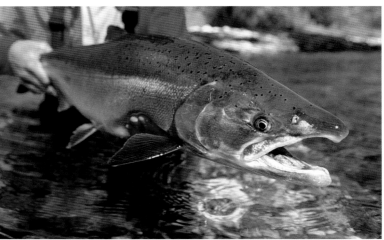

Wilson's Sporting Camps

McNamee, New Brunswick

Located in the scenic Miramichi River Valley
Founded in 1855

To have a truly successful trip fishing for Atlantic salmon, it is almost compulsory to have an appreciation for tradition and antiquity. No other fish is so enmeshed in angling history and lore. During the 13th century, the legalities of salmon fishing were mentioned in Britain's *Magna Carta*. In the same century France's clergy and noblemen decided the fish was so valuable that only the upper class deserved them. Izaak Walton dubbed the salmon the "King of Fresh Water Gamefishes" in 1653 and famous anglers have been trying to hook and land them ever since, from European kings and U.S. presidents to Bing Crosby and Ted Williams.

Keith and Bonnie Wilson, owners of Wilson's Sporting Camps, located on the Miramichi River in New Brunswick, know something of the history of Atlantic salmon fishing. The lodge Keith owns and operates with his wife was started by his great-great-aunt Grace Wilson in 1856. Originally established 18 miles nearer to the headwaters, it was moved by Keith's great-grandfather Willard Wilson back to the original family homestead during the 1920s. In 2005, Keith and his wife Bonnie moved the lodge again to its current Big Murphy's Pool location. The move resulted

RIGHT: *An angler leaves his canoe to wade into the beautiful Miramichi River.*

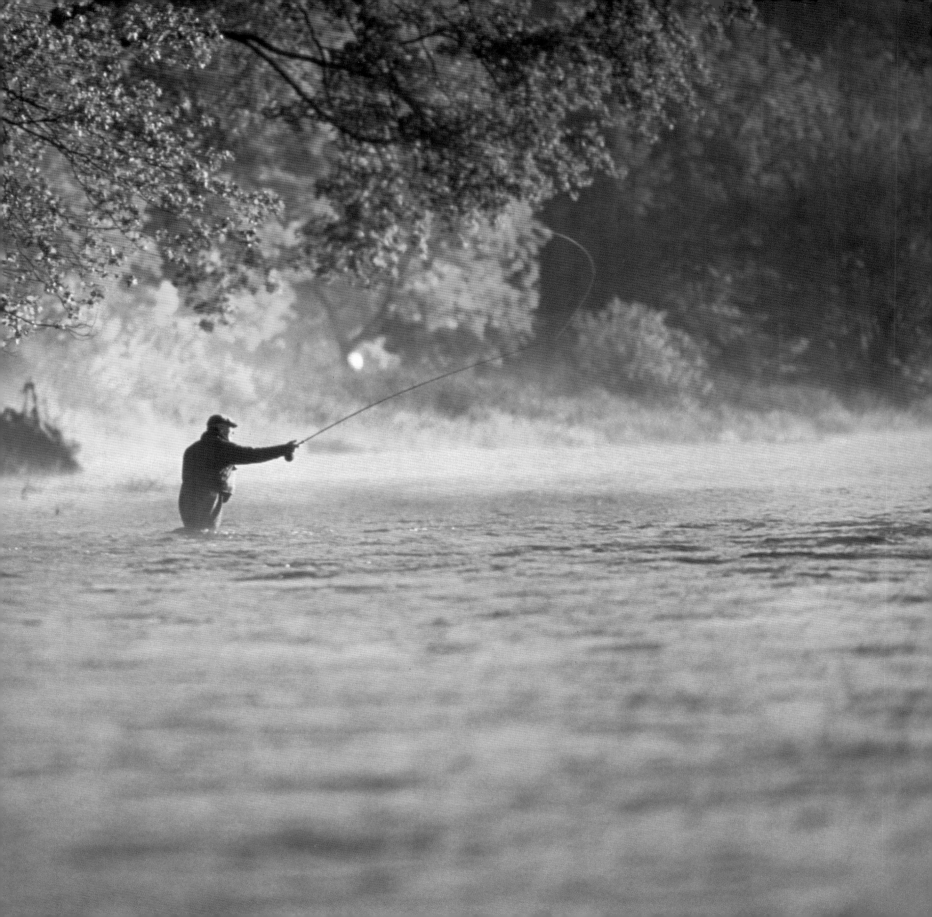

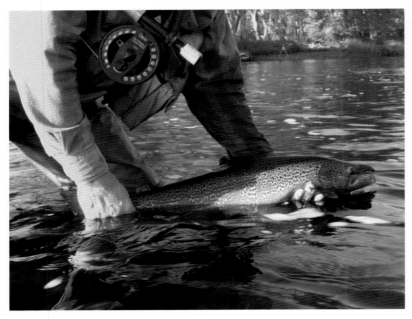

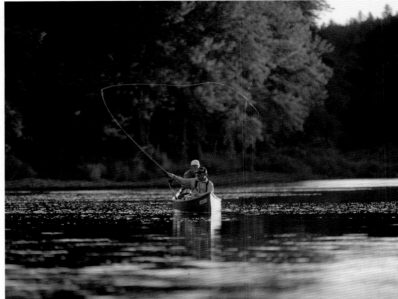

in a newly constructed and modernized facility, but one that pays homage to the past.

Stepping into Keith's lodge, it's easy to see that it's a place where the traditions of salmon fishing are respected. Old photographs of anglers and their catches, historical documents, and antique fishing tackle and collectibles from the sport's early days are displayed throughout the lodge's common spaces. The sense of tradition goes further than the décor. Legendary Miramichi guide Earnest "E.J." Long, now guiding for the fourth generation of Wilson's, presides over the guide staff and is currently passing his 70 years of Atlantic salmon knowledge on to Keith's son Karl. This will ensure that the finest aspects of the sport, little changed since Grace's days, are embedded in the latest generation of Wilson's.

With so much to be said for the history and traditions of the fishery, it might be easy to overlook the new developments on Canada's salmon rivers—namely the incredible increase in the number of fish returning to their spawning grounds in recent years.

Due to commercial netting and liberal creel limits, there were some lean years, but thanks to ambitious conservation efforts during the 1980s and 1990s, it certainly appears that the fish are back. Overall, 2008 proved to be a banner year, the Miramichi alone seeing an estimated 40 percent increase in salmon numbers over 2007.

"Camp records and personal records were broken almost on a weekly basis," said Keith, and biologists estimate that 100,000 salmon entered the river in 2008, with predictions of even greater future returns.

With 16 pools owned or leased by the lodge, Wilson's has more water at its disposal than any other lodge or outfitter on the river. The legendary staff is able to ensure that each angler has his or her own beat or solitary stretch of river with unpressured fish. Salmon are not easy to catch and are often called "the fish of a thousand casts," but there is no better place to improve those odds than on the famous pools of Wilson's Sporting Camps and the thousands of fish that fill them.

TOP LEFT: *This male Atlantic salmon is one of the estimated 100,000 that enter the Miramichi River.* TOP RIGHT: *Casting from a canoe in New Brunswick is a study in the great sporting traditions of the great north woods.*

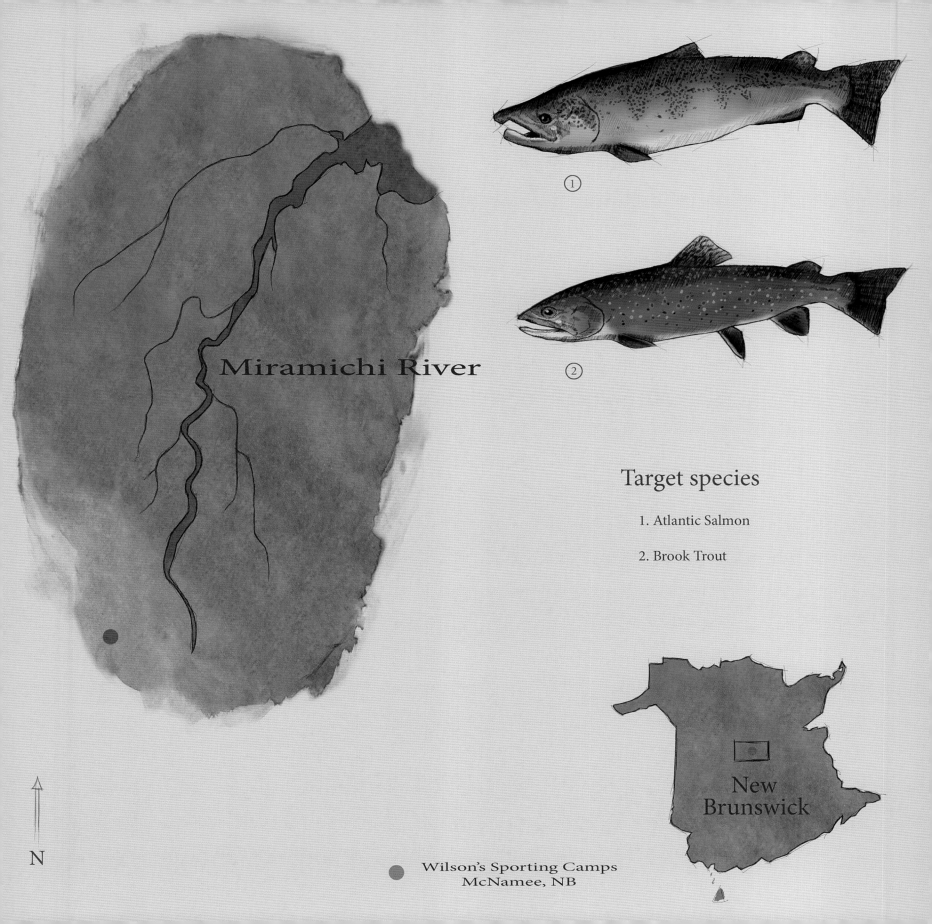

Miramichi River

Target species

1. Atlantic Salmon

2. Brook Trout

New Brunswick

Wilson's Sporting Camps
McNamee, NB

N

LODGE DIRECTORY

UNITED STATES

ALASKA

Alaska Sportsman's Lodge
Kvichak River, Lake Iliamna, AK
P.O. Box 4068
Igiugig, AK 99613
T: 907-276-7605
F: 907-276-7616
E: bkraft@alaskasportsmanslodge.com
www.fishasl.com

Alaska's Boardwalk Lodge
Prince of Wales Island
Thorne Bay, AK 99919
T: 800-764-3918
F: 801-296-1225
E: info@boardwalklodge.com
www.boardwalklodge.com

Crystal Creek Lodge
46 Big Creek Road
King Salmon, AK 99613-0046
For reservations:
T: 907-357-3153
F: 907-357-1946
To reach the lodge (June–September):
T: 907-246-3153
E: info@crystalcreeklodge.com
www.crystalcreeklodge.com

Tikchik Narrows Lodge
P.O. Box 690
Dillingham, AK 99576
T: 907-644-3961 (June–September)
T: 907-644-3971 (June–September)
T: 360-379-2842 (October–May)
E: info@tikchik.com
www.tikchiklodge.com

Tower Rock Lodge
35555 Kenai Spur Highway #222
Soldotna, AK 99669
T: 800-284-3474
E: info@towerrocklodge.com
www.towerrocklodge.com

CALIFORNIA

Oasis Springs
32400 Highway 36E
Paynes Creek, CA 96075
T: 800-239-5454
T: 530-474-1487
E: reservations@oasisflyfishing.com
www.oasisflyfishing.com

COLORADO

Broadacres Ranch
25671 West Highway 149
Creede, CO 81130
T: 719-658-2291
www.broadacresranch.com

The Home Ranch
54880 Routt County Road 129
Clark, CO 80428
T: 970-879-1780
F: 970-879-1795
E: info@homeranch.com
www.homeranch.com

North Fork Ranch
P.O. Box B
55395 Highway 285
Shawnee, CO 80475
T: 800-843-7895
T: 303-838-9873
F: 303-838-1549
www.northforkranch.com

The Lodge and Spa at Cordillera
2205 Cordillera Way
Edwards, CO 81632
For reservations:
T: 800-877-3529
For other information:
T: 970-926-2200
F: 970-926-2486
www.cordilleralodge.com

FLORIDA

The Marquesa Hotel
600 Fleming Street
Key West, FL 33040
T: 800-869-4631
T: 305-292-1919
F: 305-294-2121
E: info@marquesa.com
www.marquesa.com

Ocean Reef Club
35 Ocean Reef Drive
Key Largo, FL 33037
T: 888-422-9944
T: 305-367-5921
F: 305-367-2224
E: info@oceanreef.com
www.oceanreef.com

WaterColor Inn & Resort
34 Goldenrod Circle
Santa Rosa Beach, FL 32459
T: 866-426-2656
T: 850-534-5000
T: 888-775-2545 (for rental homes)
F: 850-534-5001
E: reservations@watercolorresort.com
www.watercolorresort.com
www.watercolorvacationhomes.com

IDAHO

The Lodge at Palisades Creek
3720 Highway 26
P.O. Box 70
Irwin, ID 83428
T: 866-393-1613
T: 208-483-2222
F: 208-483-2227
E: palisades@tlapc.com
www.tlapc.com

Three Rivers Ranch
1662 Highway 47
Warm River, ID 83420
T: 208-652-3750
F: 208-652-3788
E: info@threeriversranch.com
www.threeriversranch.com

MAINE
Libby Camps
P.O. Box 810
Ashland, ME 04732
T: 207-435-8274
E: matt@libbycamps.com
www.libbycamps.com

Weatherby's
P.O. Box 69
Grand Lake Stream, ME 04637
T: 207-796-5558 (Summer)
T: 207-926-5598 (Winter)
E: info@weatherbys.com
www.weatherbys.com

MASSACHUSETTS
Chatham Bars Inn
297 Shore Road
Chatham, MA 02633
T: 800-527-4884
T: 508-945-0096
E: welcome@chathambarsinn.com
www.chathambarsinn.com

MONTANA
The Blue Damsel Lodge
1081 Rock Creek Road
Clinton, MT 59825
T: 866-875-9909
T: 406-825-3077
E: info@bluedamsel.com
www.bluedamsel.com

Craig Fellin Outfitters & Big Hole Lodge
36894 Pioneer Mountains Scenic Byway
Wise River, MT 59762
T: 406-832-3252
E: bigholeriver@montana.com
www.flyfishinglodge.com

Firehole Ranch
P.O. Box 686
West Yellowstone, MT 59758
T: 406-646-7294
F: 406-646-4728
E: info@fireholeranch.com
www.fireholeranch.com

Hubbard's Yellowstone Lodge
287 Tom Miner Creek Road
Emigrant, MT 59027
T: 406-848-7755
F: 406-848-7471
E: info@hubbardslodge.com
www.hubbardslodge.com

Lone Mountain Ranch
750 Lone Mountain Ranch Road
Big Sky, MT 59716
T: 800-514-4644
T: 406-995-4644
F: 406-995-4670
E: lmr@lmranch.com
www.lonemountainranch.com

Madison Valley Ranch
307 Jeffers Road
Ennis, MT 59729
T: 800-891-6158
E: fishing@madisonvalleyranch.com
www.madisonvalleyranch.com

PRO Outfitters and North Fork Crossing Lodge
328 North Fork Hill Road
Ovando, MT 59854
T: 800-858-3497
E: pro@prooutfitters.com
www.prooutfitters.com

Spotted Bear Ranch
P.O. Box 4940
Whitefish, MT 59937
T: 800-223-4333
E: info@spottedbear.com
www.spottedbear.com

Triple Creek Ranch
5551 West Fork Road
Darby, MT 59829
T: 800-654-2943
T: 406-821-4600
F: 406-821-4666
E: info@triplecreekranch.com
www.triplecreekranch.com

NEW MEXICO
Cow Creek Ranch
P.O. Box 487
Pecos, NM 87552
T: 505-757-2107
E: flyfish@cowcreekranch.com
www.cowcreekranch.com

Vermejo Park Ranch
P.O. Drawer E
Raton, NM 87740
T: 575-445-3097
F: 575-445-0545
E: john.sakelaris@vermejo.com
www.vermejoparkranch.com

NEW YORK
Lake Placid Lodge
144 Lodge Way
Lake Placid, NY 12946
T: 877-523-2700
E: info@lakeplacidlodge.com
www.lakeplacidlodge.com

West Branch Angler and Sportsman's Resort
150 Faulkner Road
Hancock, NY 13783
T: 800-201-2557
T: 607-467-5525
F: 607-467-2215
E: wbangler@westbranchresort.com
www.westbranchresort.com

NORTH CAROLINA
Chetola Resort at Blowing Rock
500 North Main Street
Blowing Rock, NC 28605
T: 800-243-8652
T: 828-295-5500
F: 828-295-5529
E: info@chetola.com
www.chetola.com

OREGON

Morrison's Rogue River Lodge
8500 Galice Road
Merlin, OR 97532
T: 800-826-1963
F: 541-476-4953
www.morrisonslodge.com

Sunriver Resort
17600 Center Drive
Sunriver, OR 97707
T: 800-801-8765
F: 541-593-5458
E: info@sunriver-resort.com
www.sunriver-resort.com

PENNSYLVANIA

The Lodge at Glendorn
1000 Glendorn Drive
Bradford, PA 16701
T: 800-843-8568
E: info@glendorn.com
www.glendorn.com

Nemacolin Woodlands Resort
1001 Lafayette Drive
Farmington, PA 15437
T: 800-422-2736
T: 724-329-8555
E: birds.of.a.feather@nemacolin.com
www.nemacolin.com

TENNESSEE

Blackberry Farm
1471 West Millers Cove Road
Walland, TN 37886
T: 800-648-4252
T: 865-984-8166
E: info@blackberryfarm.com
www.blackberryfarm.com

UTAH

Falcon's Ledge
P.O. Box 67
Altamont, UT 84001
T: 435-454-3737
T: 877-879-3737
F: 435-454-3392
E: info@falconsledge.com
www.falconsledge.com

VERMONT

The Essex, Vermont's Culinary Resort & Spa
70 Essex Way
Essex (Burlington), VT 05452
T: 800-288-7613
T: 802-878-1100
F: 802-878-0063
www.vtculinaryresort.com/orvis

VIRGINIA

The Homestead
7696 Sam Snead Highway
Hot Springs, VA 24445
T: 800-838-1766
T: 540-839-1766
www.thehomestead.com

WYOMING

Canyon Ranch
59 Canyon Ranch Road
P.O. Box 701
Big Horn, WY 82833
T: 307-674-6239
F: 307-672-2264
E: pabs@canyonranchbighorn.com
www.canyonranchbighorn.com

Spotted Horse Ranch
12355 S. Highway 191
Jackson Hole, WY 83001
T: 800-528-2084
T: 307-733-2097
F: 307-733-3712
E: info@spottedhorseranch.com
www.spottedhorseranch.com

CANADA

BRITISH COLUMBIA

Minette Bay Lodge
2255 Kitamaat Village Road
Kitimat, BC V8C 2P4
Canada
T: 250-632-2907
F: 250-632-2903
E: info@minettebaylodge.com
www.minettebaylodge.com

Moose Lake Lodge
Box 3310
Anahim Lake, BC V0L 1C0
Canada
T: 250-742-3535
E: mooslk@telus.net
www.mooselakelodge.com

NEW BRUNSWICK

Wilson's Sporting Camps
Miramichi River
23 Big Murphy Lane
McNamee, NB E9C 2P6
Canada
T: 877-365-7962
T: 506-365-7962
F: 506-365-7106
E: wilsons@nbnet.nb.ca
www.wilsonscamps.nb.ca

QUEBEC

Camp Bonaventure
St. Georges Road
Bonaventure, QC G0C 2K0
Canada
T: 800-737-2740
T: 418-534-3678
F: 418-534-2478
E: info@campbonaventure.com
www.campbonaventure.com

Fairmont Kenauk at Le Château Montebello
1000 Chemin Kenauk
Montebello, QC J0V 1L0
Canada
T: 800-567-6845
T: 819-423-5573
F: 819-423-5277
E: kenauk@fairmont.com
www.fairmont.com/kenauk